THE ENTHUSIAST'S GUIDE TO PHOTOSHOP

64 Photographic Principles You Need to Know

RAFAEL "RC" CONCEPCION

THE ENTHUSIAST'S GUIDE TO PHOTOSHOP:
64 PHOTOGRAPHIC PRINCIPLES YOU NEED TO KNOW

Rafael "RC" Concepcion

Project editor: Jocelyn Howell
Project manager: Lisa Brazieal
Marketing coordinator: Mercedes Murray
Layout and type: WolfsonDesign
Design system and front cover design: Area of Practice
Front cover image: Rafael Concepcion

ISBN: 978-1-68198-298-4
1st Edition (1st printing, December 2017)
© 2018 Rafael Concepcion
All images © Rafael Concepcion unless otherwise noted

Rocky Nook Inc.
1010 B Street, Suite 350
San Rafael, CA 94901
USA

www.rockynook.com

Distributed in the U.S. by Ingram Publisher Services
Distributed in the UK and Europe by Publishers Group UK

Library of Congress Control Number: 2017945182

This book is dedicated to two people who have been
my loudest cheerleaders and close friends.

Kim Patti: You have not only singlehandedly built the ship on which we are sailing, but you have given me a new lease on life. I never would have thought I'd find a man I could say I love almost like a father.

Latanya Henry: You are my partner in crime, a trusted confidant, an incredible sounding board, and such a great cheerleader for what I want to do. You believe in me more than I am able to believe in myself at times. We switch from teacher to student so often, and that's what has made my friendship with you so special. Thank you.

ACKNOWLEDGEMENTS

FIRST AND FOREMOST, I'd love to thank my mother, Cristela Concepcion. My mom continues to be an inspiration to me. She shows me daily how hard work and respect are important things to live by. La quiero mucho mama.

To my wife, Jennifer Concepcion: I would shout to the world that if ever someone needs to see the definition of an amazing mother, they should look no further than you. Thank you for being such a rock and guiding light for me and our Sabine. I am thankful for your love, and so incredibly proud of you. You are the most incredible fifth grade teacher, and it makes me so proud to walk through your school with some swagger, bragging that I know you.

To my brothers, Victor, Everardo, David, Jesus, Carlos, and Tito: While time and distance keeps our conversations short, I cannot help but laugh out loud at all of the foolishness I see in our text threads. That has been such a gift.

To Danielle and Jim Bontempi: Your support as in-laws is overshadowed only by your love of me as one of your own. I am grateful to have you in my life.

To my best friend, Al Fudger: For over 22 years, you have been a vital part of my life. I am very thankful for every chance we get to connect.

To Bonnie Scharf and Matt Davis: I love you two very much and am grateful that there isn't much that would ever get in the way of us helping one another out—not even a trip into the Bronx!

I always want to be better, both as a teacher and as a photographer, because of three people. To Jay Maisel and Gregory Heisler: You are icons for whom I have a great admiration, and I am blessed to call you my friends. And to the inimitable Joe McNally: Your friendship, counsel, mentorship, and advice has been one of the greatest things being in this business has given me. You, Annie, Cali, John, and Lynn are just wonderful.

To Denise Patti and Linwood Henry: Aside from being great friends to me, you guys have been ever so patient with the loaning of your spouses through my crazy adventures. Thank you for being so kind and so generous with such amazing people. I promise to return them in one piece!

To Alan Shapiro: You are an amazing photographer and incredible force in the photo space. Your support and trust have been unwavering, and I am incredibly grateful for your belief in me. I'm so thankful to call you a friend.

To Edna, Joel, and Marco: Who could imagine that you would find such kinship and develop a family-like bond in such a short amount of time? Not a day goes by that we don't think about how much we miss you three.

To Karyn and Michael: If there's one thing we've enjoyed more than Jade, it's being able to share a new experience through Sabine's eyes. You have given us a great friendship and an amazing memory. I cannot wait to reconnect again in person!

Special thanks to: Corey Barker, Pete Collins, Donna Green, Katrin Eismann, Lisa Sanpietro, Kathy Porupski, Jim Booth, Rich Reamer, Steve Peer, Zack Arias, Brian Wells, Chrysta Rae, April Love, Jesica Bruzzi, Meredith Payne Stotzner, Jeff Tranberry, Dan Steinhardt, Mark Suban, Nancy Davis, Nikki McDonald, Jennifer Bortel, Sara Jane Todd, John Nack, and Mike Corrado.

To Bill Fortney: Thank you for your guidance and support. When it happens, it will be because of you.

To Kevin Agren: Thank you for wanting to come along for the ride of building a new school. Im grateful to have you on the little ship that could. We're going to go to some cool places.

Mia McCormick: You have been both a great friend to me and a source of inspiration for reinvention. I can honestly say that I am changed and am better because of what I've learned from you. Thank you for your candor and your patience; it has meant the world.

To The Waldron Family, Roz, Carl, Thalia, and Connor: It's such a gift to have friends like you just a few doors down. Our lives are so much better knowing you guys are nearby, just a sleepover away!

To my new family at Rocky Nook: Jocelyn Howell, Lisa Brazieal, Mercedes Murray, thank you for keeping up with me and being so patient! To Ted Waitt and Scott Cowlin: I'm grateful to be connected with you at this new spot. Let's see what we can do here!

Dubai has become such a special place for me to go to get away from it all. That part of the world has given me people whom I miss terribly and am so happy to see: Hala Sahli, Mohammed Somji, Saadia Mahmud, Imraan, Tarek Sakka, Raad Sabounchi, and the head of Lightning Hand Tomato, Katie Kuusker.

To Sara Lando: I'd learn Italian just to find another way to tell you how amazing you are, and how much I love to see you. I need to get out to Grappa to visit you and Alessandro.

To Jay Abramson and Susan Henry: To say that you are like family to us would be completely understating how important you guys are to Sabine, Jenn, and I. We love you very much.

To Martin Stephens: As soon as I leave you, I immediately start planning how to get halfway around the world to see again. Here's to our next adventure, buddy!

To Daniel Gregory: Your friendship has brought an incredible love in my heart, a passion for becoming a better photographer, and incredible clarity in such a clouded mind. You are one in a million.

Finally, to the most important person of all, to you, dear reader: It is because of you that I get to do what I do. I don't ever want to forget that. Thank you for your time, investment, and attention. I hope this book gives you what you need, and I stand willing to help should you need anything else.

CONTENTS

CONTENTS

CONTENTS

**You can download the original RAW files for many of the
lessons in this book at: http://www.rockynook.com/egphotoshop**

I've made these files available to you so that you can follow along with the lessons
and practice the various Photoshop techniques covered in them. Please be aware that
these are my original image files and they are not for commercial or public use.

1

MASTER YOUR TOOLS

CHAPTER 1

The best analogy I can think of for learning to use Photoshop is learning how to fly a plane. If you don't know how to fly a plane, stepping into a cockpit is very daunting. There are all these buttons and dials, and you have no idea what to push to even start the engine. And there are so many things you could do when it comes to flying a plane. You could ferry passengers from one airport to another; you could be a fighter pilot; or you could be a pilot who performs trick maneuvers. Learning to use all of the buttons and dials is only one small part of the process.

Photoshop is best explained with this kind of analogy. It should be broken down into a series of steps. The first step is to learn the anatomy of the program—which buttons do what and how to turn on the engine. Once you know where all of the buttons are, you can progress to learning a certain set of processes: how to start the plane, how to make the plane go forward, how to make the plane go backward (or in Photoshop, how to create a layer, how to increase the brush size, and so on).

These processes don't take you all the way to becoming a fighter pilot; they just deal with taking the anatomy you've learned and building it into another small step. Once you've mastered these processes, you progress to the next step and learn how to take off. That's a procedure. Your anatomy brings you to a process; the process brings you to a procedure.

Your goal as a pilot of Photoshop is to learn the anatomy, then the process, and then the individual procedures or techniques. Once you

have these techniques down, it's up to you to decide how to apply them to an overall style.

This book is designed in this fashion. I start by breaking down the anatomy of the program for you. From there, I show you some different processes you should know for working with pictures. Once you've learned those processes, I'll give you a series of techniques you can use for common Photoshop problems. It's up to you to decide how to use those techniques to exercise your photographic style or vision.

This book is not meant to be the be-all and end-all bible for Photoshop. There is a ton of information in this program, and we are just scratching the surface to get you more comfortable using it. If you find yourself interested in a specific aspect of the program, there are loads of resources out there that you can dive into to get more specialized training. My goal is to give you the techniques you need to get out there and start making pictures quickly, so let's go ahead and get started.

1. A QUICK TOUR OF THE PHOTOSHOP INTERFACE

BEFORE WE BEGIN actually using Photoshop, let's take a look at the workspace. When you open Photoshop, you'll see a bunch of windows and buttons that normally freak people out, so it's a good idea to just get an overview of what's there.

The first thing you'll see when you open Photoshop is a list of filenames or thumbnails for all of the recent files you've worked with. If you click on Create new on the left side of the screen to create a new blank document, you will get a dialog box with templates for specific types of projects that you may want to work with (**Figure 1.1**). In the Preset Details section on the right side of this dialog, you can type in specifications for a custom blank document. More often than not, if you are editing an image, you just go to *File > Open* and navigate to the image you want to work with.

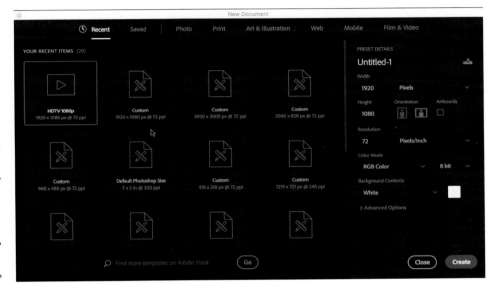

Figure 1.1 If you want to create a new blank document, you can select from a series of templates or enter custom specifications.

Your chosen image (or new blank document) will open in the center of the workspace (**Figure 1.2**). The area that contains the image is called the document window, and the gray area just outside of that is known as the canvas. The toolbar on the left side of the workspace contains all of the individual tools that you're going to be working with. Directly above the toolbar, you'll see a bar that runs across the top of the program—this is the tool options bar and it contains options for the currently selected tool. These are the most important sections of Photoshop that you'll be working with.

To the right of the document window, you'll see a series of panels, each of which has a name in the upper-left corner. It's important to note that you will not use all of these panels on every single Photoshop project. Graphic designers will use one set of panels, while someone doing retouching will use a completely different set. The goal here is not for you to master every single available panel, but rather to focus on and become experienced with the panels that you need for your specific project. Knowing what each panel is called will help as you start developing techniques for what you're trying to accomplish.

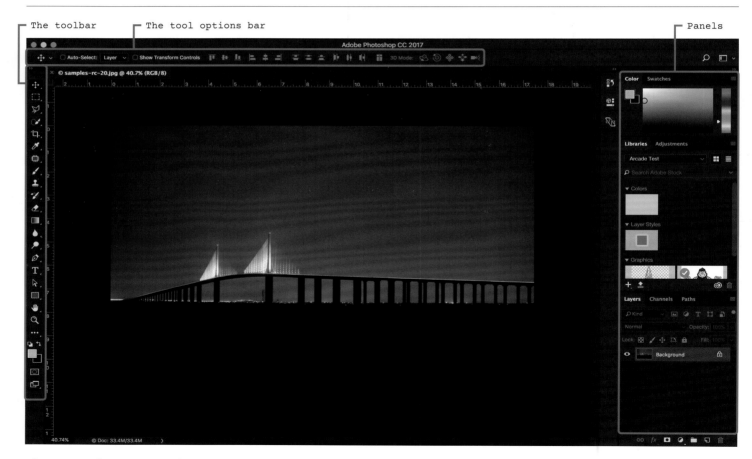

Figure 1.2 The Photoshop interface

JUST LIKE A pilot needs to understand how to navigate his or her plane, you're going to need to understand how to work the controls in Photoshop. All of the controls that you will be using are located in the toolbar on the left side of your interface (**Figure 2.1**). If you hover over an icon in the toolbar, the name of the tool and its corresponding keyboard shortcut will be displayed (**Figure 2.2**). For example, if you hover over the Move tool, you'll see that its keyboard shortcut is the letter V, so pressing the V key on your keyboard switches you to that tool—pretty straightforward.

One thing that often confuses people is that many tools have groups of tools associated with them. Let's take a look at the Rectangular Marquee tool, which is the second tool from the top of the toolbar (**Figure 2.3**). This tool is used to create selections in which you can effect changes, and its keyboard shortcut is the letter M. However, if you click and hold on the tool with your cursor, you'll open a context menu with other tool options, including the Elliptical Marquee tool, Single Row Marquee tool, and Single Column Marquee tool. These tools will help in very specific scenarios.

Figure 2.1
The Photoshop toolbar

Figure 2.2 Hover over an icon in the toolbar to display the tool name and its corresponding keyboard shortcut.

Figure 2.3 Many tools in the toolbar have groups of tools associated with them.

You can also access the different tools in a tool group with the corresponding keyboard shortcut. For example, to select the Elliptical Marquee tool, hold down the Shift key and press the letter M. Every time you press the letter M while the Shift key is held down, you will advance to the next tool in the group.

Whichever tool in the group is selected when you switch to a different tool will be the default for the keyboard shortcut. So if you're working with the Elliptical Marquee tool and switch to another tool, when you press the letter M again, you'll be taken back to the Elliptical Marquee tool. If you want to switch to a different tool in the Marquee group, you'll have to press Shift + M to cycle through those tools once again.

One of my favorite additions to Photoshop CC 2017 has to be the Edit Toolbar feature near the bottom of the toolbar. If you click and hold on the icon with the three dots, you'll see a context menu that says Edit Toolbar (**Figure 2.4**). Select this option to open the Customize Toolbar dialog box. If there are any tools in the Toolbar menu that you don't use, you can drag them to the Extra Tools area, and they will be removed from your toolbar (**Figure 2.5**). Click on Done, and your toolbar will be customized according to the choices you made.

You even have an option to save individual tool sets as toolbar presets. For example, you can create a graphic design set for when you want graphic design tools, or you can use a smaller tool set when you're doing retouching. To create a toolbar preset, make sure all of the tools you want to include are listed under Toolbar in the Customize Toolbar dialog box, and move any tools you don't want to include over to the Extra Tools area. Then click on Save Preset, give your toolbar preset a name, and click Save. To load an existing toolbar preset, open the Customize Toolbar dialog box again, click on Load Preset, and navigate to the toolbar preset you'd like to use.

Photoshop has a ton of features to satisfy the requirements of many different types of users, so not every person will understand or need every feature. That amount of bloat can sometimes create a little bit of angst for people who are just getting into using the program. Making the tool sets smaller will definitely be a big help for new Photoshop users.

Figure 2.4 You can access the Edit Toolbar option directly from the toolbar itself by clicking on the icon with the three dots.

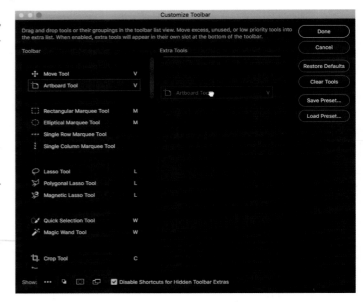

Figure 2.5 Drag any tools you don't want to see in your toolbar over to the Extra Tools area.

3. PANELS, PANELS EVERYWHERE!

THE RIGHT SIDE of the Photoshop interface holds all of the different panels you'll be working with. You won't need access to every single one of these panels, so it's a good idea for you to understand how to move them around and get rid of the ones you don't need so that you can clean up the interface and make it work well for your specific project. You can choose which panels are visible via the Window menu at the top of your screen (**Figure 3.1**). Each panel that is visible will have a checkmark next to its name. To add a panel to your workspace, simply click on the panel name to place a checkmark next to it. Click on it again if you want to remove it.

In the default workspace you have three columns of panels, and each column has a tiny double-arrow in the upper-right corner that allows you to collapse it (**Figure 3.2**).

Figure 3.1 You can add and remove panels from your workspace via the Window menu.

Figure 3.2 Click on the arrows in the upper-right corner of a column if you want to collapse it.

You can move panels around by clicking on a panel name and dragging it into a new location. In **Figure 3.3**, for example, you can see that I've decided to drag the Color panel into a new location in another column. The new location in which the panel will be placed is indicated with a solid blue bar. You can also drag a panel out into the canvas area to remove it from the columns and set it as a floating panel (**Figure 3.4**).

To make a panel bigger, click on the lower-right corner of the panel and drag outward (**Figure 3.5**). You also have the opportunity to change the function of a panel by clicking on the panel menu icon in the upper-right corner of the panel. In **Figure 3.6**, I clicked on the panel menu icon to open the options for the Color panel. Every panel has a panel options menu.

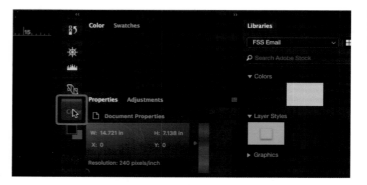

Figure 3.3
It's easy to move a panel—just drag it to a new location.

Figure 3.4
Drag a panel onto the canvas area to float it outside of the columns.

Figure 3.5 Drag the lower-right corner of a panel outward to make it bigger.

Figure 3.6 Every panel has a panel options menu that allows you to change the behavior of the panel.

If you would like to configure floating panels further, you can group panels together. In **Figure 3.7**, I've grabbed the Swatches panel and I am dragging it onto the Color panel. When I let go of my cursor, it will appear as another tab in that panel. You can see that it's going to dock itself next to the Color panel because there is a solid blue line around the Color panel. If I were to drag it directly underneath the Color panel, you'd see a solid blue line appear at the bottom of the Color panel (**Figure 3.8**). If I drag it to the left or right of the Color panel, the solid blue line will appear on the corresponding side of the Color panel (**Figure 3.9**). So you can see there are many options for configuring your panels.

Figures 3.7-3.9 You can group floating panels together in a variety of configurations.

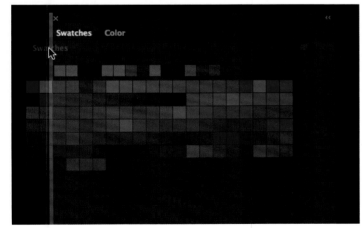

One of the things that I like to do to make it easier for myself is to arrange the Photoshop interface so that I see only the panels I am using for a given project. To do this, I float all three of the default columns inside the Photoshop interface (**Figure 3.10**). Then I drag out the panels I know I want to use, and I shut all of the other panels down by clicking on the X in the corner of each one. For our purposes, let's keep only the Layers and Properties panels open as floating panels on the Photoshop interface.

Grab the Layers panel and drag it onto the canvas so that it is floating separate from the dock. Drag the Properties panel onto the canvas and dock it next to the Layers panel (look for the solid blue line on the right side of the Layers panel). These two panels will now move with one another. Now close down all of the other remaining panels so that only the Layers and Properties panels are open inside your Photoshop interface (**Figure 3.11**).

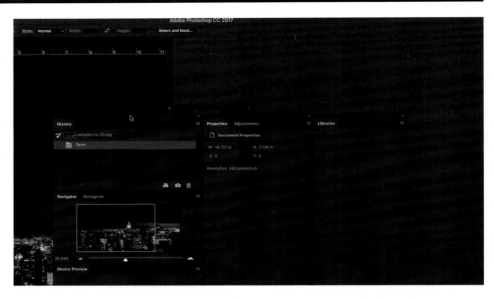

Figure 3.10 Click on and drag the thin bar along the top of the columns to float all three columns.

Figure 3.11 The Photoshop interface with only the Layers and Properties panels visible.

To save this workspace layout for future use, go to *Window > Workspace > New Workspace*. In the New Workspace dialog box, you can give your workspace a name, as well as assign keyboard shortcuts or a different toolbar to it (**Figure 3.12**). I named my workspace General Photoshop. Once you click Save, you can select this workspace at any time by clicking on the workspace menu icon in the top-right corner of the Photoshop interface (**Figure 3.13**).

As before, you can make a workspace that's dedicated to portrait retouching, and another for graphic design, and yet another for something else. The key here is to get rid of all of the clutter so that you can focus on exactly what you need for the projects you want to work with.

Figure 3.12 Save your workspace for future use.

Figure 3.13 You can access your saved workspaces and other standard Photoshop workspaces via the drop-down menu in the top-right corner of the Photoshop interface.

4. OPENING FILES IN PHOTOSHOP

THERE ARE MULTIPLE ways you can open a file in Photoshop, depending on how you get to the Open dialog box and what kind of file you are actually opening. The easiest way to open any file is to go to *File > Open* and select a file from the list. You can even select multiple files to open at the same time. Each file will open in its own tab in the Photoshop interface. You'll see the tabs directly under the Options bar (**Figure 4.1**).

To close a file, click on the X to the left of the name in the title bar, or select *File > Close*. You can close multiple files at once by selecting *File > Close All*. This will close every file that you have open with one click.

If you're working on a large screen or you have a lot of real estate on your desktop, more often than not, you'll be working with Photoshop in a smaller window. In this case, it's a lot easier for you to open files by dragging them into the Photoshop workspace from wherever they are saved than by going into the menu (**Figure 4.2**). This saves you a couple of clicks.

If you drag multiple files into Photoshop at the same time, they will open in separate tabs. If you open one file, and then decide to open up a second file using the drag-and-drop technique, do not place the second file in the center of the document window. If you do this, the file will open on top of the already existing file, which is called placing a file (see Lesson 8, "Placing Images in Photoshop"). Instead, drag the second file into the area to the right of the title bar for the existing file (**Figure 4.3**). This will ensure that the file opens up in its own individual window.

For the most part, opening files will be pretty straightforward. However, there are a couple of exceptions. First, if you are working with RAW files, they will need to be preprocessed so you can work on them in Photoshop. This processing occurs in a program embedded in Photoshop called Adobe Camera Raw (ACR). When you go to *File > Open* in Photoshop and select a RAW file, the image will automatically open in ACR. Here, you'll make adjustments to the file in terms of exposure, contrast, color, and tone, and the resulting file will be imported into Photoshop for you to use. We'll cover this in chapters 2 and 3.

The other exception is when you are working with a PDF file. Normally, when you open a PDF file, you will see a dialog box that asks for the resolution at which you would like to open an image, as well as what individual page you would like to open. Working with PDFs in Photoshop is beyond the boundaries of what we will be talking about in this book, but it's important to just note that there are a couple of differences when you're opening and working with these file types.

Figure 4.1 When you choose to open multiple files at once, each file will open in its own tab.

Figure 4.2 You can open files by dragging them directly into to the Photoshop workspace.

Figure 4.3 When you already have a file open in Photoshop, and then decide to drag another file in, be sure to place it to the right of the title bar for the existing file so that it opens in its own tab.

5. USE KEYBOARD SHORTCUTS TO ZOOM IN AND OUT

THERE ARE A couple of things that I think you absolutely need to know how to do when you're learning Photoshop, and zooming in and out of a document is one of them. Sure, it sounds pretty straightforward: zoom in, zoom out, next lesson. However, this is one of those instances in which a lot of people don't spend enough time looking at the proper technique or learning how to efficiently move around a document. When you don't use the proper technique, a job that would normally take you five minutes can turn into a 35-minute ordeal.

Think about it; zooming in and out is the cornerstone of everything you do in Photoshop. If you're retouching eyes, you need to get right into the eyeball. If you're trying to clone out a tree from a background, you need to get into the individual components of the tree. If you need to retouch skin, you're going to have to zoom in to a pore level. All of these things will require you to zoom in to a portion of the document, and then move further away from it.

The technique I'm going to share is incredibly simple, but you need to do it right the first time and you need to exercise really good habits right from the very start. If you take an hour to practice this technique, and then go in and do it for five minutes at the start of a project, you'll be surprised by how fast you can assimilate this information into muscle memory.

Before we start any of this, it's important for you to have proper Photoshop keyboard technique. Think about the keyboard that's in front of you. If I were to make a guess, I'd say your keyboard is directly in front of you, and the space bar is lined up with your belly button. You position your keyboard this way because it's the most comfortable position for typing. Half of the keyboard is covered by your left hand and half by your right hand, making it easier for you to access all of the buttons. This is how we learned to type.

However, in Photoshop you don't use the keyboard for typing. The keyboard is really just an extension of tools and shortcuts—a physical representation of your toolbar, if you will—so you don't need to have it directly in front of you. In fact, it works to a disadvantage if you do. I recommend moving it all the way over to one side, opposite your mouse. When it is over on one side, you can cover the span of the keyboard with one hand, and operate your mouse with your other hand. If you need to press Command+C (PC: Control+C), for example, you can use your ring finger and middle finger. To press Command+P (PC: Control+P), you can press the Command key (PC: Control) on the right side of the keyboard with your thumb and the letter P with your index finger. Moving around like this is a lot more comfortable and you will be more likely to remember keyboard shortcuts and commit them to muscle memory.

Now that your keyboard is set up, let's talk about zooming in. Press Z on your keyboard to trigger the Zoom tool at the bottom of the toolbar. Once the Zoom tool is selected, click and drag to the right to zoom in to your document. Click and drag to the left to zoom back out. Once you are zoomed in to a portion of the document, you're going to want to move around in the document. Select the Hand tool by pressing H on your keyboard, and then you can click and drag on the document window to move it around. So this is pretty straightforward—use the Z and H keys to toggle between the Zoom and Hand tools.

The problem with this method, though, is that more often than not, you don't want to be constantly switching back and forth between these tools. You could be in the middle of brushing in a sky or retouching some pores and you don't want to switch from the brush, to the zoom, to the hand, and keep clicking on keyboard shortcuts. Let's look at another keyboard shortcut for zooming in and out and moving around.

Press the V on your keyboard to select the Move tool. Now hold down the Command key (PC: Control) and the space bar, and you'll notice that the cursor turns into a Zoom tool and you can click and drag to zoom in and out. Once you zoom into a specific area, release the Command key (PC: Control) and space bar, and you'll be brought right back to the Move tool. If you want to move around in the

document, you can hold down the space bar to access the Hand tool. Continue holding down the space bar and add in the Command key (PC: Control) to access the Zoom tool again.

Practicing this keyboard shortcut is supremely important—hold down the space bar and Command key (PC: Control), zoom in, zoom out, release the Command key (PC: Control) to switch to the Hand tool temporarily, move to another portion of the document, and so on. Yes, I know, it feels very basic, but because you will be doing this over and over again when you're working on your projects, knowing these basics is very helpful.

When you're working with the Zoom tool, keep in mind that it is relative. That is to say, when you select the Zoom tool and click-and-drag on a portion of a document, you will Zoom in on that general area. For example, in my picture of New York City, if I hold down the Command key (PC: Control) and space bar and click-and-drag on the Empire State Building, it brings me right into the Empire State Building area (**Figure 5.1**). If I zoom in to the blue reflection on the water, it brings me into that portion of the picture (**Figure 5.2**).

You have to be very particular about where in the document you're zooming in and out. If you want to see the entire document in the workspace, you can select *View > Fit on Screen*, or use the keyboard shortcut Command+0 (PC: Control+0). If you want to see the document at 100%, press Command+1 (PC: Control+1). This will get you to the print size, or 100% of the Photoshop document. These are absolutely essential keyboard shortcuts for you to practice using, and the more you do, the faster and easier your work in Photoshop will be. Sounds simple, but it's worth it.

Figure 5.1 Zooming in on the Empire State Building.

Figure 5.2 Zooming in on the reflection on the water.

6. CHOOSE YOUR IMAGE SIZE AND FILE FORMAT

ONCE YOU'RE DONE working with your images, you're going to want to save these files in a format that either lets you make changes later or that you can share with other people, be it in print or on the web.

There are two general file formats that you will be working with most of the time. The Photoshop (PSD) file format retains all of the work that you have done to the file in Photoshop. This is largely considered to be a layered file format (we'll talk about layers a little bit later). Use this format to save any kind of work that you may want to revisit later.

The second format that you will largely work with is the JPG format. This is the format used for printing images and sharing them online. The file is generally smaller than a PSD file because there is a certain amount of compression applied to make the transmission of the file easier. The level of compression is largely dependent on what you specify.

When you select the JPG format from the *File > Save As* dialog box and click Save, you'll be presented with a JPG Options dialog box (**Figure 6.1**). This is where you can designate the quality at which you want to save the file. A higher Quality number means less compression is applied to the file. A lower Quality number means more compression is applied to the file. While you won't necessarily see the difference until you really zoom into the file, there is a drastic difference in file size (**Figure 6.2**).

Figure 6.1 The JPG Options dialog box asks you to specify the quality at which you want to save your file. If you select a higher quality, less compression will be applied to the file.

It's often a good idea to select a lower quality (higher compression) when you want to share an image online or send it via email, but if you want to retain as much detail as possible, it's better to choose a higher quality (less compression).

It's also important to know how to resize an image while you're working with it. For an image you want to share on the Internet, you generally do not need a resolution higher than 72 pixels per inch. With the file open, select *Image > Image Size*, and then adjust the Resolution right in the Image Size dialog box (**Figure 6.3**). I recommend you change the resolution before you change the width and the height of the document you want to resize.

If I want to share a photograph online—on Facebook or Instagram, for example—I generally set the longest side to no more than 1600 pixels and choose a resolution of 72 pixels per inch. I usually save the document with a Quality of about 8. That gives me a good balance between quality and a small enough file size to share online.

Figure 6.3 For images you plan to share online, a resolution of 72 pixels per inch works well.

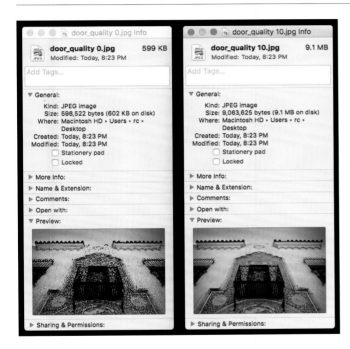

Figure 6.2 Lower quality means more compression and much smaller files. I chose a Quality of 0 for the file on the left, which resulted in a file size of 599 KB. The file on the right was saved at a Quality of 10 and is 9.1 MB.

7. MAKE USE OF THE LIBRARIES PANEL

IN THE PHOTOSHOP interface, you have a panel called Libraries. This panel allows you to store design elements that you plan to use again. You can create a new Library for a specific project by clicking on the drop-down menu at the top of the Libraries panel and selecting Create New Library. Once it's created, you can add colors, graphics, layer styles, and other elements that you can access when you're working on other projects or in other Creative Cloud applications.

Libraries become very helpful as you start working with projects across different applications, or if there are elements that you'll be using repeatedly in a Photoshop project. For example, I'm creating a mail campaign and as you can see in **Figure 7.1**, I've added a couple of colors, a layer style, and some background graphics to my Libraries panel so I can reuse them later on.

Figure 7.1 I added colors, a layer style, and some background graphics to my Libraries panel so that I can access these elements easily when I want to reuse them in my mail campaign.

You can add elements to a Library by simply selecting them with the Move tool (keyboard shortcut V) and dragging them into the Libraries panel (**Figure 7.2**). Once you've added the various elements to your Library, you have access to that Library in other applications on the Creative Cloud. If you go to creative.adobe.com and sign in to your account, you'll see that the assets in your Library are there and ready for you to use (**Figure 7.3**).

If you start up another application, like Adobe Illustrator, you can open up the Libraries panel there and all of the elements you added to the Libraries panel in Photoshop will be immediately available to you (**Figure 7.4**).

This probably isn't something you are going to use on a daily basis, but if you are working on projects in which you are using certain elements repeatedly, you should get a handle on the Libraries panel early so that you can start putting it to work for you.

Figure 7.2 Use the Move tool to drag elements directly into the Libraries panel.

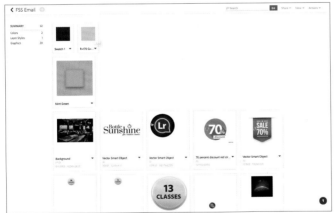

Figure 7.3 You can see all of your Libraries and the assets within when you sign in to your Adobe account.

Figure 7.4 You can access your Libraries in any Creative Cloud application. This is very helpful when you're using multiple applications to work on one project.

8. PLACING IMAGES IN PHOTOSHOP

AS YOU START adding images to documents in Photoshop, you will run in to what is called "placing" images. You can place an image by dragging it onto the Photoshop workspace, or by selecting *File > Place Embedded* or *File > Place Linked* and navigating to the image you want to use. If you select Place Embedded, Photoshop makes a copy of the image and embeds it in the PSD file. If you select Place Linked, Photoshop uses a link to the original image file, so the file is not actually embedded in your document and the resulting PSD file size is much smaller than if you had embedded the image.

When the image appears in your document, it will have an X across it, and you can drag it around the document (**Figure 8.1**). Right-click on the image and select Place from the context menu, and the image will be locked into place. Let's talk about what placing an image means and what benefits it has in your workflow.

When you place an object in a document in Photoshop, you create something called a Smart Object (**Figure 8.2**). A Smart Object references an external file (in this case, the original image file) that is separate from the document you are working with. The benefit of this is that you have a document that is referred to (linked to) outside of the bounds of the document you're working with in Photoshop. This means that any time you edit the image, all of the Smart Objects that link to that image are automatically updated. You can also perform nondestructive edits to the layer, meaning the changes will not affect the original image file.

Let's say, for example, I want to use the image of a rock formation shown in **Figure 8.1** for 35 different slides. If I embedded (*File > Place Embedded*) this rock formation picture in 35 separate documents, and then decided I wanted to make a change to the color of the picture, I would have to update all 35

references to that file. If, instead, I placed the file in each document by going to *File > Place Linked* and selecting the image, each document would simply use a reference to the original rock formation picture (which is stored somewhere on my computer), and the file is not included in the actual document. Now if I need to make an edit to the picture, I can edit the original file, and all 35 documents will be automatically updated.

We could spend a ton of time talking about Smart Objects and how they function in a workflow, but at this point it's just important to know that when you drag an image into a document, you are placing the image in the document, creating a Smart Object. There are some benefits to this, but the placed image behaves differently. You might want to keep an eye out for it.

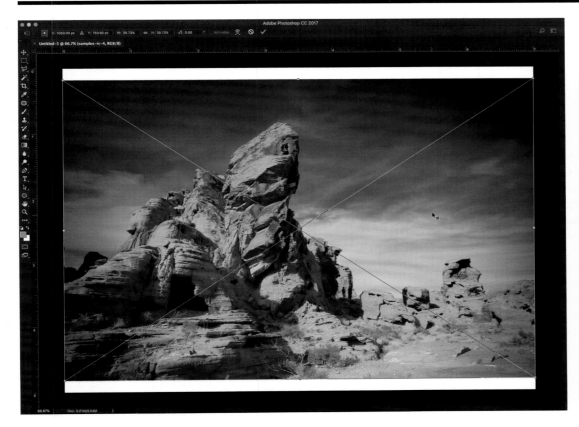

Figure 8.1 Placing an image in a document.

Figure 8.2 When you create a Smart Object by placing an image in a document, the corresponding image thumbnail in the Layers panel is marked with a Smart Object icon in the lower-right corner.

9. USE KEYBOARD SHORTCUTS TO WORK EFFICIENTLY

WHILE THERE ARE tons of keyboard shortcuts you can use in Photoshop, I find a handful of them to be absolutely vital in working with images. It's a good idea for you to get used to these early on because they'll make your work on any project go a lot smoother.

It's much easier and quicker to access the tools you use frequently with keyboard shortcuts than to select them from the toolbar with your cursor. Let's review the keyboard shortcuts for some commonly used tools:

- Press the letter V to select the Move tool, which you'll use often to move different elements in your Photoshop document (**Figure 9.1**).
- Press the letter M to access the Marquee tools (**Figure 9.2**). Press Shift+M to toggle between the Rectangular and Elliptical Marquee tools. (The Single Column and Single Row Marquee tools do not have a keyboard shortcut.)
- Press the letter L to access the Lasso tools (**Figure 9.3**). Press Shift+L to switch between the Lasso, Polygonal Lasso, and Magnetic Lasso tools.

- Hitting the letter B will access the Brush tools (**Figure 9.4**). Press Shift+B to cycle through the Brush, Pencil, Color Replacement, and Mixer Brush tools.
- Hitting the letter J will select the Patch tool, which you can use to remove unwanted elements in a Photoshop document (**Figure 9.5**).

If you want to quickly zoom in and out of a document, hold down Command+space bar (PC: Control+space bar) and drag to the right to zoom in or to the left to zoom out. If you want to temporarily access the hand tool, Hold down the space bar.

Sometimes the Photoshop interface will get in the way of the work you're trying to do, so the following two keyboard shortcuts will help you. Pressing the Tab key will get rid of all of the panels and tools so that you can focus only on your work. Pressing Shift+Tab will hide only the panels.

Pressing the letter F will toggle full screen modes, which will eliminate some of the Photoshop interface (like the title bars for any open documents), or bring you into a document only view. It's important to note that

as you keep hitting the letter F Photoshop will cycle through these different modes.

If you want to fit the document to the Photoshop interface, press Command+0 (PC: Control+0). If you want to see the document at 100% of its size, press Command+1 (PC: Control+1). It's a good idea to take a look at your document at 100% because you can see how well you have done a specific amount of retouching, or what an element looks like at print size.

Finally, you will be doing some work with masking, and it's always a good idea to make sure you have the foreground and background colors set properly. Pressing the letter D will return the foreground and background color swatches at the bottom of the toolbar to their black and white defaults. Pressing the letter X will swap the foreground and background colors (**Figure 9.6**).

I know this sounds like a lot of different tools and keyboard shortcuts to remember, but these really are just a small subset. Once you get these under your belt, you'll be surprised by how quickly you're able to work through a document.

Figure 9.1 Press V to access the Move tool.

Figure 9.2 Press M to access the Marquee tools.

Keyboard Shortcuts – Quick Reference

- **V** – Move tool
- **M** – Marquee tool
- **L** – Lasso tool
- **B** – Brush tool
- **J** – Patch / Healing Brush tool
- **Space** – Hand tool
- **Tab** – Hide Photoshop interface
- **Shift+Tab** – Hide panels
- **Command+Space (PC: Control+Space)** – Zoom in and out
- **F** – Toggle full screen modes
- **Command+0 (PC: Control+0)** – Fit to screen
- **Command+1 (PC: Control+1)** – See at 100%
- **D** – Set foreground and background colors
- **X** – Swap foreground and background colors

Figure 9.3 Press L to access the Lasso tools.

Figure 9.4 Press B to access the Brush tools.

Figure 9.5 Press J to access the Patch and Healing Brush tools.

Figure 9.6 Press X to swap the foreground and background colors.

10. INTERFACE AND PERFORMANCE CHANGES

AS YOU START working with different projects, you may want to configure Photoshop in a specific way so that it works for you and what you're doing. To do so, start by going to *Photoshop > Preferences > General*. If you're using a PC, open the Edit menu and select Preferences from the bottom of the list.

In the General section of the Preferences dialog box, you can decide whether or not you want to see specific workspaces when you create or open up a file (**Figure 10.1**). If you've used previous versions of Photoshop and you're not really all that excited about the new interface that you see in Photoshop CC, put a check next to Use Legacy "New Document" Interface in the Options area.

The options in the Interface section of the Preferences dialog box control what the Photoshop interface looks like (**Figure 10.2**). You can change the color of the interface by selecting one of the Color Theme swatches under Appearance. A lot of the time I like to use a darker interface because I think it looks a little sleeker, and I'm able to focus on my images a little bit better. You can also specify how Photoshop behaves in Full Screen mode. Right now, I have Full Screen set to Black with no border. If you find that the text is a little hard for you to read, you can select a new UI Font Size in the Text area. The default font size is Small.

The Performance section manages a lot of Photoshop's horsepower (**Figure 10.3**). The options under Memory Usage let you specify how much of your computer memory you want to use for a specific project. If you're working with larger images or in 3D or video, chances are you're going to want to move that slider a little higher. If you're doing some simple web-based design, you can probably get away with using a smaller amount of available memory. You can see the percentage of available memory you're using in parenthesis next to the Let Photoshop Use box.

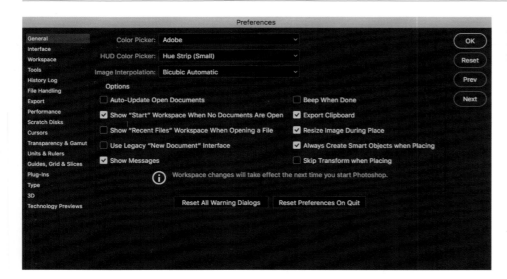

Figure 10.1 In the General section of the Preferences dialog box, you can choose which workspaces you see when you create or open a file in Photoshop.

Figure 10.2 The options in the Interface section allow you to control the appearance of the Photoshop interface.

Figure 10.3 You can control Photoshop's memory usage and history and cache options in the Performance section.

Photoshop is smart enough to be able to track your actions when you have a document open, but it only does so for a specific number of actions. Each tracked action is called a History State. Every brushstroke you make, every transform you do, is logged as a History State. This allows you to step back to previous actions if you make a mistake when you're working on a project.

You'll notice that in the History & Cache area of the Performance section you're set to 50 History States by default. This should be more than enough if you're doing any kind of graphic design work because you'll be able to step back in time quite a bit. But if you're doing something like retouching, every individual brushstroke you make is considered a separate History State, and you'll go through these 50 History States a lot faster.

If you find yourself doing stuff that's very brush intensive, I recommend that you go into your Preferences and increase your History States. That way, if you're working

on something for a while and then realize you've done too much, you have enough History States to be able to go back and safely recover that portion of the project. However, you should be conscious of the fact that a higher History States number will use more memory on your computer.

When you start working with things like 3D or advanced filters, a lot of the heavy lifting is done by the graphics processor card in your computer. You can specify how much work is being offloaded to that card by going into the Advanced Graphics Processor Settings (click on Advanced Settings under Graphics Processor Settings; **Figure 10.4**). I have my Drawing Mode set to Advanced, which means that Photoshop uses the graphics processor card as much as it can, but your results may vary. If you notice that Photoshop starts becoming a little choppier, you might want to change that Drawing Mode to something like Basic, so that Photoshop is not leaning so much on that card.

Figure 10.4 If you notice that Photoshop is not running as smoothly in the Advanced Drawing Mode, switch to Normal or Basic.

Photoshop uses RAM on your computer, but the bigger the project the greater the chance that you're going to run out of RAM. To counteract this issue, Photoshop uses space on your hard drive to perform some tasks. This space is known as the scratch disk. If you're working on large projects, it's not a good idea for you to use the hard drive on which you're running all of your other computer stuff as the scratch disk for Photoshop.

When you're working with large projects, you're probably better off using a secondary drive in your computer or an external drive as the scratch disk. You can activate an alternate drive in the Scratch Disks section of the Preferences dialog box (**Figure 10.5**).

Finally, you can change the units of measurement you work with in Photoshop in the Units & Rulers section (**Figure 10.6**). You may be a pixel person, or an inches person, or a millimeters person. You can change the a lot of this in the main workspace when you have a document open, but if you know that you're always going to work in pixels, you can go ahead and make that change here.

Under New Document Preset Resolutions, you can set the print resolution for your documents. By and large, almost every document I work with is at a print resolution of 240 pixels per inch. Photoshop sets Print Resolution to 300 by default, so that's one of the first changes I make.

Now you've tuned Photoshop so that it works best for you and your projects.

Figure 10.5 It's a good idea to select an alternative drive to use as a scratch disk when you're working on large projects.

Figure 10.6 Change the units of measurement Photoshop uses in the Units & Rulers section.

11. WORKING WITH BRUSH-BASED TOOLS IN PHOTOSHOP

BRUSH-BASED TOOLS—anything from a paintbrush to an eraser to a stamp—are used frequently in Photoshop, so it's important to get a good handle on how these tools work. As I mentioned in Lesson 9, you can select the Brush tool by pressing B on your keyboard. When you do so, you'll notice that your brush is set to a specific size (**Figure 11.1**). You can regulate the size and hardness of the brush in the Options bar at the top of the workspace. Click on the second drop-down menu from the left to open the Brush Preset picker (**Figure 11.2**).

The Size slider regulates the diameter of the brush, and the Hardness slider dictates the transition from the center of the brush to the very edge. A Hardness of 0% would make the center of the brush solid and the very edges of the brush transparent. A hardness of 100% would make the brush solid from the center to the very edge.

Below these sliders are your recently used brushes, followed by other brush presets. These brush presets are great for artistic effects, but for the most part, you'll probably be using more basic brushes. Select a brush, adjust the size, adjust the hardness, and you're good to go.

I have a couple of tips that I think will help you a ton when you're working with brushes. First, if you hold down Control+Option (PC: Alt+right-click) and drag right or left, you

can see what the brush will look like as you change its size (**Figure 11.3**). You can also drag up to make the brush softer or drag down to make it harder. This is a much better option than changing the size and hardness in the tool options bar or with the left and right brackets on your keyboard because it provides you with a visual as you modify the settings. Also, reducing the number of times you have to go up to the Options bar to make an adjustment to your brush will definitely keep you on task when you're working.

Figure 11.1 Press B to select the Brush tool.

The second thing that I think is important when you're working with brushes is to understand the effects of the Opacity and Flow settings. When you're working with a brush, you can regulate how much color is applied to your document by adjusting the brush Opacity and Flow in the tool options bar.

In **Figure 11.4**, you can see three different brushstrokes that I've created. For the top brushstroke I used a solid, hard brush with an Opacity of 100% and a Flow of 100%. This gave me an even brushstroke. I used the same brush for the middle brushstroke, but I adjusted the Opacity to 14%. The color of this brushstroke is a lot darker because more of the background shows through. To create the bottom brushstroke, I used the same brush with an Opacity of 100%, but I adjusted the Flow down to 14%. All three of these brushstrokes look very different due to the fact that I changed the Opacity and Flow settings.

Figure 11.2 Open the Brush Preset picker to modify the size and hardness of your brush, or to select a brush preset.

Figure 11.3 Hold down Control+Option (PC: Alt+right-click) and drag to the left or right to change the size of the brush. Drag up to make the brush softer, or down to make it harder.

Figure 11.4 These three brushstrokes are all the same size and hardness, but I've adjusted the Opacity and Flow settings for each one.

2

WORKING WITH
ADOBE CAMERA RAW

CHAPTER 2

If I had to give you one piece of advice in regard to your photography, it's this: understand that the processing of an image is as important as the capture of the image. You can have a wonderfully composed image with good detail coming out of the camera, but it's your job to process the image to get the most out of it. Exposure, contrast, vibrance, saturation, sharpness—these are all things that are essential in realizing the picture that is in your mind on the screen or a print. When you're working with RAW image files, all of these adjustments will be made in a free, preinstalled Photoshop plug-in called Adobe Camera Raw. All RAW files must be processed in Camera Raw before you can work with them in Photoshop.

When you make an image with a camera using a JPG setting, the exposure, color, contrast, and sharpening settings are applied to the image during capture and baked into the final file. When you shoot in a RAW format, the camera captures all of the information it can, and you can interpret and manipulate that information later on with post-processing software. This is the core function of Camera Raw. You will open every RAW image in Camera Raw to make these adjustments before a copy of the image is passed into Photoshop.

Although Camera Raw has an incredible amount of power, it is actually quite simple. With just a couple of sliders, you can create some amazing work, provided you understand how each slider works. In this chapter, I give you a strategy for how to use the individual sliders in as simple of terms as possible. You can definitely dive deeper if you want, but having a simple, proven strategy right out of the gate will enable you to make some amazing pictures quickly, and inspire you to take a deeper dive into this wonderful program.

Adobe Camera Raw will work with JPG images as well, but you will definitely see better gains when you use a RAW file. As previously mentioned, with a JPG, most of the contrast, color, and sharpness has already been baked into the file, so any kind of overexposure or underexposure you apply will be limited. The draw of using Camera Raw for working on JPG images is that its sliders are a little easier to understand and use than things like layer masks, levels, or curves in Photoshop. If you do use Camera Raw to further process your JPG images, keep in mind that some of the tool options will not be available.

All of this does not mean that a JPG file is inferior to a RAW file, though. If you're happy with the quality of the contrast, tone, and sharpness that you're getting out of the camera, then congratulations, a lot of your work is done. However, it's still a good idea to do a little clean up on those images.

To open a RAW image file in Camera Raw go to *File > Open* in Photoshop and select the image you would like to work on. To open a JPG image, the process is a little different. I recommend opening the file in Photoshop, and then selecting *Filter > Camera Raw Filter*. (We'll talk about filters later on in the book.) This is the least cumbersome way to open a non-RAW file without having to use a program like Adobe Bridge or change something in the *File > Open* preferences.

Adobe Camera Raw and Lightroom

Adobe Camera Raw has an identical engine to Lightroom. If you are a Lightroom user, you will be going through all of the same steps, just in a different location. If you have already processed your RAW files in Lightroom before opening them in Photoshop, you may be able to skip this chapter. However, you can apply all of the lessons in this chapter and the next one to the processing you do in Lightroom.

Camera Raw Plug-In versus Camera Raw Filter

If you open a JPG in Photoshop and then go to *Filter > Camera Raw,* you will notice that you do not have a full toolbar in Camera Raw. Some of the tools, such as Crop, are not available in the Camera Raw Filter because they're provided in Photoshop. If you want to access the full toolbar while working on JPGs in Camera Raw, you can set your preferences to open all files directly into the Camera Raw plug-in, as if you were opening a RAW file. Go to *Photoshop CC > Preferences > Camera Raw,* and under JPEG Handling, select Automatically open all supported JPEGs from the drop-down menu. Now when you go to *File > Open* in Photoshop and select a JPG, it will open in Camera Raw. To be honest, though, most people working with JPGs will probably prefer to open Camera Raw as a Filter.

12. UNDERSTANDING WHITE BALANCE AND CAMERA PROFILES

WHEN YOU SHOOT RAW images, the camera collects all of the information about the picture and lets you make changes to the picture later on in post-processing. One of the first things you'll do is adjust the white balance. White balance is the combination of temperature and tint in a picture.

Temperature can be measured in a range from low (cooler, or blue) to high (more of a yellowish tone). The tint allows you to change the color of the picture, from green to a magenta color. Your DSLR has a set of white balance options that automatically set the temperature intent for the scene you are shooting. While it is always advantageous for you to make this white balance decision in-camera, shooting in a RAW format allows you to make changes to the white balance at a later date in Camera Raw.

When you open a file in Camera Raw, you'll see the Basic panel on the right side of the interface (if not, click on the aperture icon below the histogram). In the White Balance drop-down menu you can select from a series of white balance presets that will change the temperature and tint of the image automatically for you (**Figure 12.1**). If you are manipulating a JPG image in Camera Raw, you will only see three options: As Shot, Auto, and Custom. This is because the white balance information for a JPG image is decided by the camera (or you) when the image is shot, and it is baked into the file; therefore, the white balance presets are not available. That's not to say you can't change the temperature and tint sliders manually, but the results will be more limited than if you were working with a RAW file.

Figure 12.1 Try as it might, sometimes the DSLR does not make the best white balance choices.

If you selected an incorrect white balance in-camera, simply select the preset for the white balance that you intended to use, and the image will be automatically adjusted. You can also select Auto, and Camera Raw will take care of the temperature and tint for you.

It's important to note that you don't have to use the white balance preset options in the drop-down list. More often than not, your selection of temperature and tint is the first place where you can exercise some creative control in making a picture. For example, in many of my blue-hour cityscape shots, I tend to ride the temperature slider a little cooler (to the left) and add a little bit more magenta to create a surreal look (**Figure 12.2**). Automatic settings are great, but it's your individual touch that's going to make your picture stand out.

In the toolbar at the top of the Camera Raw interface, you'll see an eyedropper (third tool from the left). This eyedropper allows you to select an area of the picture to use as the basis for a white balance adjustment. If you're not sure of the correct white balance for your picture, scan the image and see if you can find an area of gray. Clicking on the gray portion of the image with the eyedropper will yield a great white balance result.

Oftentimes if I want to make sure I have the right white balance for a picture, I will photograph a gray card at the start of my shoot to get an image with a neutral gray

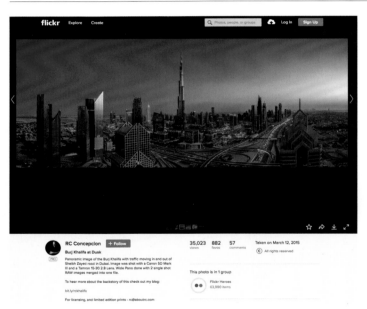

Figure 12.2 A picture of the Burj Khalifa at sunset. The only settings I changed for this shot were the Temperature and Tint.

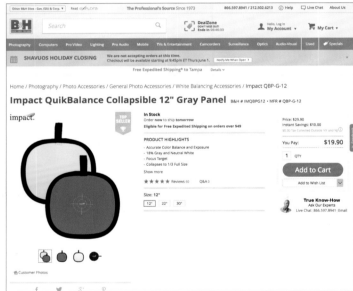

Figure 12.3 Sometimes a simple collapsible gray card can take care of a lot of the white balance problems you have on a shoot.

color (**Figure 12.3**). Then I can use the eyedropper in Camera Raw to click right on the target, and that gives me the Temperature and Tint numbers for a neutral gray.

There will be plenty of times when you're not carrying around a gray card. In these instances, you'll be left scrounging around the image looking for a gray portion you can use. If you can't find one, try using the eyedropper to select an area that you believe may have a neutral tone (**Figure 12.4**). This will at least get the Temperature and Tint settings in the right ballpark, and you can finish the adjustments yourself.

Figure 12.4 I believe the back wall in this picture was whitish. Clicking on it with the eyedropper got me pretty close to the white balance I was looking for.

Using Camera Raw's Camera Profiles

Have you ever taken a shot with your DSLR, looked at the picture on the camera screen, and thought it looked great? Have you then looked at it later on your computer, only to see that the great picture that was in your camera has all but disappeared, leaving you with a picture that looks extremely plain?

When you make a picture in a JPG format, your camera applies color, contrast, and sharpening adjustments to the image based on the settings you choose. When you shoot in a RAW format, the camera presumes that you'll make these changes later on in post-processing. However, if you look at pictures on the back of your camera when you take them, you're staring at an image that will look quite different from the RAW file you'll work on later.

The reason you see this discrepancy has to do with the fact that the camera exposes a picture using its built-in JPG settings, and shows you that JPG on its screen. This JPG is also embedded in the RAW file as a thumbnail for import into Photoshop. When Photoshop opens the image in Camera Raw and starts building its own previews, it takes the JPG the camera created and replaces it with a JPG that *it* creates, often with very "blah" results.

The good news is that you don't have to accept these results, and this is where the Camera Calibration panel can be quite useful. To access this panel, click on the camera icon below the histogram on the right side of the interface. At the top of the panel there are two drop-down menus: Process and Name (**Figure 12.5**). If you click on the Name drop-down, you'll see a series of camera profiles that are similar to the ones you would have selected in your DSLR. Cycle through the previews to find a color and contrast treatment that brings the thumbnail closer to what you saw on the back of your camera, and you're done!

Figure 12.5 The Camera Profile settings are specific to the camera you used. If the image was shot with a Canon, you will only see Canon Profiles; if it was shot with a Nikon, you will only see Nikon Profiles; and so on.

13. THE POWERFUL FOUR—EXPLORING THE BASIC PANEL

THE EXPOSURE, CONTRAST, Highlights, and Shadows sliders in the Basic panel can take care of an extremely large amount of processing in your pictures. If I look back at the last 50 shoots I've done, I can say pretty confidently that I've been able to edit my pictures completely with these four sliders about 80 percent of the time. And the even better news is that they're pretty straightforward to understand and easy to use.

Exposure and Contrast—
The Bottle of Water

When you make a picture, you are, in essence, making a recording of the scene in front of you. Your camera registers your scene in a file that contains a range of pixels from extremely dark all the way to extremely bright. When you bring the image into Camera Raw, the program tries to give you an accurate readout of what you captured. To do this, it creates a histogram.

In extremely simplified terms, a histogram is a glorified bar chart. The chart records information from the darkest of tones to the brightest of tones. The only problem here is that there are so many tones (about 255 of them) in such a small space that the bars are literally rubbing up against one another. The histogram shows the entire tonal range of your picture.

I like to picture the histogram like a half-full bottle of water. For the most part, you want to try to make sure some water is touching the entire bottom of the bottle. One of the ways you can do that is by tipping the bottle one way or another—that's exposure.

Figure 13.1 An imaginary Excel file showing the tonal data of a picture. It would be completely accurate if cameras had Microsoft Excel installed, which they don't.

The Exposure slider in Camera Raw controls how bright an image is (**Figures 13.2** and **13.3**). Dragging it to the right makes the image brighter, and dragging it to the left makes it darker. Tilt the bottle to one side, and the water slides in one direction. Tilt it to the other side, and the water goes in the other direction. Adjusting the exposure is your first option.

Contrast, by contrast (I know, very punny), works by increasing the distance between the shadow and highlight areas in a picture. So by making the shadows darker and the highlights brighter, you increase the contrast of the image (**Figures 13.4** and **13.5**). It's the equivalent of going into the center of the bottle of water and parting it a little. It's a split.

Figures 13.2–13.3 Exposure makes things brighter and darker, but that is just part of the picture. #PunsRule

Figures 13.4-13.5 Before and after, with contrast parting the water. I'll forgo the abundantly plain religious reference I could have made here and just go with "split the water, just like Moana." #SpoilerAlert

Rather than overburdening myself on the technical side of things, I like looking at the pictures I want to work with in this manner—tip or split (**Figure 13.6**). When I first start making a change to a picture, I'm just trying to get enough of the tonal data in the correct range and make sure that no parts of the water bottle are completely empty. Simplifying this process helps because sometimes you stare at a picture and you're not quite sure *what's* wrong with it. You know that it doesn't look good, but you don't really know where to begin. Now you have a basic question you can ask yourself when you look at the histogram: tip or split?

Shadows and Highlights

There are times when the picture you're working on has a problem in just one specific region. For example, you've taken a picture of a sunset and you notice that some ground elements are too dark to see. Or you'll attempt to take a picture and some of the elements in the picture are too bright, showing up as flashing highlights in your DSLR.

These kinds of problems are usually caused by the limitations of your DSLR's sensor compared to what you can see. The human eye is capable of seeing both the sunset and the ground in perfect exposure; it has a higher dynamic range of sensitivity. Camera sensors have not been able to reproduce this to date, but they are slowly catching up.

Thankfully, the Shadows and Highlights sliders in Camera Raw can help us get some of this detail back. If an image is too dark in the shadow area, drag the Shadows slider to the right to make the image brighter (**Figures 13.7** and **13.8**). If the image suffers from a blown out highlight, drag the Highlights slider over to the left to make the highlight area darker.

Figure 13.6
If you were staring at this picture and its histogram, would you choose to tip or split?

Figures 13.7-13.8 The most powerful part about the Shadows slider isn't what it does to the shadows; it's how it leaves the rest of the image alone.

The question here is, just how far do you drag the sliders? At the very top of the histogram you'll see two arrows. The arrow on the left side is for the shadow clipping. If you click on this to turn it on (or hover over it for a temporary look), the areas of the image that are too dark to show information will have a blue overlay (**Figure 13.9**). If you click on (or hover over) the arrow on the right, you'll see the highlight clipped areas with a red overlay (**Figure 13.10**). In these areas that are too dark and too bright, there is no data to show any visual information. This is a bad thing. Your goal is to adjust the Highlights and Shadows sliders so that these warnings go away. Once they do, you can play around with them to taste.

There are two things to keep in mind here:

- If you drag the sliders to their extreme limits, you'll produce a very unnatural effect. Be sparing with how you use them.
- If regions of your picture have been extremely underexposed, brightening the shadow areas will introduce a bit of noise to the picture. You may need to dial in more noise reduction later on.

Figure 13.9
The shadow clipping overlay in Camera Raw is blue.

Figure 13.10
The highlight clipping overlay is red. You definitely want to avoid seeing the shadow or highlight clipping overlays.

14. MANAGING BLACKS AND WHITES IN AN IMAGE

NOW THAT YOU'VE adjusted exposure, contrast, highlights, and shadows, let's move into the whites and blacks. This is somewhat controversial because a lot of individuals like to set their whites and blacks first. But with how well the four sliders at the very top work, I find that I use the Whites and Blacks sliders less and less. More often than not, I like using these sliders when I see that I have enough water across the bottle in the tonal range, but just need to tweak the file a little bit.

In **Figure 14.1**, you'll notice that there's a pretty good amount of range, but if you look at the histogram (**Figure 14.2**), you can see that the image could use a little bit more information on the extreme ends. We can solve that problem pretty quickly with the Whites and Blacks sliders.

Think of the whites and blacks as the brightest and darkest portions of the picture. You want to find the point that's completely

Figure 14.1

Figure 14.2

white and the point that's completely black, but it's really hard to see this in the picture. To achieve this, I recommend you hold down the Option key (PC: Alt) and drag the Whites slider to the right. At first, the image will turn completely dark, and then as you drag the white slider to the right, you'll see some areas of the picture change. You're looking for the first area that turns white, which is the portion of the picture that could clip (**Figure 14.3**). This is the brightest level that's there; it is about as bright as you can make the white

appear. You may see other colors in this process, but what you're looking for is white.

Next, hold down the Option or Alt key and drag the Blacks slider to the left. As you do this, you may see other colors appear, but what you're looking for is the first spots of black (**Figure 14.4**). This will tell you how far you can technically move the Blacks slider. Once the white and black points are set, you can use the Shadows and Highlights sliders to bring back as much information as you can in the file.

This is technically a good way to set your white and black points, but again, I can't stress enough how rarely I use these sliders. I only use them when I need to do some final cleanup work. If you want to see how much you have changed on the image with these sliders, press the Q button to see before and after views of the picture (**Figure 14.5**). Keep pressing Q to cycle through a series of different views.

Figure 14.3 The brightest part of the image is in the sky, just above the structure on the far left.

Figure 14.4 The darkest part of the image is under the arches on the left.

Figure 14.5 Press Q to see a before-and-after view of your image.

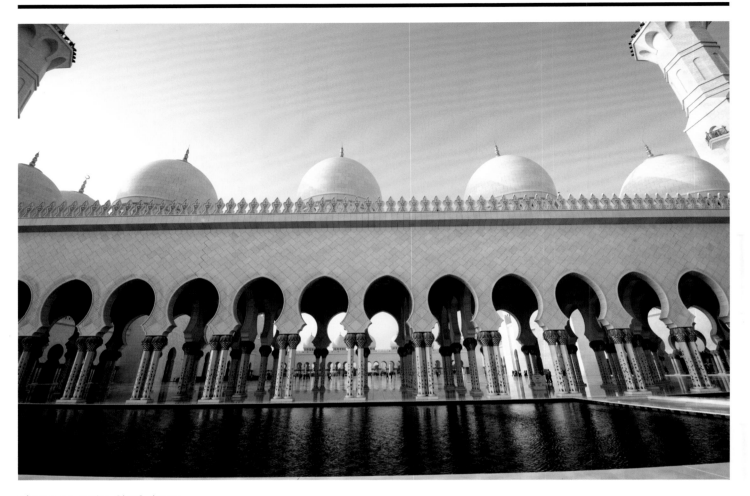

Figure 14.6 The final image

15. CLARITY, VIBRANCE, AND SATURATION

ONCE YOU'VE DIALED in the tonality of your picture, you can move on to making some of the final adjustments. The Clarity, Vibrance, and Saturation sliders can be used to round out the basic editing of an image.

Clarity

The general exposure of a picture adds contrast in the shadows and highlights, and treats the whites and backs of the image. The one part that doesn't get a lot of attention is the midtone portion of the image. There are times when adding a little punch to the midtone area could be very helpful. The Clarity slider controls the midtone contrast.

Midtone contrast is great for adding a bit of grit to your pictures (**Figures 15.1** and

15.2). Metals, textures, brick walls, and hair are all things that could benefit from a little bit of a clarity boost. The only thing to keep in mind when you're using the Clarity slider is that, in general, out of focus areas will not look good with Clarity applied to them.

Saturation and Vibrance

The Saturation and Vibrance sliders deal with the application of color in the picture, but they work a little differently. Dragging the Saturation slider to the right will increase all of the colors in the image (**Figure 15.4**). The only problem with this slider is that it doesn't take into account whether or not a color is already overused in a picture. That's where Vibrance comes in.

As you increase the Vibrance slider, you'll notice that any underrepresented colors will be increased a lot more (**Figure 15.5**). Any colors that are overrepresented will not be adjusted as much. If there are any skin tones in the picture, Vibrance will not affect them as much either.

I tend to add a more generous Vibrance boost to a picture and see how it does before I try making any adjustments with the Saturation slider. That said, if there is an individual color you wish to adjust, I wouldn't focus on it by trying to increase Vibrance or Saturation here. You can either adjust that color individually in the HSL panel, or paint in a color change later with an adjustment brush.

Figures 15.1-15.2
A before-and-after comparison showing the effects of the Clarity slider. Notice how it improves the look of the background elements in the second picture. However, I'd prefer it to have a little less of an effect on the subject.

Figure 15.3
This is the image before I adjusted the Saturation or Vibrance sliders.

Figure 15.4
I used the Saturation slider to adjust the image, and you can see that the skin tones and reds in the image are overdone.

Figure 15.5 When I used the Vibrance slider, only the blues were affected.

16. MANAGING HUE, SATURATION, AND BRIGHTNESS

ONCE YOU'VE FINISHED adjusting the exposure and tonality of your image, you can focus on making changes to individual colors. Camera Raw makes it pretty easy to do this with the Hue, Saturation, and Luminance (HSL) sliders. To access the HSL/Grayscale panel, click on the fourth icon from the left underneath the histogram.

The HSL panel separates colors and lets you change them with a series of sliders. When you first expand the panel, you'll note that the Hue option is selected (**Figure 16.1**), so sliding each of the color sliders will adjust the hues in the image first. The color bar directly under each slider marker shows you what the color change will be when you adjust that slider. Switching from Hue to Saturation or Luminance will change the effect those sliders have on the individual colors you see.

While these sliders are very powerful, I find that a lot of people don't know which color they want to adjust when they are looking at an image. I mean, if I asked you to change the magenta values in a picture, I would guess that a good portion of people wouldn't really know what they're changing—I barely do.

This is why I think the Targeted Adjustment tool is pretty brilliant (fifth tool from the left in the toolbar at the top; **Figure 16.2**). Rather than having to figure out what color you need, you can click on the tool to select it, and then click and drag on the area you want to change in the image. Clicking on the area and dragging to the left and right will adjust the associated color sliders in the HSL panel (**Figure 16.3**). If you want to change the Luminance or Saturation, just switch to the appropriate mode and select the Targeted Adjustment tool again.

If you want to reset a slider, simply double-click on the slider marker and it will jump back to its default middle position (**Figure 16.4**). To reset all of the sliders in one pass, double-click on the word Default, and all of the markers will return to their original positions.

It's important to note that the changes you make to each slider will affect that specific color throughout the entire image. If you want to have greater control over how a specific color looks in a particular area of a picture, you are better off using Photoshop to do a selective color adjustment with the HSL Adjustment Layer and a Layer Mask.

Figure 16.1 The HSL Sliders in Camera Raw.

Figure 16.2 The Targeted Adjustment tool.

Figure 16.3
Adjusting the hue in an image with the Targeted Adjustment tool.

Figure 16.4
Resetting the Blues Hue slider.

17. MAKING A BLACK-AND-WHITE IMAGE

IN MY OPINION, you can make a very powerful photographic expression by working in black and white. It's been said that working in black and white lets you see the "bones of the image," and I could not agree more.

Working with black-and-white images involves a lot more than just removing the color. There are plenty of ways you can make the process of creating a black-and-white image uniquely your own.

Put a check next to Convert to Grayscale in the HSL/Grayscale panel, and your image will immediately turn into a black-and-white image. Under the Grayscale Mix header,

you'll see a series of color sliders that allow you to change the overall look of the black-and-white image. Dragging one of the color sliders to the right will take all of that color in the image and make it brighter. Dragging it to the left will make the color darker.

Figure 17.1
This shot I took of the sunset in NYC from the Top of the Rock is nice in color, but I'm looking for a more timeless look. This would be a perfect candidate for black and white.

You can also adjust the brightness of each color by using the Targeted Adjustment tool (**Figure 17.2**). Activate the tool by clicking on it in the top toolbar, and then click on one of the colors in the picture and drag to the right to make brighter, or drag to the left to make darker.

Directly controlling which colors you make brighter and darker is a great way to make your own black-and-white image, but many people skip over the fact that you can develop this image further by going back to the Basic panel.

The change to black and white often reduces exposure and contrast in an image, or decreases clarity. Once your conversion to black and white is complete, make sure you go back to the Basic panel and reprocess your image to offset any of the changes lost in the conversion. You can then finalize the black-and-white image by adding a little extra sharpness in the Detail panel, and some additional grain in the Effects panel (**Figures 17.3** and **17.4**).

Figure 17.2 I like toning black-and-white images with the Targeted Adjustment tool. Rather than having to think about what colors the sliders control, it's a "what you see is what you get" approach.

Figure 17.3 Adjust the Sharpness Amount in the Detail panel.

Figure 17.4 Adjust the Grain Amount in the Effects panel.

Figure 17.5 This is the resulting black and white changes with some sharpness and grain added to the picture. Because of their timelessness, you'd be surprised as to how much grain and sharpness you can get away with.

18. CREATING DUOTONES AND TINTED IMAGES

ANOTHER WAY YOU can give your images a classic look is by tinting them. This process is very straightforward and opens the door to a lot of creative interpretations of your work. Let's take a quick tour of how tinting works, and then go over a couple of things you should consider when you are making your own custom looks.

The Split Toning panel (fifth icon from the left under the histogram) allows you to change the tint of your image. It contains two settings: Highlights and Shadows (**Figure 18.2**). These two settings are responsible for the coloring of the highlight and shadow tones in the picture. The Hue and Saturation sliders can be adjusted individually for the highlights and shadows (**Figure 18.3**). You can also enter values

Figure 18.1 We'll use the previous picture of NYC as our starting point.

Figure 18.2 The Split Toning panel allows you to adjust the tint of an image.

manually in the corresponding fields.

At this point, it's just a matter of finding the color that agrees with you. As a general rule, I like to start by giving my shadows a little bit of Saturation, and then I'll set my Hue. Once that's complete, I'll move to the Highlights sliders and start again with Saturation. The Balance slider helps create a good look by mixing how the shadows and highlights colors interact with one another in the picture.

When you're tinting an image in Camera Raw, remember that you are tinting only the shadows and highlights of the image. If you are working with a color image, there will be a little bit of a color bleed in the midtones.

Figures 18.3 Changing the color of the highlights and shadows in an image creates a cool tint look.

If you'd like to eliminate this, I recommend that you make a good black-and-white image before you do any tinting (**Figure 18.4**).

Want to try a quick sepia-inspired tinting?

Set your Highlights Hue to 56 and the Saturation to 51; set your Shadows Hue to 62, and the Saturation to 5; and set the Balance to -36, and you're done (**Figure 18.5**)!

Figure 18.4
Tinted images look much better when you start with a black-and-white image, which is what I did here.

Figure 18.5
A sepia-toned image.

While it seems obvious to use this tool to create a sepia-toned image (everyone tries the sepia look at least once), I like to use the tinting to create a little bit of a different black-and-white image. Once you've converted your image to black and white, set your Highlights Hue to 227 and the Saturation to 43; set your Shadows Hue to 62 and the Saturation to 5; and set the Balance to -36. This will give the black-and-white image a little bit of a blue tint (**Figure 18.6**).

Figure 18.6 Adding a slight blue tint to a black-and-white image gives it a different look.

Share Your Best Tinted Image!

Once you've captured your best tinted image, share it with the Enthusiast's Guide community! Follow *@EnthusiastsGuides* and post your image to Instagram with the hashtag *#EGTint*. Don't forget that you can also search that same hashtag to view all the posts and be inspired by what others are shooting.

19. THE LOWDOWN ON DETAIL AND NOISE REDUCTION

IN THE DETAIL panel (third icon from the left under the histogram) you will see that the Sharpening section has four sliders: Amount, Radius, Detail, and Masking. In order to get a good feel for how much to sharpen a picture, I recommend using the Zoom tool to get you to about 100% view (**Figure 19.1**). Then hold down the spacebar to temporarily access the Hand tool, and move the picture around to see how sharpness is going to be applied to a specific area. Okay, now that we've covered that, we can turn back to the sliders.

The Amount slider is pretty straightforward—it dictates how much sharpness is applied to the picture. The Radius slider offers you the opportunity to set how far from the center of the pixel the sharpness is applied. It's really hard to see this when you adjust the Radius slider, so I recommend that you hold down the Option key (PC: Alt) while you drag the slider. When you drag it all the way to the left, the image will turn gray, and as you drag it over to the right, you will start seeing more edge information (**Figure 19.2**). The edge information indicates the area that is going to be sharpened—anything that's gray will not be sharpened. This allows you to apply the sharpness that you need.

Once you have that set, move down to the Detail slider. The Detail slider increases the frequency in an image, and by doing so, it brings out more texture or more detail (**Figure 19.3**).

I recommend you use the Radius and Detail sliders first to define the areas you want to see in the picture. Once you have those set, then go back and adjust your Sharpening amount.

Another thing to keep in mind is that if the Detail slider is moved all the way to the right (or almost all the way to the right), it will start to introduce a little bit of noise. So you want to be careful with that.

If you want to limit where the sharpening is applied, you can use the Masking slider. This slider creates a black-and-white overlay, where black shows the areas that are not going to be sharpened and white shows the areas that will be sharpened (**Figure 19.4**).

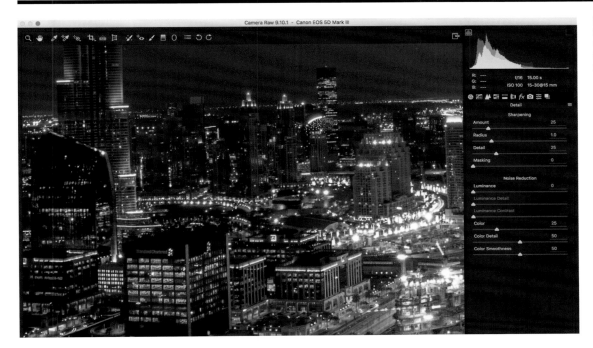

Figure 19.1
Zooming in to 100% will give you a more accurate view of what you are sharpening.

Figure 19.2
Adjusting the Radius for sharpening in Camera Raw.

Figure 19.3
Adjusting the Detail for sharpening in Camera Raw.

Figure 19.4
Adjusting the Masking for sharpening in Camera Raw.

Again, hold down the Option key (PC: Alt) and drag the Masking slider to the right to dictate where you want sharpening to be applied. Once that is set, let go of the Masking slider, and now you have a much sharper picture.

At this point, you can press the letter Q on your keyboard to see the before and after versions of your image (**Figure 19.5**). This allows you to make a better judgment as to whether you've added enough sharpening to the picture.

Figure 19.5 Hit the Q key to compare before and after versions of your picture.

Now let's go ahead and tackle noise. Noise in a picture is the result of two different things. First, it can be caused by the use of a really high ISO setting. I shot the image shown in **Figure 19.6** at 12800 ISO, which is pretty high, so there was some noise in the image.

The Noise Reduction section of the Detail panel has a few different settings, the first of which is Luminance. When you drag the Luminance slider to the right, the noise in the image will start to disappear. This is the slider that you'll use for 90% of the noise reduction you do.

Noise reduction works by blurring the image slightly, so as you reduce the noise, you will also lose some detail. If you want to add some detail back into the picture, you can grab the Luminance Detail slider and drag it to the right. If you want to increase the contrast in the picture, you would drag

Figure 19.6 Removing noise in a high ISO image.
Pete Collins—AKA: The Next Mo Willems!

the Luminance Contrast slider over to the right. However, it's important to understand that increasing the detail and contrast in the image is going to reduce some of the effects of the Luminous slider, so they tend to work more as counterbalances to one another.

Again, you can press Q to see the before and after versions of your image and check how well the noise reduction is performing (**Figure 19.7**).

The Color sliders deal with the fact that some camera sensors will display noise as colored pixels, rather than just as little black, white, or gray dots. If you want to mitigate this, you can use the Color slider to remove some of that color noise from the picture. Then you can add a little bit more detail and smoothness back in with the Color Detail and Color Smoothness sliders.

This lesson dealt largely with how to reduce noise that resulted from the use of a high ISO. But it's important to note that this is something you also have to do if you excessively sharpen a picture. The more you sharpen a picture, the more noise you will introduce, especially if you are using the Detail slider. So every time you increase the sharpening, go back into Noise Reduction and add a little bit more there as well. You'll be surprised by the quality of the results you get.

Figure 19.7 Adding some detail back into the picture after noise reduction. The Before is on the left, the After is on the right.

20. CROPPING YOUR IMAGE

WHEN IT COMES to conversations that will cause a little bit of controversy, you can always count cropping to be pretty high among the list of topics. On one side, there are individuals who believe that it is your job as a photographer to try to frame the picture in the camera exactly as you want it to look in the final image, and that cropping is "cheating." The second camp believes that if there is something in the image that takes away from what you are trying to convey, you should crop to your heart's delight.

I consider myself to be firmly in the "crop to your heart's delight" camp, but I totally respect your point of view if you are on the "no cropping" side of things. Feel free to skip this chapter entirely.

But before you do, I'd like to give you something to consider:

When I started developing an interest in photography, the picture that did it for me was one of the pianist Igor Stravinsky by Arnold Newman (http://arnoldnewman.com/media-gallery/detail/58/316). It is a beautiful black-and-white image. The open lid of a grand piano fills the majority of the frame and is a stark contrast to the white wall behind it. Stravinsky sits in the lower-left corner of the frame, staring straight out at the viewer with his elbow propped up on the piano and

his head resting in his hand. He is only visible from the shoulders up, and occupies a very small portion of the image.

I remember staring at that picture in awe: how masterful it was to use the piano in that manner; the use of negative space; the subject being the smallest part of the frame. I thought it was brilliant.

A couple of years into my practice, having adopted the whole "thou shalt never crop a picture" mindset, I stumbled upon a picture that would quickly change my mind. It was a picture of the original negative, clearly showing that there was more to the picture, with lines where Newman had specified it should be cropped. Later, I found additional pictures that showed how Newman had posed Stravinsky in different places before deciding that the picture that's universally famous would be "The One."

While many of us hold onto the idea that cropping is something that just wasn't done, shouldn't be done, or is a form of cheating, this picture illustrates that the practice has been going on for much longer than many people may think. At the end of the day, you serve the image that was in your mind when you took the picture, and if making a different crop of it gets your message out further, you owe it to yourself to try.

To activate the Crop tool in Camera Raw, press the C key on your keyboard or click on the Crop icon in the toolbar at the top of the window (sixth icon from the left). Once you've selected the tool, simply drag out an area on the picture to start the cropping process. You'll notice that there are some transformation handles on the corners of the picture. Drag them in to crop the picture tighter (**Figure 20.1**). If you want to keep the crop proportional to what you originally selected, hold down the Shift key as you drag the transformation handles in or out. If you want to crop from the center of the picture, hold down the Option key (PC: Alt). You can also hold down both Option (PC: Alt) and Shift to resize proportionally from the center of the image.

If you place your cursor on the outside portion of the crop, you can adjust the overall rotation of the picture. You can also straighten the picture with the Ruler tool inside of the crop area. Simply select the Ruler tool from the toolbar (next to the Crop tool), click on the picture, and drag a line along whatever area you believe should be straight (**Figure 20.2**).

The Crop Overlay serves as a compositional guide that's often helpful. To turn on the Crop Overlay, right-click on the image and select Show Overlay from the context menu.

If you want to use a specific aspect ratio for your picture, you can click-and-hold on the Crop icon to open a menu of Crop options (**Figure 20.4**). This menu includes some commonly used aspect ratios, and gives you an option to make your own. For example, let's say you want to crop a picture for the header on your Facebook page. Click on the Crop options drop-down menu, select Custom, type in 8.51 to 3.15, and click OK. Now when you use the Crop tool, the crop will be restricted to that aspect ratio.

Figure 20.3 Enabling the Crop Overlay.

Figure 20.4 Click-and-hold on the Crop tool to open the Crop options menu. Here you can select a commonly used aspect ratio, or select Custom to enter your own.

Figure 20.5 The final shot, cropped to remove some distractions. Because who wants distractions while doing laundry?

21. LOCAL ADJUSTMENTS TO MAKE GREAT IMAGES BETTER

SO FAR, EVERY adjustment you have made has been to the picture as a whole. Every slider has affected every component of the image. But the reality is that when you make adjustments to pictures, you want to do it in pieces. There's not just one global adjustment that you make for everything. So, in Camera Raw you want to have the ability to make some global changes, but at the same time, go back and start working with individual elements in the picture.

In this respect, the Adjustment Brush is a fantastic tool for you to get used to. You can access this tool with the keyboard shortcut K, or you can click on the brush icon in the toolbar at the top of the window (**Figure 21.1**). When you select the Adjustment Brush, a new panel will appear on the right side of the window with a whole host of things you can apply with the brush (**Figure 21.2**).

The first section contains all of the sliders that are found in the Basic panel: Temperature, Tint, Exposure, and all the way down to Saturation. Directly under that, you have another section that deals with detail: Sharpness, Noise Reduction, Moiré Reduction, and Defringe. And following that,

you have an area that allows you to control the size of the brush and how soft the feathering is, as well as the rate at which the effect is applied (**Figure 21.3**).

All you have to do now is load the Adjustment Brush with the specific change you want to make. I wanted to apply a little bit of an exposure change to the example picture in this lesson, so I moved the Exposure slider to the right and made sure the brush was large enough to paint on the adjustment (**Figure 21.4**). At the bottom of the panel there is a selection called Auto Mask. This is a good feature because it automatically detects an edge area and tries to limit the effect of your adjustment to that one mask area.

Figure 21.1 The Adjustment Brush tool

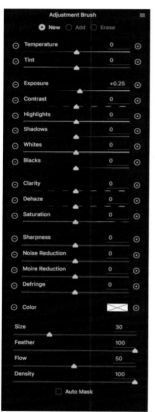

Figure 21.2 The Adjustment Brush panel

Figure 21.3 The Adjustment Brush characteristics

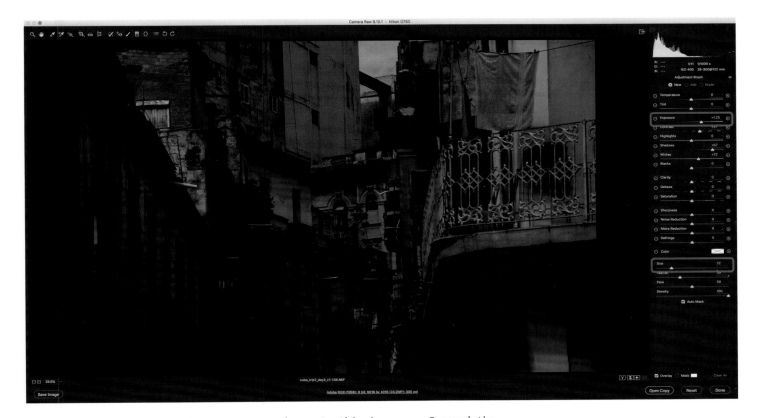

Figure 21.4 I wanted to apply an exposure change to this image, so I moved the Exposure slider to the right and adjusted my brush size.

Once you have adjusted the appropriate sliders, you can go ahead and paint the effect across the image. When you let go of the brush, a small pin will appear on the image (**Figure 21.5**).

Generally, when I work with this tool I like to increase my effect pretty drastically so that I can see exactly where I'm painting it. Then once I'm done, I bring the effect down.

If you want add a second brush, you can click on New at the very top of the panel, and that will give you a new set of controls that you can adjust for the brush (**Figure 21.6**).

In my example image I increased the Exposure, Contrast, Shadows, and Whites in the bottom and upper portion of the picture (**Figure 21.7**). I was able to paint with a large brush while pretty confident that the Auto Mask was going to keep me within the confines of the area I was working on.

Figure 21.5 Every time you use the Adjustment Brush, a small pin will appear on your image. You can click on the pin at any time to access that adjustment and make any additional modifications.

Figure 21.6 Click on New at the top of the Adjustment Brush panel to add a second brush with a new set of adjustments.

Figure 21.7 I adjusted the Exposure, Contrast, Shadows, and Whites in my image.

Notice that when you hover over any pin that is not currently selected, you can see the gray area that reflects the changes you made with the associated brush (**Figures 21.8** and **21.9**). At any point in time, you can click on an individual pin to go back to that brush and make more adjustments to the image. If you decide you don't like the changes you made with one of the brushes, you can single-click on the pin and hit the delete key on the keyboard to take away the brush.

There are times when you're working with a brush and you want to remove some of the effect that you've applied with it. If you are actively using one of the brushes, you can switch to the eraser by selecting Erase at the top of the Adjustment Brush panel (**Figure 21.10**). When you want to continue using the brush as normal, click Add. I find this to be somewhat cumbersome because I have to go back over to the panel every single time I want to switch between the eraser and the brush. Instead, as you're brushing, you can hold down the Option key (PC: Alt) to temporarily turn the brush into the eraser.

You can decrease and increase the size of both the brush and the eraser with the left and right bracket keys on your keyboard. If you're trying to adjust the size of the eraser, make sure that you hold down the Option key

Figure 21.8-21.9 When you hover over any pin that is not currently selected, you will see a gray overlay that shows where you made changes with the associated brush.

Figure 21.10
The Erase option in the Adjustment Brush panel.

(PC: Alt) while you press the bracket keys so that you are actually changing the size of the eraser and not the brush. Once you have it set to the appropriate size, you can remove the effect by simply painting on the picture while you hold down the Option key (PC: Alt).

If you want to see a really cool before and after, just hit Q on your keyboard to cycle through a series of before and after views.

It's also important to note that making changes with the Adjustment Brush does not preclude you from going back into the Basic Camera Raw panels and making additional changes after these local adjustments have been made.

This is a great way for you to add sharpness and noise reduction to portions of a picture. In this instance, I would want to add just a little more saturation and contrast in the sky while keeping the contrast and color the same in the bottom part of the picture. I can accomplish this by making two separate brushes—one that will let me adjust the upper part of the picture separately from the lower structures on the shot.

Figure 21.11 The final image

3

NEXT-LEVEL EDITING IN ADOBE CAMERA RAW

CHAPTER 3

When you start working with Adobe Camera Raw, you'll immediately lean on it to fix the overall exposure of your pictures, since that's what it was primarily designed to do. However, the plug-in has matured, and now you can accomplish a lot more with it. Take blemishes, for example. When working with earlier versions of Camera Raw, if the blemish wasn't circular in nature, it was a little difficult to fix, but that's not the case now. If you wanted to straighten a picture, bringing it into a layer in Photoshop was always a good bet, but that's no longer necessary. There are so many things you can do right inside Camera Raw that you'll be pretty happy with the results you can get without having to go into Photoshop.

So how is this beneficial to you? When you are working in Camera Raw, any changes you make to an image are nondestructive. Those changes are added to a separate file and do not affect the original RAW file. If you ever need to get back to the original image, any of the changes you've made can be undone. You also save a lot of time by not having to dive into the rest of Photoshop. In the end, the seconds you save for each image really add up.

The techniques covered in this chapter are slightly beyond the sliders we've worked with so far, but they are by no means difficult. All you need to know is where the tools are and how to use them effectively. As you work on this next level of editing, you're going to want to have the ability to save the changes you've made so you can repeat them over and over again as quickly as possible. Camera Raw allows you to do exactly that, and you can even share the styles you create with others.

Again, to open a RAW image file in Camera Raw go to *File > Open* in Photoshop and select the image you would like to work on. To open a JPG image, first open the file in Photoshop, and then select *Filter > Camera Raw Filter*.

22. SPOT AND BLEMISH REMOVAL

NOW THAT YOU'VE finished making some of the major edits to your picture, let's go ahead and do a little bit of cleanup. No matter how hard you try to keep your camera clean, you're always going to get something on your sensor that will translate to spots on a picture. The last thing you want is to send a picture to print, only to get it back with spots that stand out like a sore thumb.

Fortunately, Camera Raw provides a couple of tools that make spot correction fairly easy. Select the Spot Removal tool by pressing the letter B on your keyboard, or by selecting the icon that shows a paintbrush with some dots around it. When you select the tool, your cursor will turn into a circle, which you will use to cover the whole spot on your image.

In the image shown in **Figure 22.1**, it's kind of hard to see where the spots are. In this type of situation, I recommend using the Visualize Spots option, which is located at the bottom of the panel on the right. When you put a check in the Visualize Spots checkbox, you will get a black-and-white overlay on the picture (**Figure 22.2**). The slider next to the Visualize Spots option allows you to adjust how much of the image turns black and white.

Drag the Visualize Spots slider to the left and right until you see the spots appear in your picture. From there, all you have to do is adjust the size of the brush size so that it covers the spot you want to remove, and then click on the spot and release. Camera Raw will sample the surrounding area and find the best area from which to pull information to replace that spot.

Figure 22.1 The Spot Removal tool in Camera Raw.

Figure 22.2 The Visualize Spots option can make spotting sensor dust problems much easier.

You'll notice that when you click-and-release on the spot, a red circle and a green circle will appear on your image. The red circle shows the area where you clicked (the area with the spot), and the green circle shows the area from which information is being pulled to replace the area with the spot (**Figure 22.3**). You'll also see a blue circle, which is your brush. If you don't like the area that Camera Raw chooses, you can always change it by selecting the area and dragging it to a new location. You can also change the size of the spot after the fact. Hover over the edge of the spot, and you'll see a two-headed arrow appear. Click and drag it out or in to make the sample area bigger or smaller.

Previously, Camera Raw only worked with circular spots, but recent changes to the software have made it possible to use brushstrokes as well, which I think is great. Notice that there are a couple of cars in the bottom-left corner of my picture. They're not spots per se, but I can use the Spot Removal tool to cleanly remove them from the image.

For this removal, I'll use a really large brush and I'll drag it across the two cars (**Figures 22.4** and **22.5**). You can see that this creates a brushstroke option and samples from a surrounding area. Again, I can always change that area by clicking on the sample and dragging it into a new spot. Once I find the area that I think is a better match, I can hit the Return (or Enter) key.

Figure 22.3 Performing Spot Removal in Camera Raw.

Figure 22.4 I selected a large brush size to remove the cars from my image.

Figure 22.5 I dragged my brush over the cars to create a long brushstroke, and Camera Raw replaced the area with a sample from a nearby area in the image.

You will see all of the different brushes and sample spots as black-and-white circles on your image (**Figure 22.6**). Don't worry, these won't print, but they give you a good idea of the type of work you've done so far.

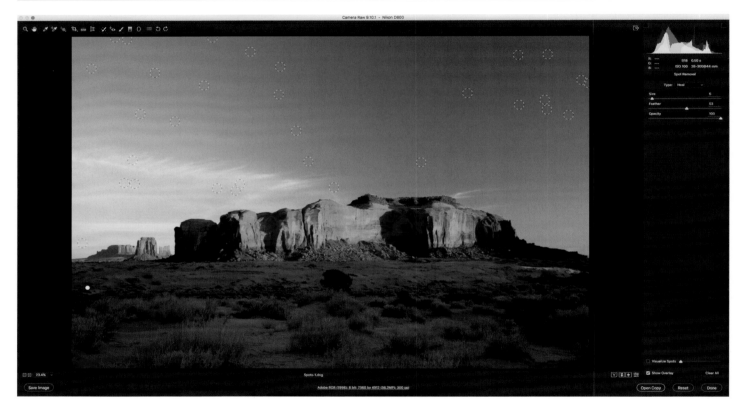

Figure 22.6 The black-and-white circles make it easy to see where you've done work so far.

Figure 22.7 The final product with spots removed.

The Spot Removal tool is also great for portrait retouching (**Figures 22.8–22.10**). Individual blemishes or marks can be quickly removed right in Camera Raw. This is something you previously would have had to do in Photoshop, but now it's quick and easy to do it in Camera Raw without having to leave the program at all.

Figure 22.8 The Spot Removal tool is great for removing marks or blemishes on portraits.

Figure 22.9 Before spot removal.

Figure 22.10 After spot removal.

23. LENS CORRECTION AND GUIDED TRANSFORMATION

AS YOU START making pictures with your camera, you'll notice that certain lenses cause distortion and vignetting in the images (**Figure 23.1**). This is common across different types of lenses, but thankfully you have the opportunity to change and mitigate some of this distortion in Camera Raw.

Open the image you want to fix in Camera Raw and click on the Lens Corrections icon in the panel on the right side of the screen (sixth icon from the left under the histogram). In this panel you will see a checkbox that says Enable Profile Corrections (**Figure 23.2**). When you click on this checkbox, Camera

Raw will make some changes to the image based on the make, model, and profile of the lens you used to shoot the image (information that is stored in the image metadata). Note: if you have opened a JPG image in Camera Raw, some of these features may not be available.

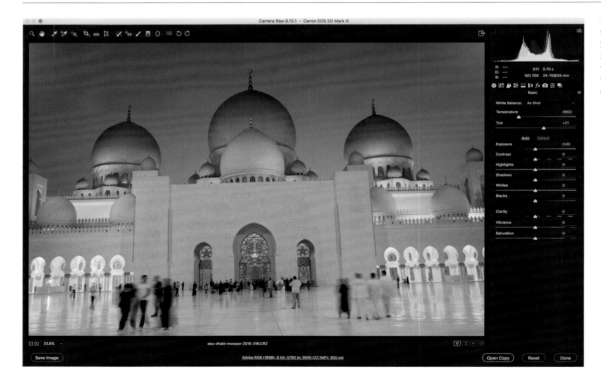

Figure 23.1
This image, which I shot in Abu Dhabi, is definitely going to need some distortion correction to straighten it out.

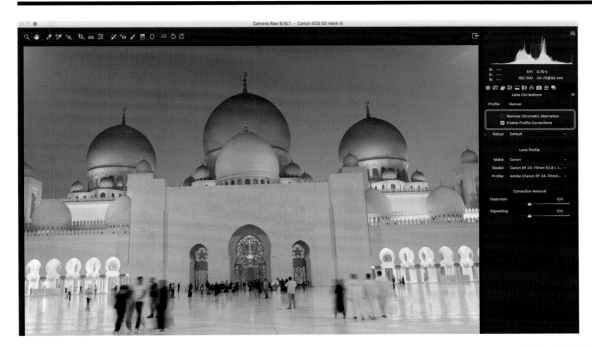

Figure 23.2
Applying corrections
based on the lens
profile.

Adobe is constantly updating these lens profiles so that you can quickly correct distortion and vignetting in your images. If you want to adjust the distortion and vignetting on your own at any point, you can use the sliders under Correction Amount (**Figure 23.3**).

If you notice that your lens suffers from chromatic aberration, you can remove a lot of that by clicking on the Remove Chromatic Aberration checkbox.

If you want to take this correction a step further, click on Manual at the top of the panel, and you will find additional options for increasing or decreasing the distortion and vignetting (**Figure 23.4**). The Defringe sliders enable you to get rid of different pixel colors on the very edges, something that is very common with chromatic aberration.

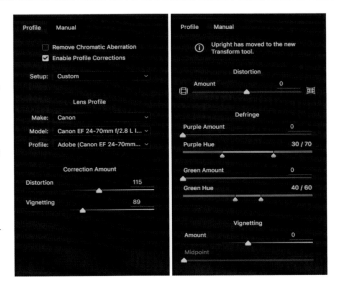

Figures 23.3–23.4 Adjusting the lens correction after applying a profile.

If your picture is fairly straight and you just want to make these small distortion corrections, the Lens Corrections panel is a great place to start. However, there are times when your camera is off-center or you're shooting from a vantage point that is a little too low, and you need Camera Raw to do an additional transformation to get rid of any lines that seem to be bending in an odd direction. This is when you would use the Transform tool (eighth tool from the left in the toolbar at the top, or Shift+T; **Figure 23.5**).

By default, the Transform tool is set to Off and all of the sliders in the panel on the right are set at 0. If you click on Auto (A), Camera Raw will perform an automatic transformation by looking at the lines instead of the picture, and will attempt to straighten this information for you (**Figure 23.6**). To be honest, I find that Auto works best for me more often than not, but there are a couple

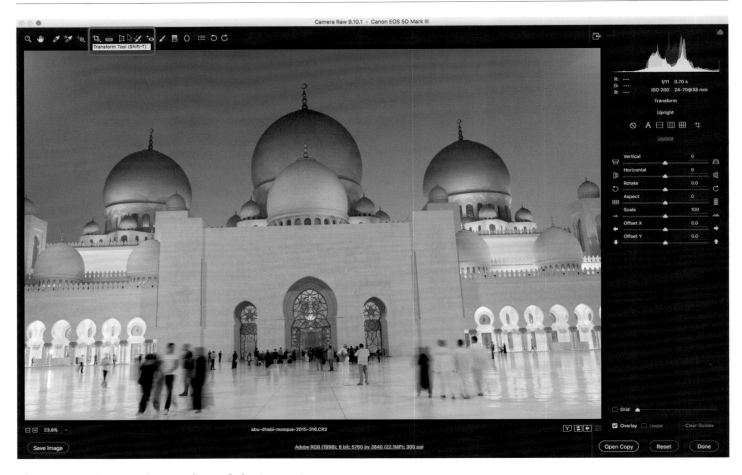

Figure 23.5 The Transform tool panel in Camera Raw.

of different options here that I think that are important to mention.

The Level option (icon with horizontal rectangles) will allow you to work with the horizontal elements to straighten the picture. The Vertical correction (icon with vertical rectangles) allows you to adjust the horizontal elements, but will also try to straighten vertical lines for you. The Full option (icon with grid) applies horizontal and vertical perspective corrections. Full is the option I use the least because I find that it usually doesn't work very well.

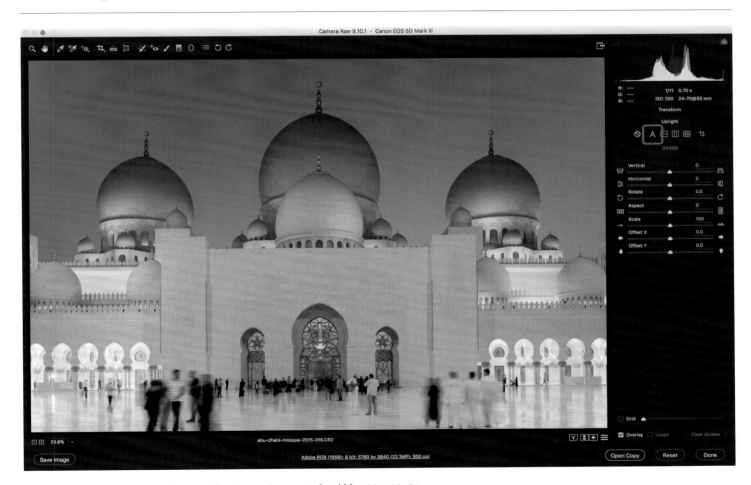

Figure 23.6 The Auto option in the Transform panel will attempt to straighten your image based on the lines in the picture.

The newest option in this panel is the Guided transformation (**Figure 23.7**). This allows you to put a series of straight lines in the picture where you believe the straight lines should be. Simply click and drag in an area that you believe should be straight. In **Figure 23.8**, for example, I drew a vertical line along the right wall of the mosque. Once I placed that line, I drew a secondary line along the left wall (**Figure 23.9**). When I drew the second line on the structure, the image straightened itself out a bit. When it tries to straighten itself out, there will be some transparent space that appears around the edges of the picture.

You're not limited to drawing vertical lines, however. In my example, I wanted to straighten the front of the image, so I drew a horizontal line across the top of the center facade (**Figure 23.10**).

It's important to note that you only get to use four lines, so I drew my fourth line across the top of the walls on either side of the central structure (**Figure 23.11**). This straightened the image horizontally.

Figure 23.7 The Guided transformation option allows you to draw lines on the areas you think should be straight.

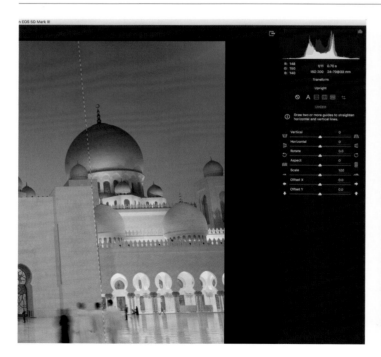

Figure 23.8 The right wall in this picture should be vertically straight, so I drew a straight line here with the Guided transformation tool.

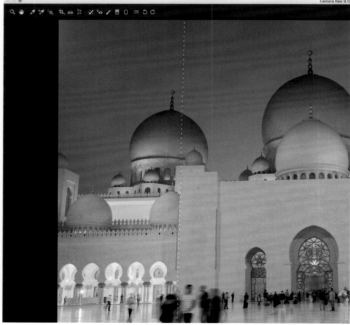

Figure 23.9 I drew a secondary line along the left wall, which should also be straight.

Figure 23.10
I drew a horizontal
line across the top of
the wall in the center
of the image.

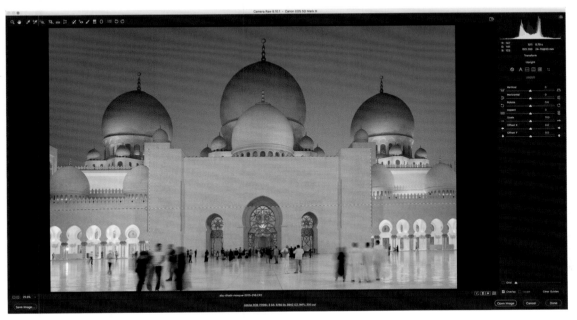

Figure 23.11
I drew my fourth and
final line along the
top of the walls that
flank the central
structure.

Oftentimes, this transformation will get you 99% of the way there, but you may need to do some final cleanup work. This is where the sliders in the Transform panel can help. The ones I use most often after a Guided transformation are Rotate and Scale. Rotate will let me turn the image clockwise or counterclockwise in varying degrees, and Scale will zoom the image in or out. This can help to remove any transparent elements that resulted from the Guided Transformation. In the end, you'll have a smaller picture, but the elements in the picture will be straight (**Figure 23.12**).

The one tip I would leave you with is to just try Auto. You'll be surprised by how well it can do.

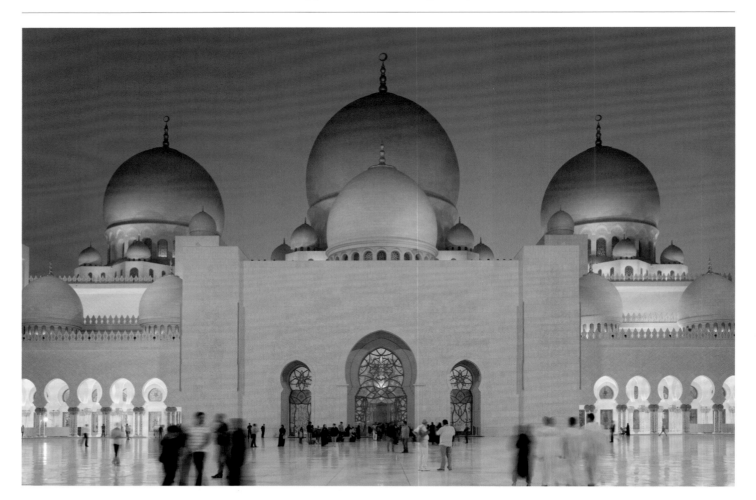

Figure 23.12 The final image

24. STACKING EFFECTS

IN THE BASIC panel, you'll notice that the sliders have a limit to which they can be pulled. That does not mean you need to stop there, however. The technique I'm sharing here is a little bit of a hack, but I tend to use it when I want to get a little extra out of the file, or when I want to create a really cool look (**Figure 24.1**).

For example, let's look at the image of an artist in New Mexico (**Figure 24.2**). The picture is pretty cool, but I want to add a little bit of grit to it, so I'm going to grab the Clarity slider and drag it out to 100 (**Figure 24.3**). This added a little bit of grit, but not as much as I wanted. I'm limited to a Clarity of 100, but I need more cowbell—what do I do?

This is where I would use the Graduated Filter to increase the effect. When you use the Graduated Filter, anything that sits above the top line is going to get whatever effect you select in the Graduated Filter sliders, and that effect will taper down to the bottom line. So what prevents us from grabbing the Graduated Filter and dragging it all the way to the bottom of the picture so that the entire picture gets the effect?

Figure 24.1 Stacking effects in Camera Raw lets you go past the basic treatment of a image to make it special. A portrait of my friend Mashael at the Coffee Museum. #Love

Figure 24.2
The original picture
before stacking
effects.

Figure 24.3
I took the Clarity
slider to it's maximum,
which added some grit,
but I want more.

Click on the vertical rectangle icon in the top toolbar (fifth from the right) to select the Graduated Filter. Hold down the Shift key, place your cursor under the picture, and click and drag down just slightly. You'll see two lines appear beneath the picture—a green one and a red one (**Figure 24.4**). Anything above the green line—in this case, the entire picture—will get the effect. Anything below the red line will not get the effect. The space between the two lines is the transition from the full effect to no effect.

Let's go ahead and grab the Clarity slider and drag it over to the right to +100.

Figure 24.4 Notice the green and red Graduated Filter lines below the picture.

Now hit the New button at the top of the Graduated Filter panel (**Figure 24.5**) and create another Graduated Filter immediately next to the first one. Hold down the Shift key and drag your cursor down ever so slightly, and you'll see a new set of lines appear (**Figure 24.6**). Again, everything above the green line will get the effect you select with the Graduated Filter sliders. At this point, we can grab the Clarity slider and drag it all the way over to +100 again. Now we have a Clarity of +200.

Some of the image has gotten a little too dark, so I'm going to do the exact same thing to recover some of the shadow areas. I'll create two more Graduated Filters here, and I'll pull the Shadows slider to the right to +100 for each one (**Figure 24.7**). This will bring the Shadows to +200.

I'm doing all of this to create a cool black-and-white effect, so once I've adjusted the shadows, I'm going to open the HSL/Grayscale panel (fourth icon from the left under the histogram) and put a check next to Convert to Grayscale (**Figure 24.8**).

Now I can finish up by adjusting the Contrast and Whites sliders back in the Basic panel. I'll also adjust the Post Crop Vignetting Amount slider in the Effects panel (*fx* icon under the histogram) to burn the edges of the image a little bit from the corners (**Figure 24.9**).

I can even add some realistic photographic grain by grabbing the Grain Amount slider in the Effects panel and dragging it to the right. If you want to change the overall size of the grain you can drag the Size slider to the right. The Roughness slider will let you adjust how uniform or random the grain is—move it to the left for more uniform grain, and to the right for a more uneven look.

Figure 24.5 Adding a new gradient in Camera Raw.

Figure 24.6 Now there are two sets of Graduated Filter lines below the picture.

Figure 24.7 We can recover some shadows by stacking effects.

Figure 24.8 Select Convert to Grayscale in the HSL/Grayscale panel to convert the image to black and white.

Figure 24.9 Adding a post-crop vignette and photographic grain.

Share Your Favorite Unique Effects!

Once you've created a unique image by stacking multiple effects, share it with the Enthusiast's Guide community! Follow *@EnthusiastsGuides* and post your image to Instagram with the hashtag *#EGStackedEffects*. Don't forget that you can also search that same hashtag to view all the posts and be inspired by what others are shooting.

So now we've bypassed what the Basic panel can do by using Graduated Filters to create an even cooler effect (**Figure 24.10**).

Figure 24.10 The final image

CAMERA RAW MAKES it very easy for you to make adjustments to your picture with sliders, and it's pretty straightforward. However, you're not going to be working on just one picture; you're going to work on a ton of pictures, and you don't want to have to go through every single picture to make the same changes.

Fortunately, there's an easy way for you to take advantage of the changes you've made to one picture and copy those changes to all of the other pictures in your shoot by using the sync settings.

I recently did a photo shoot of my friend Mia McCormick for a new website we're kicking off called Bottle Sunshine (she's also the cofounder of the online educational website I run—FirstShotSchool.com). I processed **Figure 25.1** in Camera Raw, and I've got the picture exactly where I need it. But this is one of about 100 pictures that I shot, and I would like to apply the same effect to all of them.

Instead of clicking on Open Copy in Camera Raw, I'm going to click on Done in the bottom right corner of the window. When you click on Done, all of the adjustments that you've made in Camera Raw are saved as an XMP file next to the RAW file in your folder (**Figure 25.2**). The best way to think of this is to picture the RAW file as the ingredients in a dish, and the XMP file as the recipe for how to cook it.

Figure 25.1 A portrait shoot I did for my friend Mia McCormick for her new website Bottlesunshine.com, which includes tons of photo projects, tips, and techniques for moms. Make sure you check it out!

Figure 25.2 When you select Done from the Camera Raw window, the changes you've made to your image are saved as an XMP file next to the RAW image file.

The major takeaway here: never, ever delete those XMP files. If you do, all of the changes you made in Camera Raw are lost and you're back at square 1. This is also one of the reasons I often tell people that managing a large number of pictures becomes much easier if you use Adobe Lightroom. [I also wrote a book on how to use Lightroom: *The Enthusiast's Guide to Lightroom* (Rocky Nook, 2017). Make sure you check it out! #FreePlug]

So, the settings for that one picture are saved, and I'm back in the main Photoshop workspace. Now I'm going to go back and select *all* of the images from the shoot by going to *File > Open* and selecting them from the list (**Figure 25.3**).

Camera Raw will open again, and all of the shots I selected will appear in a filmstrip on the left side the window. I'm going to find the image that I made the changes to and highlight it, and then click on the Filmstrip options menu (icon with horizontal lines next to the word Filmstrip) and choose "Select All" from the menu (**Figure 25.4**). [You can also use the Command+A (PC: Control+A) to select all of the images.] Even though all of the pictures are now selected, Camera Raw will remember that the picture I first clicked on is the source image.

Figure 25.3 Selecting multiple files via *File > Open* in Photoshop.

Figure 25.4 Selecting all of the images in the filmstrip.

Now I can click on the Filmstrip options menu once more and select Sync Settings to open the Synchronize Settings dialog (**Figures 25.5**). This allows me to decide which of the sliders in Camera Raw I would like to include as part of the sync process. At this point, all I have to do is select the ones that I adjusted.

When you're selecting the sync settings, keep in mind that Process Version (fourth from the bottom) is almost always going to be needed when you want to select a different picture in the series. This has to do with how Adobe processes the RAW file. If you deselect this option, you're going to get a warning. I recommend you always leave it on.

After selecting all of the sliders that I worked with, I'll go ahead and hit the OK button. I can then navigate up and down on the images in the Filmstrip to see the changes that were made. This is a *huge* time-saver.

Figure 25.5 Select Sync Settings from the Filmstrip options menu to open the Synchronize Settings dialog.

Figure 25.6 All of the images you've selected change before your very eyes. Think about all of the time you've saved.

26. CREATING CAMERA RAW PRESETS

CAMERA RAW IS not just about getting the best out of your pictures; it is also about creating special effects and different treatments for your files. That said, when you spend all of your time working on a specific treatment, you'd probably like to be able to use that treatment again on another type of image (**Figure 26.1**). This is where Camera Raw presets can definitely help you with your images.

To save your current Camera Raw develop settings as a preset, click on the next-to-last icon under the histogram to open the Presets panel. Next, click on the New icon in the lower-right corner of the panel (next to

Figure 26.1 I made adjustments to this image in the Basic panel, the HSL/Grayscale panel, and the Split Toning panel. I also added some grain and vignetting in the Effects panel. I would like to save all of this information so I can use it again later on.

the trash can) to open the New Preset dialog, where you can give your new preset a name (**Figure 26.2**). I named my preset "Cool Amsterdam." Use the checkboxes below to select all of the changes you made for the development of the current picture. When you click OK, you will see the new preset appear in the Presets panel.

Figure 26.2 Click on the New icon in the lower-right corner of the Presets panel to open the New Preset dialog.

You can now select another image to which you would like to apply your new preset, and then single-click on the preset name in the Presets panel (**Figures 26.3** and **26.4**). And just like that, the image is complete.

Figure 26.3

Figure 26.4

If you want to share your preset with others, simply click on the menu icon in the top-right corner of the Presets panel and select "Save Settings" (**Figure 26.5**). You can save the preset file anywhere on your computer, and then share it with other individuals (**Figure 26.6**).

If you receive a preset from someone, the import process is just as easy. Click on the menu icon at the top of the Presets panel and select Load Settings. Select the preset that you want to import and it will appear in the Presets panel.

Figures 26.5-26.6 Exporting your Presets in Camera Raw

Bringing Your File Into Photoshop

When you're happy with the changes you've made in Camera Raw, click on Open Image. Photoshop will combine the changes you've made to the RAW file with your raw data and open a copy of the file in the Photoshop workspace.

4

SELECTIONS AND TRANSFORMATIONS

CHAPTER 4

Once you have a good idea of how to develop a picture in Adobe Camera Raw, you're going to need to start looking at the nitty-gritty details of each individual picture you make. This is where we start working in the Photoshop workspace.

Perhaps you want to darken the sky, but at the same time, you want to make a foreground element a little brighter. In order to do all of these different things, you need to know how to isolate a specific section of a document as effectively as possible so you can focus your attention on it.

Photoshop has some great tools that allow you to get you right into a document and select a precise portion of the picture to work on, from the Magic Wand tool to the Refine Edge Brush. These tools are all designed to make the process of creating a selection a lot easier for you; you just have to know which tool is the best one for the job you want to do.

THE FIRST TOOL you'll start working with to make any kind of selection is the Magic Wand. You can access this tool by pressing the letter W on your keyboard, or by clicking on the icon that looks like a little wand with stars around it in the toolbar. (Remember that this tool also cycles with other tools in the group, including the Quick Selection tool.) The Magic Wand tool is great for any type of selection that has solid colors in it, but you will need to make some adjustments to the selection.

Let's look at an example image that has two hot air balloons against a blue sky. I'd like to make a selection of the sky. With the Magic Wand selected, I can click on the sky, and Photoshop will automatically sample as much of the sky as it can (**Figure 27.1**).

How much of the sky is selected is based on the Tolerance specified in the Magic Wand tool options bar (**Figure 27.2**). In this example, I decreased the Tolerance to 5, and I clicked on the sky in between the two balloons. Photoshop searched that area for any pixel that was within five shades of the pixel I clicked on, and included those pixels as part of the selection. Anything outside of that range was not included.

In Figure 27.1, you can see that only a small portion of the sky has been selected, even though I wanted to select the entire sky.

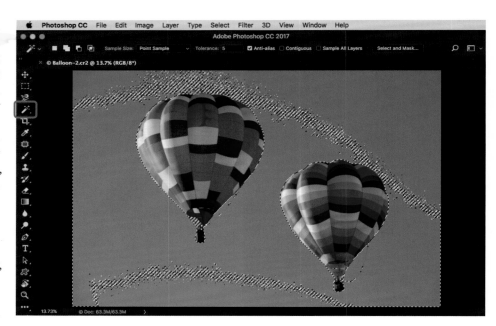

Figure 27.1 I used the Magic Wand tool to make a selection of the sky.

Figure 27.2 The Tolerance setting in the tool options bar controls how much of the sky is included in the selection.

Increasing the Magic Wand Tolerance up to 32 gave me the entire sky because all of the pixels in the sky fell within 32 shades of the pixel I clicked on (**Figure 27.3**). If you have trouble getting an accurate selection with the Magic Wand, try increasing or decreasing your Tolerance, and you'll notice that you can most likely get a much better selection.

In the example image, you can see that the balloons also have blue patches. Why didn't the Magic Wand select those colors? This has a lot to do with the Contiguous selection in the tool options bar at the top. If Contiguous is selected, Photoshop will only look for the pixels that both fall within the specified color range and sit next to one another. If there is another color between pixels, Photoshop will not select the pixels on the outside of that color.

When Contiguous is not selected, Photoshop searches the entire picture and selects *any* pixel that falls within the specified color range, regardless of whether there is another color between that pixel and the one you clicked on. Deselecting the Contiguous option and clicking on the sky gave me a selection that included not only the sky, but also the colors that fell within the specified color range inside the balloon (**Figure 27.4**).

You may be asking yourself when you would use this as an option. One example would be if you wanted to decrease the saturation of a specific color. You could also deselect the Contiguous option if you wanted to select all of the red squares in the balloon so you could change them to green, for example. Knowing the simple nuances of the Magic Wand will help a lot. The goal here is to make a selection as fast as possible.

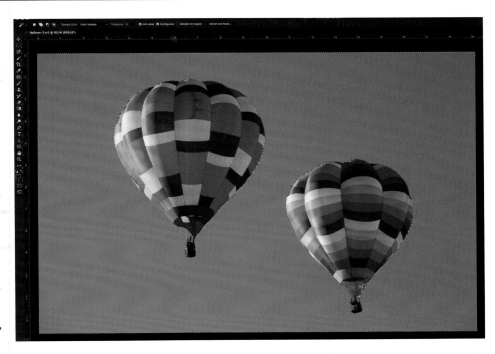

Figure 27.3 I increased the Tolerance to 32, and now the entire sky is selected.

Figure 27.4 When the Contiguous option is not selected, the Magic Wand will select any pixel that falls within the Tolerance range of the pixel you clicked on, even if there is another color between the pixels.

28. CREATING SELECTIONS WITH THE MARQUEE AND LASSO TOOLS

THE MARQUEE AND Lasso tools are pretty straightforward and easy to use. Pressing the letter M will give you either the Rectangular Marquee tool or the Elliptical Marquee tool. To use it, click and drag on the document until the selection is the size you want it to be. If you'd like to constrain the selection so it is proportional, hold down the Shift key as you drag, and you'll notice that now you cannot make it wider than it is tall.

When you use the Rectangular or Elliptical Marquee tool, the selection will start wherever you click and expand out in the direction you drag. So if you are making a box and you drag down and to the right, the point at which you started the selection will be the upper-left corner of the box. If you want to make a selection based on a center point, hold down the Option (PC: Alt) key as you drag (**Figure 28.1**).

Figure 28.1 I used the Rectangular Marquee tool to drag out a selection.

In a perfect world, everything would be a circle or a square, making it a lot easier for us to select things, but that's rarely the case. To help with that, we have the Lasso tools. Press the letter L on your keyboard to select the Lasso, Polygonal Lasso, or Magnetic Lasso tool. Remember, you can hold down Shift while you press L to cycle through the three options. Let's start with the Lasso tool. Click and hold your mouse button down as you to draw a line around an area you wish to select. Once you let go of your mouse button, a set of marching ants will appear showing you the selection (**Figure 28.2**).

The Lasso tool offers a great amount of control, but it is really hard to be precise when you're making a free-form selection. The other lasso tools—the Polygonal Lasso and the Magnetic Lasso—give us tighter control.

The Polygonal Lasso tool works a lot like connect-the-dots. Click and release on an area in your document to create a start point for your selection, and then drag out a line. Click a second time to drop an anchor point, creating a segment between the two points. Continue to click and drop dots around the area you wish to select until you've created an entire selection. The goal is to get the selection all the way around to the original point. You'll know you've reached the original point when you see a tiny circle next to the Lasso (**Figure 28.3**). Clicking on that point will activate that selection.

If you drop a dot in an area where you did not want to, hit the Delete key, and the previously made dot will be removed. If you hit the Escape key, the entire selection will be canceled.

Figure 28.2 A selection made with the Lasso tool.

Figure 28.3 When you reach the original point you made with the Polygonal Lasso tool, a tiny circle will appear next to the Lasso. Click on that point to activate the selection.

In my example image of the Olloclip lens, the Polygonal Lasso tool created a very jagged selection. This is a great tool. It's a fast tool. It's just not the best tool for this job. The Magnetic Lasso tool combines the best features of the Lasso and the Magic Wand. With the Magnetic Lasso selected, click and release on an area where you want to start your selection, and then start moving your cursor along the edge of the area you wish to select. As you do so, a series of dots will be placed along the path you're drawing (**Figure 28.4**). The frequency at which dots are added to the path is determined by the Frequency setting in the tool options bar (**Figure 28.5**).

If you want to add additional dots to the path at any point, just click and release and an extra dot will be added at that point. Continue to slowly trace around the boundary of the selection area, letting Photoshop drop the dots based on the Frequency you've set. To get rid of one of the dots, hit the Delete key and the previously made dot will be removed. Hit the Escape key to cancel the selection altogether. Once you get back to the original point, click and release to activate the selection.

Figure 28.4 Making a selection with the Magnetic Lasso tool.

Figure 28.5 You can set the frequency at which dots are added to your path in the Magnetic Lasso tool options.

Figure 28.6 This selection that I made with the Magnetic Lasso tool is pretty accurate, and it was easy to do.

IMAGINE YOU'VE SPENT a lot of time making a selection and then realize you forgot a portion of it, or that you've selected too much of something and you need to modify it. Well, you don't need to deselect (Mac: Command+D; PC: Control+D) everything. Instead, you can use the opportunity to refine your selections by adding to or subtracting from existing selections. It's a pretty simple process, but it is very far reaching in terms of cleaning up specific areas.

Let's take it right from the top. In **Figure 29.1**, I've made a selection using the Rectangular Marquee tool. In the tool options bar, there are four options for working with selections: New selection, Add to selection, Subtract from selection, and Intersect with selection (**Figure 29.2**).

When New is selected, every time you use a selection tool it will create a new selection, and any existing selection will disappear. When Add to is selected, every selection you make will be added to any existing selections (**Figure 29.3**).

If you use the Subtract from selection option, any new selection that overlaps an already existing selection will cause that portion of the selection to be removed (**Figure 29.4**). Finally, if you choose Intersect with selection, any time you draw a selection that overlaps an already existing selection, the area where those two selections intersect will become the new selection (**Figure 29.5**).

Figure 29.1 I used the Rectangular Marquee tool to draw a square selection.

Figure 29.2 There are four options for working with selections in the tool options bar: New selection, Add to selection, Subtract from selection, and Intersect with selection.

Figure 29.3 Add to selection

Figure 29.4 Subtract from selection

Figure 29.5 Intersect with selection

Now let's look at an example that shows how something like this could help you. In **Figure 29.6**, I made a selection of the background area around an Olloclip phone lens. I wanted to make a selection of the background only so that I could then reverse it and get a selection of the Olloclip itself (see Lesson 30 for more on reversing a selection). To do that, I used a Magic Wand tool, but it cut into the Olloclip in one section (top left) and didn't get close enough in another area (bottom). To solve this issue, I can switch to the Lasso tool and select Subtract from selection in the tool options bar, and any areas that I draw around with the Lasso tool will automatically be removed from the selection (**Figure 29.7**).

Once I'm done with the top section, I'll switch my Lasso tool to Add to selection and drag out the area at the bottom where I would like the selection to be extended (**Figure 29.8**). In this case, I want to include more of the background area in the selection (**Figure 29.9**).

This could get a little tedious if you're having to go back to the tool options bar every time you want to add to and subtract from a selection, so I'm going to give you a quick shortcut here. When you're using a selection tool, hold down the Option key (PC: Alt) to temporarily activate the Subtract from selection option. Hold down the Shift key to temporarily switch to Add to selection. Finally, hold down Option+Shift (PC: Alt+Shift) to use the Intersect with selection option.

I almost never use Intersect with selection, but I use the Add to selection and Subtract from selection options constantly when I'm working on a project. It's important to note that these options are available for all of the selection tools. For example, you could start with a Magic Wand tool, clean up with a Polygonal Lasso tool, add to the selection with a regular Lasso tool, and subtract from the selection with a Magic Wand. All of these tools can add and remove, and your job is to find the tool combination that is going get you exactly what you need for your project.

Figure 29.6 I created this selection with a Magic Wand tool, but it's not perfect, so I will clean it up with the Lasso tool.

Figure 29.7 The selection I created with the Magic Wand tool cuts into the object at the top. I can use the Lasso tool (set to Subtract from selection) to remove that portion of the selection.

Figure 29.8 I'm adding this area to the selection so that all of the background area is selected.

Figure 29.9 Now I have a pretty good selection of the background area. When I go to *Select > Inverse* to reverse it, I'll end up with a selection of the Olloclip.

30. TRANSFORMING AND SAVING SELECTIONS

IN PHOTOSHOP YOU'LL have to make things bigger or smaller. You'll either have to work with selections and make them bigger or smaller, or transform and resize entire layers or portions of a layer. The good thing is that the techniques in this lesson can be used to transform anything in Photoshop, so even though we're talking about selections, you'll be able to apply what you learn to everything from small elements in a document to entire layers.

The easiest way to transform a selection is to go to *Select > Transform Selection* (**Figure 30.1**). A box with markers on each of its corners and sides will appear around the selection (**Figure 30.2**). Click on the markers and drag them in or out to make the selection smaller or bigger. If you drag from the sides you can make the selection wider or taller. If you drag from the corners you can do both of these at the same time. You can constrain the proportions of the transformation box by holding down the Shift key while you drag one of the markers in or out. To resize the selection based on the center point of the transformation box, hold down the Option key (PC : Alt) as you drag.

Figure 30.1
I'd like to transform this Lasso selection.

Figure 30.2 Click on one of the transformation box markers and drag it in or out to make the selection smaller or bigger.

If you move your cursor just outside of the transformation box you'll notice you get a rotation arrow. Click and drag outside the box to rotate the selection in a clockwise or counterclockwise direction (**Figure 30.3**). The box will rotate around its center point (which can also be moved anywhere inside or outside of the box). If you need to do a quick rotation, this would be the easiest way to do so. If you want a more precise rotation, you can input a specific angle of rotation in the Set rotation box in the tool options bar (the box next to the angle icon).

Finally, you can move the selection around by placing your cursor anywhere inside of the transformation box (as long as it's not on one of the transformation handles or the center point), clicking, and dragging the box to a new location.

Another thing you may want to do with a selection is select the inverse. In **Figure 30.4**, I selected the background, but I really wanted to select the lens itself. To accomplish this, all I have to do is go to *Select > Inverse*, or use the keyboard shortcut Command+Shift+I (PC: Control+Shift+I), and the selection will be reversed so that the lens is selected. This is going to be a very handy tip for you to keep; you'll use it a lot.

Figure 30.3 I've rotated the selection counterclockwise by clicking outside of the box and dragging to the left.

Figure 30.4 Selecting the inverse is a very common selection step, so keep this option in mind.

If you get to a spot where you want to save a selection for later use, go to *Select > Save Selection* (**Figure 30.5**). A dialog box will appear where you can name the selection (**Figure 30.6**). You can load a saved selection by going to *Select > Load Selection*, and choosing the selection name from the Channel drop-down menu (**Figure 30.7**). Keep in mind that when you save a selection, it will only be available to you if you are working in a Photoshop (PSD) document; a JPG file will not have this information.

You can also see the selection in the Channels panel by Command-clicking (PC: Control-clicking) on the name of the selection (**Figure 30.8**).

Congratulations, we've killed two birds with one stone here. Now you know how to transform a selection, and these techniques are also applicable for transforming anything in Photoshop, from small elements to entire layers!

Figures 30.5-8 Saving a selection could not be easier, and it is beneficial if you want to return to work later.

Figure 30.5

Figure 30.6

Figure 30.7

Figure 30.8

31. USING THE QUICK SELECTION TOOL AND THE REFINE EDGE BRUSH

THE QUICK SELECTION tool is another Photoshop tool that does a really good job of making selections. This tool sits under the same group as the Magic Wand tool, and you can access it with the keyboard shortcut W. It is almost a combination of the Magnetic Lasso tool, a brush, and the Magic Wand. You can specify a brush size and paint over a specific area that you would like to turn into a selection (**Figure 31.1**).

The Quick Selection tool does a really good job of finding areas that you want to select, and it also has some additional characteristics that I think make it even better.

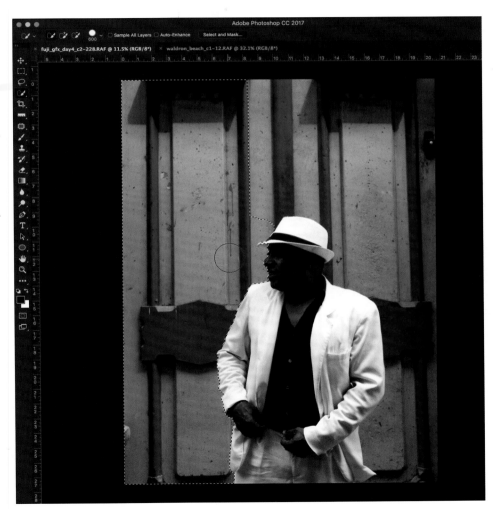

Figure 31.1 Using the Quick Selection tool to select the blue background.

As we discussed in Lesson 29, there will be times when you will want to add to and subtract from a selection. Like all of the other selection tools, the Quick Selection tool offers you the ability to add to and subtract from a selection by clicking on the options in the tool options bar, or by using the corresponding keyboard shortcuts. Hold down the Shift key as you paint to add to a selection, or hold down the Option key (PC: Alt) to remove a portion of your selection (**Figure 31.2**).

Another benefit of working with the Quick Selection tool is that you can use really small brushes to get into smaller, more detailed areas. In my example image, I needed to get the blue area in between the man's arm and jacket (**Figure 31.3**). The best way for me to do that was to use a small brush. As you can see, I included a little too much in the selection because I got part of the jacket, so I removed that section by holding down the Option key (PC: Alt) and brushing over it.

More often than not, when you make selections like this you'll select the larger area that you want to remove, and then invert the selection. For example, in this picture I wanted a selection of the person, not the background. But when I used the Quick Selection tool, it was easier for me to select the background, and then invert the selection by going to *Select > Inverse* (**Figure 31.4**).

The Quick Selection tool does a great job of isolating elements, but let's be honest, not

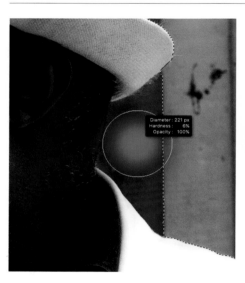

Figure 31.2 My original selection did not include this dark blue area under the hat, so I selected a smaller brush size and held down the Shift key to add this area to the selection.

Figure 31.3 I used a small brush to select the blue area in between the subject's arm and jacket.

Figure 31.4 After I made a selection of the blue background, I inverted it so that I could get a selection of the person instead.

all elements are going to be this easy. Take a look at the picture of my friend Connor in **Figure 31.5**. He's got beautiful, curly blond hair, and in this picture of him at the beach, there's only so much we can do with the Quick Selection tool. In a project like this, where you need to have extreme attention to detail, and none of the Marquee or Lasso tools work, how do you clean up existing selections?

The answer is in the tool options bar. Photoshop CC now has an option called Select and Mask. When you click on this option, you will activate the Select and Mask screen, which makes it much easier to refine your selection (**Figure 31.6**). You'll notice that the area outside of your selection is still visible, but has a checkerboard overlay. The transparency of this overlay can be controlled with the Transparency slider in the Properties panel on the right side of the screen.

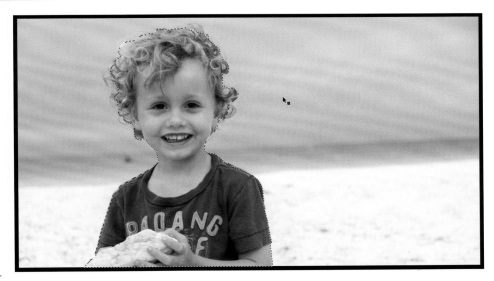

Figure 31.5 Using the quick selection on my friend Connor and his wispy hair.

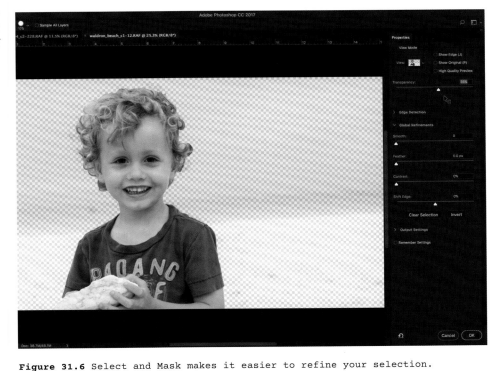

Figure 31.6 Select and Mask makes it easier to refine your selection.

On the left side of the Select and Mask workspace, you have a series of tools that you can work with, including the Refine Edge Brush and the regular Brush tool (keyboard shortcuts R and B, respectively (**Figure 31.7**).

When you're working with the Refine Edge Brush, you simply have to select the appropriate brush size in the tool options bar, and paint around the edge of the hair area (**Figure 31.8**). Photoshop does a wonderful job of removing the background and keeping all of the wisps of hair. In an area where you remove too much information, you might want to select the Brush tool (keyboard shortcut B) and paint back in the area that has disappeared.

In the Properties panel, you can click on the View drop-down menu to select how you want to view your selection (**Figure 31.9**). If you're going to put your selection on a white background, for example, you can select the On White option (keyboard shortcut T) and adjust the Opacity slider to see how well you are doing with the selection.

If the selection needs to be modified a little bit more, you can control the edges of the selection by going down to the Edge Detection section and dragging the Radius slider to the right or left (**Figure 31.10**). When you use the Refine Edge Brush, Photoshop automatically adjusts the mask you are making depending on where it believes the edges are in the picture. By increasing the Edge Detection Radius, you are telling Photoshop to make these calculations for mask adjustment farther away from what it believes to be the edges, which can help.

Figure 31.7 The Refine Edge Brush and Brush tools

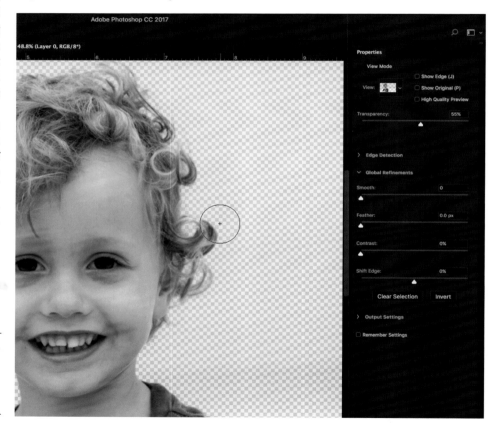

Figure 31.8 Using the Refine Edge Brush to capture all of the wisps of Connor's hair.

To smooth out any jagged edges, grab the Smooth slider in the Global Refinements section and drag it to the right (**Figure 31.11**). If you'd like to soften the edges of your selection, you can do that with the Feather slider, or if you want to add a little bit more contrast to those edges, you can do that with the Contrast slider. Finally, you can drag the Shift Edge slider to the left to contract the edges, or to the right to expand them.

The final section in the Properties panel—Output Settings—is an important one. In this section, the Output To drop-down menu lets you specify how you want to see the results of what you've done. Do you want to use a layer with a layer mask, or a new document, or a selection?

If you intend to modify the selection any further (e.g., refine it or add a special effect to the area you've selected), you would just output what you've done to a selection. If you output the selection to a new document, Photoshop will create a separate file with the contents of what you've selected, and you have the option to output it with or without the mask. More often than not, you'll find that you are making selections and refining them for the file you are currently working on. In this case, you'll want to select New Layer with Layer Mask (**Figure 31.12**). This places the selection on its own individual layer that you can transform and move around, and you also have the option to hide or show components of that layer with the mask that's attached.

One final thing I want to discuss is the Decontaminate Colors option in the Output Settings section. When would something like this be useful? If you used some form of green screen for your project, you'll notice that although the green screen makes it a lot easier for you to remove an element from the background, the color from the green screen will be reflected back into the picture at the very edges. You'll see a halo of color around the very edges of the picture. To remove something like that, all you have to do is select the Decontaminate Colors option.

Photoshop includes technology that makes it so much easier to create accurate selections. Once you understand the basics of how each tool operates, applying this technology to your projects should be a no-brainer.

Figure 31.9 There are several different ways you can view your selection.

Figure 31.10 Drag the Radius slider to the right or left to further modify your selection.

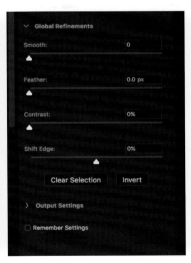

Figure 31.11 The sliders in the Global Refinements section allow you to modify the edges of your selection.

Figure 31.12 Use the Output To drop-down menu to specify how you want to see the results of what you've done in Select and Mask.

5

PHOTOSHOP
LAYERS

CHAPTER 5

The most important feature in Photoshop is layers. Whenever you look at an advanced document in Photoshop, you're really looking at a top-down view of a series of different layers that have been put together to produce this one image. Think of it as a sandwich. A peanut butter and jelly sandwich is just a sandwich, but if you start digging a little deeper, you'll notice that there is a bread layer, a peanut butter layer, and a jelly layer. All of the layers are put together to produce a final product.

The Photoshop layered document is the source file for all of the work that you're doing, so the goal of this chapter is to get you up to speed with how to create layers, how to organize them, and how to move them around so that they best serve your projects.

32. HOW LAYERS WORK

WHEN YOU LOOK at a document that has layers, you're basically looking at a stack of design elements that sit on top of one another. More often than not, you start with a background layer, which is the bottom layer, and new layers are created directly on top of that. A document with multiple layers is like a giant sandwich of information, and what you see is a top-down view of all of the individual elements.

All of the layers in a Photoshop document can be controlled in the Layers panel (**Figure 32.1**). If you can't see the Layers panel when you open Photoshop, go to the Window menu at the top of your screen and select Layers. Each layer in the document will be listed in the panel. The thumbnail to the left of each layer's name shows you the contents of that layer.

You have the ability to hide a layer and its components by clicking on the visibility icon (eyeball) to the left of the layer's name (**Figure 32.2**). When you hide a layer, the contents of that layer will not be visible in the document you see in the main workspace.

Figure 32.1 A finished design project consisting of multiple layers. In the Layers panel, you can see that there are six layers that make up this document. The contents of each layer is shown in the thumbnail to the left of the layer name.

Figure 32.2
To hide an individual layer, click on the eyeball next to its name.

To create a new layer you have a few different options. The easiest way to do it is to click on the new layer icon in the lower-right corner of the Layers panel (to the left of the trash can icon; **Figure 32.3**). You can also create a new layer by clicking on the Layer options menu in the top-right corner of the Layers panel and selecting Duplicate Layer (**Figure 32.4**), or by going to *Layer > New > Layer* (**Figure 32.5**).

While the concept of layers is pretty straightforward, its application is where the artistic component comes into play. Figure 32.1 shows a simple design that looks like a keyhole, and it appears as though you're looking through a hole. However, if you take those layers and move them around, you'll see that the design is actually made up of a series of circles that have been stacked on top of one another (**Figure 32.6**). The way in which they are organized creates the illusion that you're looking through a hole.

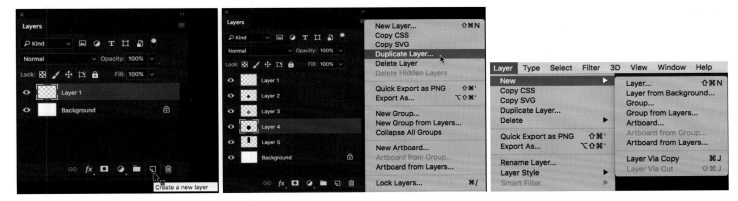

Figures 32.3-32.5 Three different ways to create a new layer.

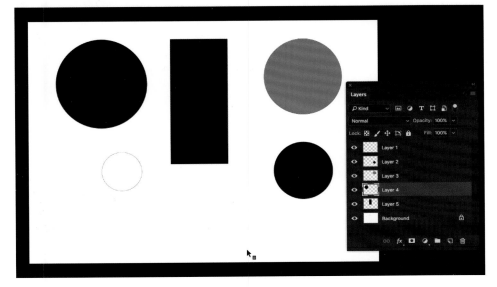

Figure 32.6 I moved the components of the keyhole design around to different spots on each layer.

Once you get your head around how all of this is organized, you can start to see the practical applications for working with graphics. Let's use the selection I made of my friend Connor in Lesson 31 as an example. I shot the original picture at the beach, but I want to place Connor in a forest setting. I can create a new document with a forest image on the background layer (Trees) (**Figure 32.7**), and then place my selection of Connor on its own layer on top of the Trees layer (**Figure 32.8**). Now I have an interesting composite of the two elements (**Figures 32.9**).

Notice that when I turn off the visibility of the Trees layer, the Connor layer has a checkerboard background (Figure 32.8). This signifies that on this layer, all of the area around Connor is transparent. The forest image that is on the layer beneath it is only visible when you turn on the visibility for the Trees layer.

Once you have the elements of your image on individual layers, you can work on each layer separately and move elements around to create the picture you want (**Figure 32.10**).

Sometimes I think the biggest problem people have when it comes to learning how to use layers is that they go into it with very elaborate designs. It's best to start by just getting your head around the basic concepts, and then you can start applying them to more advanced techniques little by little.

Figure 32.7 The Trees layer is the background layer.

Figure 32.8 My selection of Connor is on a separate layer on top of the Trees layer.

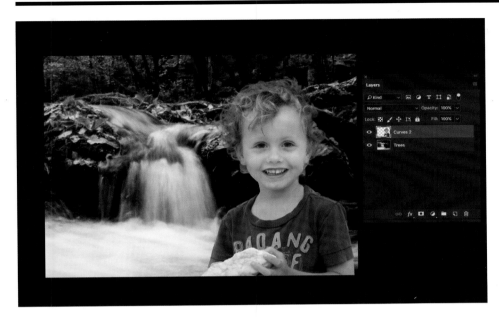

Figure 32.9 The composite consists of two layers.

Figure 32.10 I made the Trees layer a little larger, and then moved it so that the water sits closer to Connor. I think this makes a better picture.

33. LAYER ORDER, GROUPING, AND OPACITY

WHEN YOU'RE WORKING with documents that have a lot of layers, you to need to manage them well. This lesson provides some tips and techniques for making sure that you don't lose your head while you're trying to work on a project.

The first thing to keep in mind is that the order in which you place your layers in the Layers panel means everything. If you look at **Figure 33.1**, you can see that there is a white circle at the very top of the layer stack. This means that element is going to appear on the very top of your document; no other layer will cover it. The layer with the black circle sits in between the white and red circles in the layer stack, and you can see that the black circle is over the red area but under the white area in the document.

If we move the Black Circle layer to the top of the stack, the black circle will now sit on top of both the white and red circles in the document, blocking portions of both (**Figure 33.2**). With the layers organized this way, if we moved the black circle over to the center to make our keyhole design, it would completely cover the white circle.

Moving a layer is as simple as grabbing it and dragging it above or below another layer in the stack. However, you cannot move anything under the Background layer. If you want to put something under the Background layer, simply double-click on the name "Background" in the Layers panel and type in a new name. You can change the name of any other layer this way as well.

As you start amassing more and more layers in your projects, you might want to spend some time organizing them. You can move multiple layers at once by single-clicking on one layer, and then Command-clicking (PC: Control-click) on a series of other layers to select them all. At this point, if you have your Move tool selected, you can move all of the selected layers in one shot.

Let's try doing this a different way. With all of the layers selected, hold down your Shift key and click on the Create a new group icon (file folder) at the bottom of the Layers panel

Figure 33.1 The initial layer order with the white circle at the top of the layer stack.

Figure 33.2 The Black Circle layer is at the top of the layer stack.

(**Figure 33.3**). This will put all of the selected layers into a group (**Figure 33.4**). Now if you want to move those layers, all you have to do is select the group and use the Move tool to drag it above or below another group or layer.

If you want to create a duplicate of an element that you have in Photoshop, all you have to do is select the layer in the Layers panel, and then go to *Layer > New > Layer Via Copy* [or use the keyboard shortcut Command+J (PC: Control+J)]. If you have made a selection on that layer, Photoshop will duplicate the selection and place it on a new layer. If you have not made a selection on the layer, Photoshop will duplicate the contents of the whole layer. If you selected multiple layers, it'll duplicate all of the layers.

To delete a layer, click on the layer and drag it down to the trash can icon in the lower-right corner of the Layers panel. You can delete multiple layers at once by Command-clicking (PC: Control-clicking) on each layer to select them all, and then dragging the group down to the trash can icon (**Figure 33.5**).

In addition to the organization of your layers, another thing to pay attention to is the opacity of each layer. You can make the contents of an individual layer more transparent by selecting the layer in the Layers panel, clicking on the Opacity drop-down menu, and dragging the slider to the left. For example, in the keyhole design, the white circle is completely white when the Opacity is set to 100% (**Figure 33.6**). By dragging the Opacity slider down to 40%, I have made the color darker by increasing the transparency of the layer and revealing the layers that sit beneath it (**Figure 33.7**).

Figures 33.3-33.4 I selected three layers—Black Circle, Red Circle, and Layer 4—and placed them into a layer group.

Figure 33.5 Deleting multiple layers is simple—just select all of the layers you want to delete and drag them down to the trash can icon.

Figures 33.6-33.7 In this case, when I decrease the Opacity of the White Circle layer, the white circle turns gray in the document because the layers underneath it show through.

Understanding these very basic foundations will help you get a better handle on your projects. For example, take a look at this grid that shows samples from previous and forthcoming chapters (**Figures 33.8–33.16**).

The final picture is a simple composite of my friend Connor (not award-winning; I'm just trying to explain the basics here). If you look at all of the layers, you can see that it is a composite of multiple different pictures from different occasions at different times. The final image is all based on how the layers are organized—where each layer is placed in the stack.

Figures 33.8-33.16 Take a look at the breakdown of the individual layers I used to create the final composite.

Share Your Image!

Once you've created an image by stacking multiple layers, share it with the Enthusiast's Guide community! Follow *@EnthusiastsGuides* and post your image to Instagram with the hashtag *#EGLayers*. Don't forget that you can also search that same hashtag to view all the posts and be inspired by what others are shooting.

In the Layers panel you'll notice a layer called Piton Cover 1 and another called Piton Cover 2 (**Figure 33.17**). These two layers serve only to cover portions of the structure you can see in the first image that aren't covered by the waterfall. The technique I used here is exactly the same as what I used for the keyhole design; it's just been applied to a picture.

Figure 33.17 I made this composite by just playing around with the mountains and waterfall and reorganizing my layers.

AS YOU START working with individual elements in your image, you're going to want to isolate them by putting them on separate layers. To do this, start by making a selection of the area around the element that you want to keep. For example, in **Figure 34.1** I want to isolate the little ceramic, so I'll use the Quick Selection tool to get a selection of the area around the ceramic, cleaning it up as I go. (See chapter 4 for information on how to make a selection.)

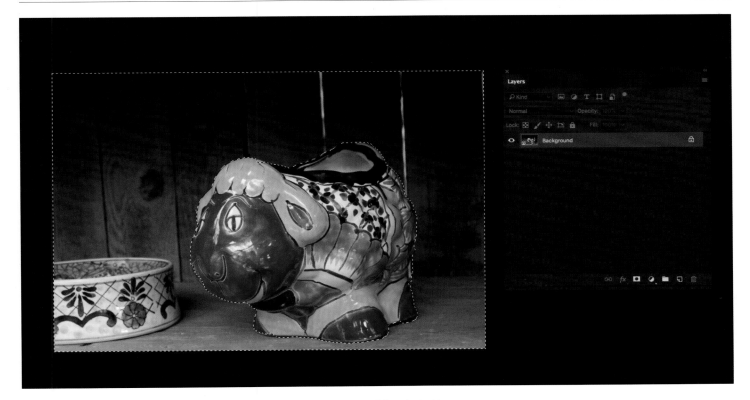

Figure 34.1 Using the Quick Selection tool to select everything but the element I want to keep.

When I'm happy with the selection, I'll go to *Select > Inverse* so that the element I want to keep is selected. Now I can move that element over to a new layer by going to *Layer > New > Layer Via Copy*. Once that element is on its own individual layer, I can go to *Edit > Transform > Scale* and scale it up or down as I need to (**Figure 34.2**).

When you're working on a project with a lot of layers, it's easy to lose sight of what is in each individual layer. The thumbnails in the Layers panel can be helpful, but the problem with these is that they're usually too small to show much (**Figure 34.3**).

I recommend that you isolate the element you're working on by turning off all of the other layers in your document. The easiest way to do this is to Option-click (PC: Alt-click) the eyeball in the layer you're working on. This will turn off the visibility of every layer except the one you clicked on. Do the same thing again to turn all of the layers back on. In **Figure 34.4**, I've turned off all of the layers except one by Option-clicking on Layer 5, and I can see that this is just one section of a gas tank.

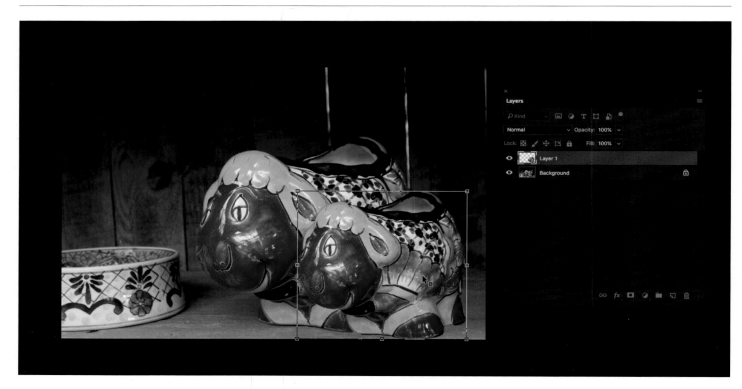

Figure 34.2 I've placed my selection of the ceramic on its own layer and now I can use the transform tools to scale it down.

Figure 34.3 A Photoshop project with multiple layers.

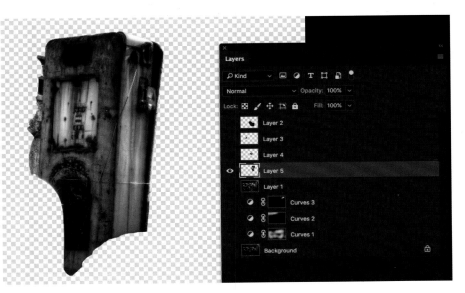

Figure 34.4 I turned off all of the layers except Layer 5 to isolate one element of this Photoshop document.

Another easy way to turn off multiple layers (or turn them back on) is to click-and-hold on the very top eyeball, and then drag your cursor down the column of eyeballs (**Figure 34.5**).

To move from one layer to another, you can hold down the Option key (PC: Alt) and press the left or right bracket key. The left bracket will move you down in the list of layers, and the right bracket will move you up. If you hold down the Command key (PC: Control), you can press the left or right bracket key to move the selected layer down or up in the list.

You can see all of the layers that intersect at a specific point in your document by selecting the Move tool and right-clicking on that area (**Figure 34.6**). Click on one of the layers listed in the context menu to select that layer in the Layers panel. You can also Command-click (PC: Control-click) on an element in your document to select the layer for that element (**Figure 34.7**).

There is also a feature that allows you to select a layer by simply clicking on an element in your document (without having to right-click or press any other keys). In the Move tool options at the top of the interface, there is a checkbox that says Auto-Select (**Figure 34.8**). When this is turned on, as soon as you click on an element in the document, the layer on which it sits will be selected. To be honest, I find this feature to cause more problems than it's

Figure 34.5 Click-and-hold on the top eyeball, and then drag your cursor down to turn off layers en masse.

Figure 34.6 With the Move tool selected, I right-clicked near the Ford emblem to see which layers intersect at this point.

Figure 34.7 When you Command-click (PC: Control-click) on an element in your document, the layer for that element will automatically be selected in the Layers panel.

worth. I'd rather Command-click (PC: Control-click) on the individual elements as I need them.

The last two tips I'll share in this lesson deal with flattening an image so that you can do some other things with it. In our example picture, there are a bunch of different layers. If I wanted to combine all of these into one layer, I would go to *Layer > Flatten Image* (**Figure 34.9**).

If you Command-click (PC: Control-click) on the thumbnail of a layer, it will load the contents of that layer as a selection on your document (**Figure 34.10**).

Figure 34.8 When Auto-Select is turned on, you can click on an element in your document to select the associated layer.

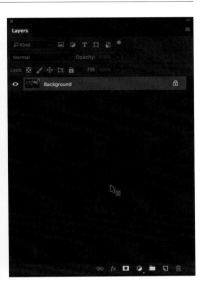

Figure 34.9 Flattening a multi-layered file.

Figure 34.10 Command-click (PC: Control-click) on a layer thumbnail to load the contents of that layer as a selection.

In full disclosure, I almost never flatten all of my layers into one layer. I'd much rather save a copy of the layered document as a JPG, which will automatically flatten everything into one file. Then I can keep all of the layers in the document and save it as a PSD file so that I can go back and reedit something if I need to.

There may be times when you need to merge all of the layers you've created and place the aggregate on its own individual layer. This is very common if you are working with things like filters or special effects.

Make sure all of the layers that you want to merge together are visible (there should be an eyeball next to each one in the Layers panel) and that the top layer is selected in the Layers panel (**Figure 34.11**).

Now hold down the Option key (PC: Alt) as you select *Layer > Merge Visible*. [You can also use the keyboard shortcut Option+Command+Shift+E (PC: Alt+Control+Shift+E)]. This will merge all of your layers and place the combined layers on a new layer at the very top of the stack—what I call a merge up. It takes all of the work that

you've done and produces a new layer that is the sum of all of the pieces you have below.

This is extremely helpful when you want to run a filter or effect on something. You can't necessarily run a filter if you have pieces of the puzzle separated into individual layers. You need to apply the filter to a copy of the whole document, but you don't want to merge everything and lose the layers. Do a merge up and you won't run into that problem (**Figure 34.12**).

Figure 34.11 Preparing to create a Merge up.

Figure 34.12 The results of a Merge Up in the Layers panel.

35. LAYER STYLES

YOU PROBABLY WON'T work with Layer Styles in a photography project very often, but you may inadvertently approach the Layer Style tool, so it's a good idea to know what it is and how you can use it. **Figure 35.1** shows a picture that we worked with in the previous lesson, in which we made a selection of the ceramic and copied it into its own layer.

If you double-click on the name Layer 1, you can rename the layer; however, if you double-click to the right of the words Layer 1, a Layer Style panel will open (**Figure 35.2**). The Layer Style panel has a set of canned effects that you can add to elements on the selected layer. In the list of Styles on the left side of the panel, you can see things like Bevel & Emboss, Stroke, and Drop Shadow.

Figure 35.1 A selection of just the ceramic sits on its own layer—Layer 1. We're going to apply a couple of different Layer Styles to this element.

Layer Styles are helpful if you want to create design elements for projects; they just don't apply much in a photographic space. But let's give it a shot here so you can see how they work.

In Figure 35.2, you can see that I've opened the Layer Style panel for Layer 1, which contains my selection of the ceramic, and clicked on the Outer Glow checkbox. This added a glowing halo around the ceramic. To modify the properties of the glow, you have to click on the words Outer Glow (not just in the checkbox). This will show you all of the different properties for the effect, and you can modify things like spread, size, or color. To change the color of the glow, click on the box under the Noise slider, and then use the color picker to choose a new color (**Figure 35.3**).

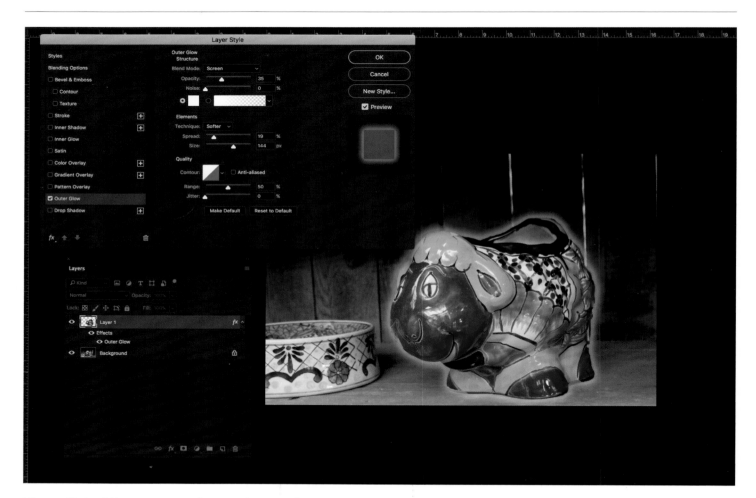

Figure 35.2 Adding an outer glow to the ceramic selection.

Figure 35.3 Changing the color of the outer glow.

A common Layer Style to use is the Drop Shadow. This adds a drop shadow directly underneath the element you're working on (**Figure 35.4**). Again, if you want to modify this effect, make sure you click on the words Drop Shadow, and you'll see settings for Distance, Spread, Size, Angle, and all of the other properties that affect how the shadow is placed in the image. You can also move the drop shadow around your document by clicking on it and dragging it to a new location.

Once you've added and adjusted all of the effects you want to use in the Layer Style panel, click OK. You'll notice that the effects you applied are now listed in the Layers panel directly under the associated layer (**Figure 35.5**). There is an eyeball next to Effects, which allows you to turn on or off the visibility of all of the effects, and there is also an eyeball next to each individual effect you applied (**Figure 35.6**).

Again, the amount of time you are going to spend with this in photography projects will be minimal. However, this is something that is very helpful if you're doing any kind of graphic design or layout work because these effects can make your designs pop (**Figure 35.7**). If you're using type or shapes, you can really benefit from using Layer Styles, so I would recommend that you investigate these further if this is something that you want to do.

Figure 35.4 Adding a drop shadow.

Figure 35.5 The Layer Styles applied are listed under the associated layer.

Figure 35.6 Turning off the Outer Glow.

Figure 35.7 Layer Styles can be immensely helpful in graphic design and type work.

36. WORKING WITH ADJUSTMENT LAYERS

IF I WERE to guess where you are going to spend the largest amount of time in Photoshop, I would say it's working with adjustment layers. This is the cornerstone of any development of a picture, and it is what turns a good picture into a great picture. I often tell people that adjustment layers and masks (we'll talk about masks in chapter 6) are the key components for working with your pictures; everything else is really just sprinkles that you add to the already finished sundae. This is the meat of everything. But before we get into it, I'd like to provide you with a quick Photoshop history lesson so you can understand the issues that adjustment layers solve.

Prior to the introduction of adjustment layers in Photoshop, any kind of tonal adjustment you wanted to do to an image had to be done via the Image Adjustments menu. For example, let's say I wanted to make a Levels adjustment to the image shown in **Figure 36.1**. I would go to *Image > Adjustments > Levels*, and in the Levels dialog,

Figure 36.1 Preparing a Levels adjustment via the Image Adjustments menu.

I would drag the Highlights slider over to the left and drag the Shadows slider over to the right (**Figure 36.2**).

The problem with this is that once I've made this adjustment, it is fully committed. If I save and close this file, this is my new starting point for the picture. If I overdid something and wanted to bring it back a little bit, I wouldn't have that option because I've already permanently changed my picture. This is not a good place to be.

Let's take it one step further. What if you wanted to apply an adjustment to one portion of an image, and then apply a completely different adjustment to another portion of the image? You can't really do that when you're working this way.

In response to these issues, the Photoshop team came up with a brilliant idea. What if these adjustments were turned into layers as well? Anything we put as a layer element on top of another layer can be adjusted in terms of opacity, or even deleted, so what if adjustments were as flexible as layers?

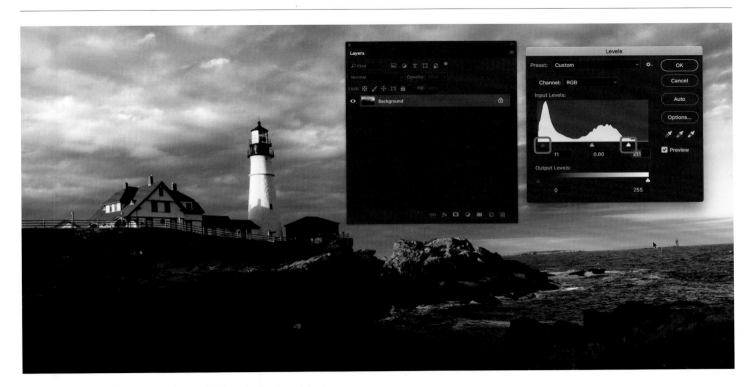

Figure 36.2 Making a Levels adjustment destructively.

This is where we saw the birth of the adjustment layer. To add an adjustment layer, go to *Layer > New Adjustment Layer* and select the type of adjustment you'd like to make (**Figure 36.3**). For this example, I'm going to select Curves. You can also add a new adjustment layer by clicking on the New Adjustment Layer icon (half-solid circle) at the bottom of the Layers panel and making a selection from the list (**Figure 36.4**).

You'll notice that a new layer is created on top of the layer that was selected when you added the adjustment layer. When the new layer is selected, its properties can be adjusted in the Properties panel. In my example, I'll click on the center of the curve and drag it down slightly to darken the picture a bit (**Figure 36.5**). Now if I save and close this file, when I reopen it, these layers *are still there*. I can click on the Curves layer in the Layers panel and go back into the Properties panel to continue making any kind of adjustments.

Let me give you a little tip for Curves adjustments. While many people would use just the standard curve adjustment to make tonal adjustments to a picture, I'm a big fan of using a targeted adjustment. In the Properties panel, look for the finger icon directly under the Preset drop-down (**Figure 36.6**). When this is selected, you can click on a specific area right in the document and increase or decrease the tonal adjustment in that section by dragging up or down. When you do this, a corresponding dot will be placed on the curve.

Figures 36.3-36.4 Two different ways to add an adjustment layer in Photoshop.

Figure 36.5 I've applied a Curves adjustment layer and dragged the center of the curve down to darken my image slightly.

Figure 36.6 Using the targeted adjustment for the curve.

The other benefit of adjustment layers is that if the adjustment itself is a little too harsh, not only can you readjust it in the Properties panel, but you can also fade the adjustment by changing the Opacity of the layer itself (**Figure 36.7**). Just click on Opacity in the Layers panel and drag the slider to the left. It behaves exactly like it does for other layers.

You can also stack multiple adjustments on top of one another. In **Figure 36.8**, I've stacked a warming Photo Filter adjustment on top of a Vibrance adjustment, which is stacked on top of the Curves adjustment. I can play with the opacities and densities of these layers to create a better image.

Adjustment layers are going to be the core of everything you do, and this alone would make it the perfect tool. In the next chapter, we'll take it even further by finally tackling the other amazing tool inside of Photoshop—layer masks.

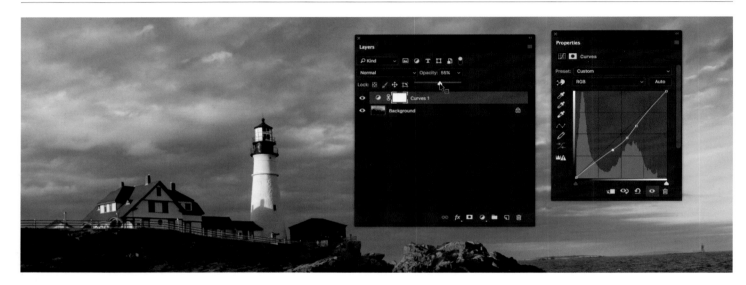

Figure 36.7 Decreasing the opacity of an adjustment layer.

Figure 36.8 I've added three different adjustment layers to this image, and I can play with the opacities and densities of each until I get the look I want.

6

LAYER MASKING
AND RETOUCHING

CHAPTER 6

Once you've developed a Photoshop project with a series of layers, it's time to start working on some creative explorations, from creating composites to advanced image processing. This type of work relies on your ability to show and hide specific portions of individual layers. To accomplish this, you'll use layer masks, which will completely transform how you work with your images.

In this chapter, you will learn how to create layer masks and how to use them to do things like adjust tone and color in your images. You'll also learn how to copy masks from one layer onto another so you don't have to redo all of your work every single time you create a new adjustment layer. This will help to speed up your workflow in Photoshop. Let's go ahead and get started.

37. WORKING WITH LAYER MASKS

LAYER MASKS ARE one of the most important features of Photoshop. Previously in Photoshop, when you wanted to use an individual element from an image, you often had to cut out the element and put it onto its own layer, and that worked very well. However, the problem with this method was that when you needed to go back and add to or remove portions of the element, you would have to go all the way back to the original source document and do the process all over again.

So how do you set yourself up to make duplicates or copies of an element that gets stuck inside of a layer process, but at the same time have the malleability to go back and add to or remove portions of it as you see fit? This is where the layer mask is absolutely vital.

The easiest way to think about a layer mask is to imagine throwing a drop cloth over the contents of a layer. Any area that is covered by the drop cloth will be hidden, and any area that is not covered by the drop cloth will be visible.

There are two ways to activate a layer mask. In both cases, you need to start by selecting the layer to which you want to apply a mask in the Layers panel. One method is to go to *Layer > Layer Mask*, and you'll see two options available: Reveal All and Hide All (**Figure 37.2**). In this instance, let's go ahead and select Hide All to hide the contents of the layer. You can also add a layer mask by clicking on the Add layer mask icon at the bottom of the Layers panel (**Figure 37.3**). Either of these methods will get you to a spot where you can either reveal or hide portions of a layer.

In Photoshop, instead of a using a drop cloth to hide portions of the layer, we use color. Take a look at the Layers panel, and you'll notice that to the right of your layer thumbnail is a square that is either white or black. If the square is black, you are successfully hiding the contents of that layer. If the square is white, you are revealing the contents of that layer. If you want to disable the layer mask so you can see the entire layer, all you have to do is press the Shift key and click on the mask thumbnail. A red X will appear on the mask thumbnail, and the contents of the layer will be visible in your document (**Figure 37.4**).

Figures 37.2–37.3 There are two ways to add a layer mask.

Figure 37.4 Press the Shift key and click on the layer mask thumbnail to disable the layer mask.

If you want to get rid of the layer mask at any point, all you have to do is click on it and drag it down to the trash can icon in the bottom-right corner of the Layers panel (**Figure 37.5**). You will see a pop-up message that asks whether you want to apply the mask that you have created to the layer or delete the mask to start anew. More often than not, you will just delete the mask and create a new one.

Let's use my image of the truck to talk about how we might work with a layer mask. I'll start by making a duplicate of my background layer by pressing Command+J (PC: Control+J). Now I have a new layer with the truck and its surroundings. But I'm only really doing this so that I can use one of the truck's headlights.

With this duplicate layer selected, I'll choose a selection tool and trace around the headlight. Once I've completed that, I'll go to *Layer > Layer Mask > Reveal Selection*. (You can also do this by just clicking on the Add layer mask icon at the bottom of the Layers panel.) Now I have a brand-new headlight that I can position anywhere I want. I'll select the Move tool and move it over to the left side of the image (**Figure 37.6**).

On this masked layer, only the individual headlight is visible because that is the area I selected, and the rest of the layer is masked out. If I hold down the Option key (PC: Alt) and click on the mask thumbnail, I can see only the mask itself—there is a white circle where the headlight is, and the rest of it is black (**Figure 37.7**).

In this instance, the mask is a little blobby—too much of the area around the headlight is still visible (**Figure 37.8**). I'm going to have to refine the mask a bit to make it look better.

Figure 37.5 Removing a layer mask from a layer.

Figure 37.6 You can only see the extra headlight because the rest of the layer is masked out.

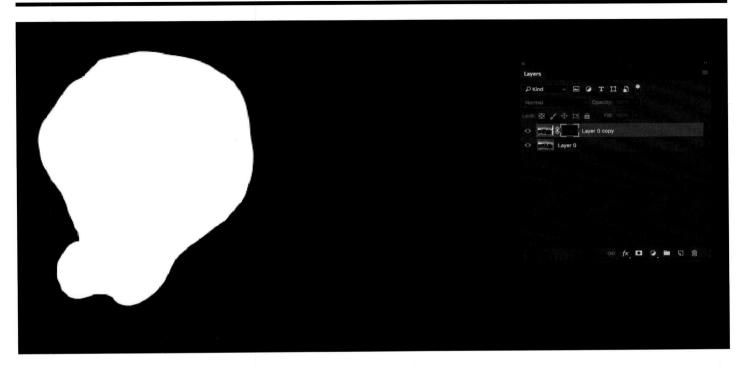

Figure 37.7 You can see the layer mask by holding down the Option key (PC: Alt) and clicking on the mask thumbnail in the Layers panel.

Figure 37.8 The duplicate headlight on the car with the rest of the layer masked out.

38. ADDING TO AND REMOVING PORTIONS OF LAYER MASKS

WHILE A LAYER mask is an extremely powerful component for making a cool Photoshop composite, it is also important that you understand the finesse that's required to make pieces fit together inside of a Photoshop document. This has everything to do with the use of brushes.

In the previous lesson, I added an extra headlight to the truck. But if I hide the bottom layer (in this case, Layer 0), you'll notice that on the masked layer (Layer 0 copy) there are some extra elements around the headlight that the mask doesn't quite cover—a little bit of background is still visible (**Figure 38.1**).

At this point, I can use a brush to add or remove some of the background. If I set my brush color to black, any area that I paint will be added to the mask; in other words, the areas I paint will be hidden. If I use white, the contents of the layer will be revealed wherever I paint (**Figure 38.2**).

It's important to understand that when you paint with white, you are not revealing the contents of the Layer below the one you're working on because that layer is hidden. You are revealing the contents of the masked layer

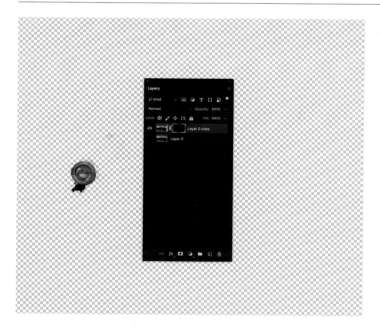

Figure 38.1 Some of the original background is still visible around the headlight. I need to clean up the mask a little bit.

Figure 38.2 I painted with white to reveal some of the contents of this layer.

by removing some of the mask.

If I Option-click (PC: Alt-click) on the mask thumbnail, I can see just the mask itself in the main workspace (**Figure 38.3**). The black area is the mask, and the white area is where the contents of the layer are still visible.

In **Figure 38.3**, you can see that some brushstrokes I made have a hard edge and some have a soft edge. This has to do with the hardness of the brush I used. This is where all of those brush techniques that we talked about in Lesson 11 come in handy. You can change the hardness of your brush on the fly by holding down Control+Option (PC: Alt+right-click) and dragging your cursor up or down (**Figure 38.4**).

To show you a clear example of the effects of a brush, I made my brush harder and painted with black in the center of my layer. This created a hole in the layer where I painted (**Figure 38.5**). Again, when I Option-click on the mask thumbnail, the mask itself is visible, and you can see that there is a solid color in the center of the layer (**Figure 38.6**).

There are two things I like to do with my brush, and we talked about this in Lesson 11, which covers brush techniques. First, I almost always like to make my brush softer. Second, I reduce the Flow setting, usually to anywhere between 10% and 20% (**Figure 38.7**). This makes it easy to softly bring back in or remove components of the layer that you want or *do not* want to show up in the composite.

Now that I've set up my brush, I can go back in and really finesse this one headlight in my document. I want to make sure that it looks like it really belongs in the image, so I'm going to take great care when painting with black and white to hide or reveal portions of the layer. I'm going to constantly adjust my brush size and brush hardness to make sure that it looks convincing (**Figure 38.8**). This is the part that usually takes the most amount of time.

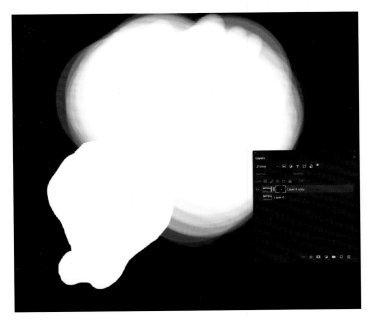

Figure 38.3 Revealing the mask itself to see where the brushstrokes have been painted.

Figure 38.4 Adjusting the hardness of the brush.

Figures 38.5-38.6 Painting a mask with a solid, black brush.

Figure 38.7 A soft brush with a low flow is something that I always use when working with composites.

Figure 38.8 Working to make sure that the added headlight looks like it is actually part of the image.

In **Figure 38.9**, you can see that there is a lot of movement between a hard brush and a soft brush to make this happen. When somebody tells you that they spent two hours in Photoshop working on a document, they're probably not referring to all of the stuff we talked about in the previous chapters. That stuff is easy. It's this level of detail that is involved in making something look believable that takes serious work.

Now that the mask is all cleaned up, if you compare the final composite in **Figure 38.10** to the initial mask in **Figure 37.8**, you can see that it really did look like a bit of a hack job before. Now it looks like the headlight actually belongs in this section.

The one thing that I think can make this work a lot easier is a tablet. I am a big fan of Wacom tablets because they offer a great amount of precision. I still use my mouse for ninety percent of the work I do during the day, such as email, browsing the web, and writing this book. However, when it comes to retouching, the mouse goes away and the pen comes out because this is where you're going to get an amazing amount of control over the work that you're doing. I recommend the Wacom Intuos Pro line, and a medium is a good place for you to start.

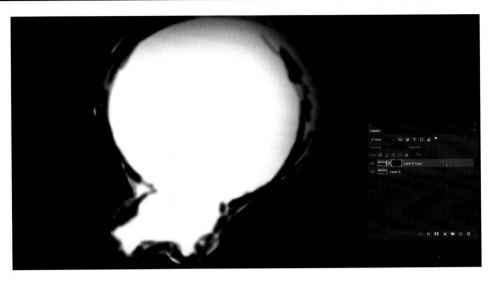

Figure 38.9 You can see that I switched up my brush a lot to make this image believable.

Figure 38.10 Finishing up the composite.

39. USING LAYER MASKS FOR ADJUSTING TONE

IF YOU THOUGHT making a layer mask was cool, this is where we can take it even further. In Lesson 36, we talked about adjustment layers and how we can use them to adjust the tonality of the picture. But what if we wanted complete control of that tonality in individual sections of a picture? This is where I think the techniques covered in this lesson are a lifesaver. To be honest, adjustment layers will probably account for eighty percent of the photographic toning that you do in a picture. They're dead easy to use, so let's just walk through it.

As an example, we'll use a still-life picture of an old Ford and sprocket that I took in Old Car City just outside of Atlanta (**Figure 39.1**). What I want to do is make some portions of the image pop, and make other portions a little bit more subdued.

To do this, I'll start by clicking on the adjustment layer icon at the bottom of the Layers panel and selecting Curves to add a Curves adjustment layer (**Figure 39.2**). In the Properties panel, I'm going to click on the center portion of the curve and drag it down slightly. This will make the midtones in the image darker.

Now I'm going to press Command+I (PC: Control+I)—which is the same as selecting *Image > Adjustments > Invert*—to turn the white Curves adjustment mask into a black mask, hiding the adjustment that I made to

the image (**Figure 39.3**). Now the image looks like it did before I made the Curves adjustment.

Whenever I teach this technique in person, I always tell people this really, really bad joke:

How do you catch a unique rabbit?
Unique up on him and catch him.
How do you catch a tame rabbit?
Tame way!

I know, the joke is very dumb. However, it illustrates a point here. Everything you're going to do when it comes to toning, special effects, or compositing will be done the *Tame Way*—the exact same way: Make an adjustment; hide the adjustment; use a soft, white brush with a low flow to bring the effect back into the area where you want it to be. Sometimes you'll leave the mask set to white, revealing the entire effect, and use a

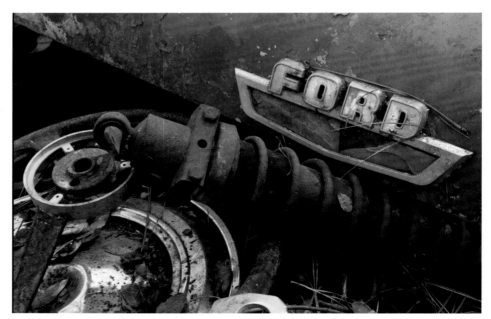

Figure 39.1 Let's tone this picture using adjustment layers.

soft, black brush to paint over the area you want to hide. But it's always the same process. *Tame Way!*

In this case, I've hidden the Curves adjustment, I have white set as my foreground color, and I've selected a soft brush with a low flow (**Figure 39.4**). All I have to do now is paint the Curves adjustment back in wherever I want to see it.

Once I'm happy with the effects of the Curves adjustment layer, I can add additional adjustment layers. In this case, I'm going to add a Brightness and Contrast adjustment layer. Again, I'll hide the adjustment layer, and then use a soft, white brush with a low flow to paint the Brightness and Contrast adjustment back in where I want it. I'm using this Brightness and Contrast adjustment to bring in just a little bit more detail in the letters and the steering wheel on the left side of the image.

The image is beginning to look very different from what I started with. If you look at the Layers panel in **Figure 39.5**, you can see that I have done quite a bit of work on the masks. When you're working with masks, keep in mind that you can use the keyboard shortcut X to toggle your foreground and background colors, so you can quickly alternate between hiding and revealing the effect with your brush. (If set to its default, the keyboard shortcut D will automatically set white as your foreground color and black as your background color.)

I'm going to add one more brightening adjustment here. I'll create a new Curves

Figure 39.2 Using an adjustment layer to darken the midtones.

Figure 39.3 Inverting the Curves adjustment mask.

adjustment layer and drag the center point of the curve up (**Figure 39.6**). Once I have it exactly where I want it, what am I going to do? *Tame Way!* I'll invert the mask, select a soft brush with a low flow, set my foreground color to white, and carefully paint the adjustment back in on the letters and the steering wheel (**Figure 39.7**).

If you take a look at the mask in **Figure 39.8**, you'll see just how much work has been done to add some brightness and contrast to the image. The white areas are where I used my white brush to reveal the Brightness and Contrast adjustment. **Figure 39.9** shows the work that was done to increase the brightness of the letters, and **Figure 39.10** shows where I darkened the image.

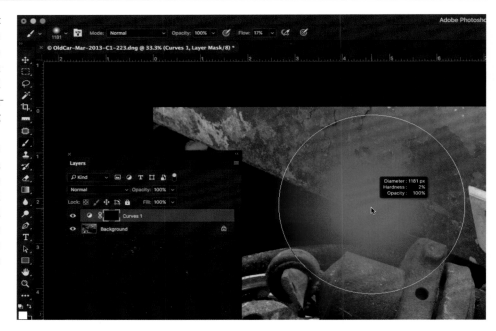

Figure 39.4 I'll use a soft, white brush with a low flow to paint some of the Curves adjustment back in.

Figure 39.5 Brightening, darkening, and adding contrast to the picture.

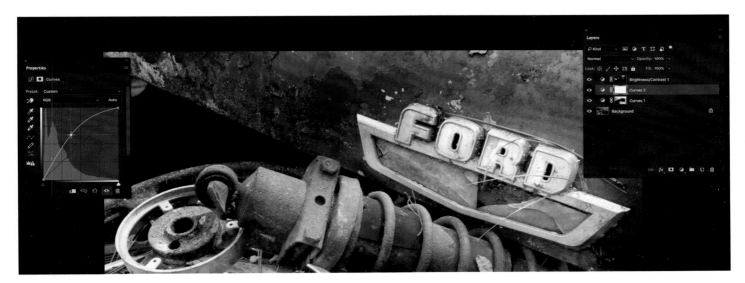

Figure 39.6 Adding one more Curves adjustment layer.

Figure 39.7 Brightening up the letters and the steering wheel.

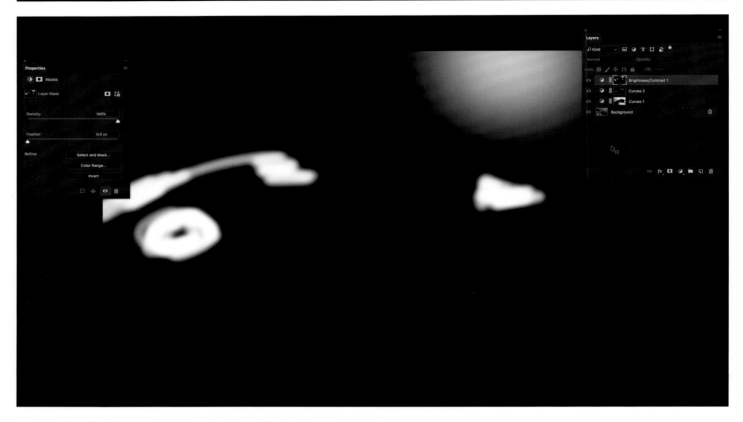

Figure 39.8 The Brightness and Contrast adjustment layer mask.

Figure 39.9 The second Curves adjustment layer mask. You can see that I painted over the letters to reveal the brightness adjustment in this area.

Figure 39.10 The first Curves adjustment layer mask. This allows you to see where I darkened the image.

40. USING LAYER MASKS FOR ADJUSTING COLOR

NOW THAT THE tonality of the example picture has been adjusted, let's spend some time talking about how to work with color using adjustment layers.

The first thing I want to do is adjust the blue color cast in the hubcap area on the left. The best way to do that is to create a Hue/Saturation adjustment layer, and then use the Targeted Adjustment tool (the little finger under the word Preset in the Properties panel) to select the color that I want to desaturate (**Figure 40.1**). I'll click on the hubcap

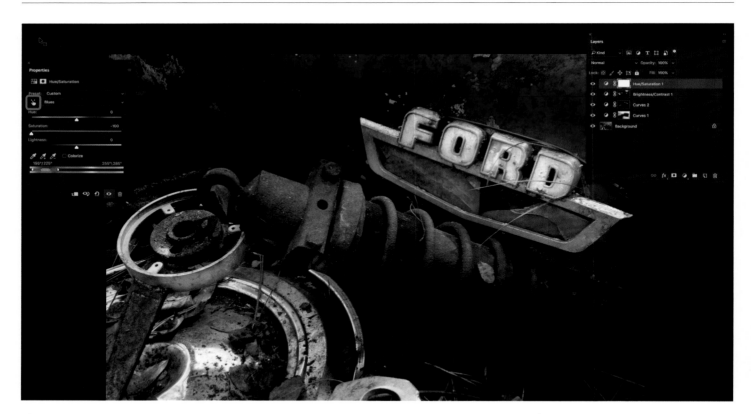

Figure 40.1 I used a Hue/Saturation adjustment layer to pull the blue out of the image. Notice that the blue has been pulled out of not only the hubcap, but out of the car and steering wheel as well.

with the Targeted Adjustment tool and drag to the left to pull out all of the blue.

The Hue/Saturation adjustment layer pulled all of the blue from the entire image based on what I selected with the Targeted Adjustment tool. I didn't want to remove the blue from everything; I only wanted to remove the color cast from the chrome hubcap. To fix this, I'll (*Tame Way!*) invert the mask to hide the Hue/Saturation adjustment, and use a soft, white, low-flow brush to reveal the adjustment in only the hubcap area

(**Figure 40.2**). When I Option-click (PC: Alt-click) on the mask icon in the Layers panel, you can see just how much I've brushed in that one area (**Figure 40.3**).

Next I'll add a little bit of Vibrance to the picture by clicking on New adjustment layer icon and selecting Vibrance from the list. Vibrance is almost like a smart saturation— it'll take colors that are underrepresented and amp them up a little bit. But I don't want to do that across the entire image.

This time, I'm not going to invert the

adjustment. I'll leave the Vibrance on everything and use a soft, black brush to mask out only the section where I don't want to see the effect (**Figures 40.4** and **40.5**). In this case, I'll remove the Vibrance from the area around the old steering wheel. (*Tame Way!*)

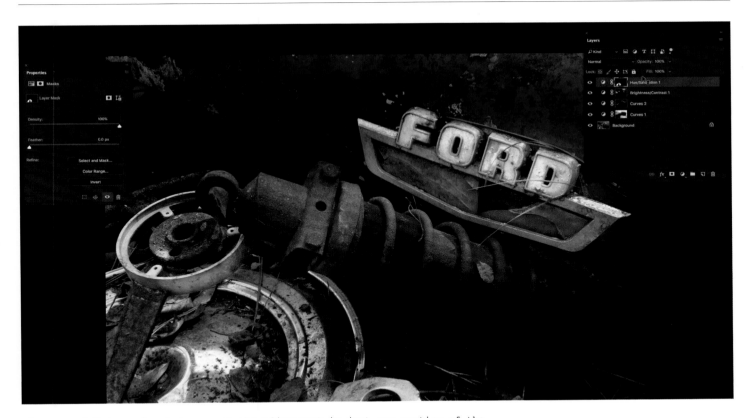

Figure 40.2 Using a brush to reveal the adjustment in just one portion of the image. Notice that now there is blue in the car and the steering wheel, but not the hubcap.

Figure 40.3 The Hue/Saturation adjustment layer mask.

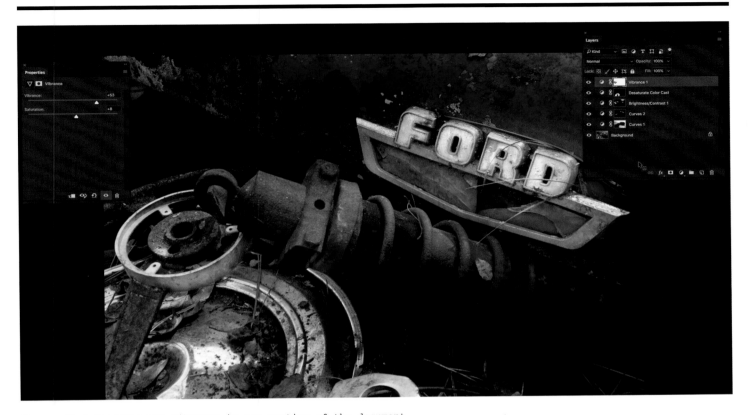

Figure 40.4 Removing the Vibrance in one section of the document.

With just a few tonality adjustments and a few color adjustments—and a bad joke—I've made this picture look *completely* different.

We've been slowly building up to these techniques, which will be the cornerstone of all of your work in Photoshop. You will be repeating these steps over and over throughout your projects, but how you apply these techniques stylistically is what will separate you from everybody else doing Photoshop work.

Figure 40.8 Before

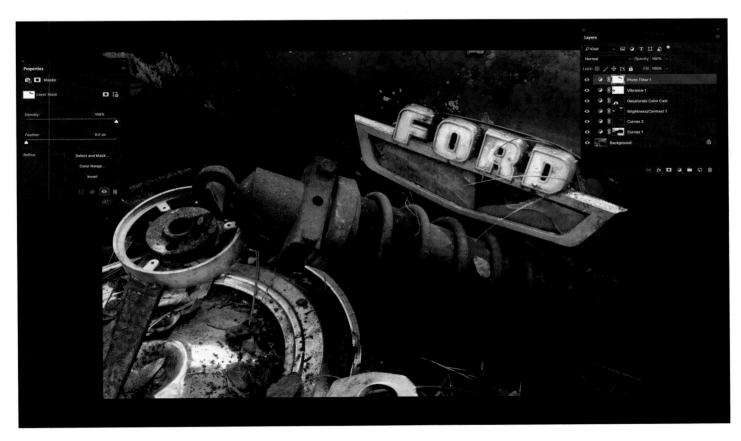

Figure 40.9 After

41. SPEED UP YOUR WORK BY DUPLICATING LAYER MASKS

BECAUSE YOU'RE GOING to be using this adjustment layer masking technique over and over again, I want to give you one essential tip that will speed up a lot of the work you'll be doing in Photoshop. We'll pick up where we left off with the example image from the previous lesson.

Let's take a look at the area in **Figure 41.1** where I did a Hue/Saturation adjustment on the hubcap. If you look at the mask for that layer, you can see that I spent some time working on it (**Figure 41.2**). (Note: I

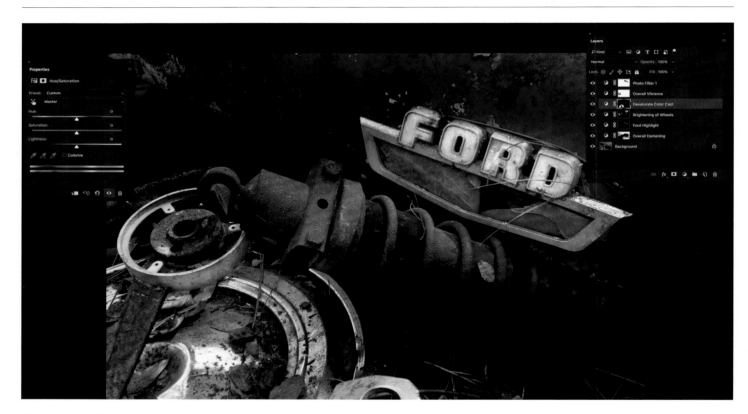

Figure 41.1 This image could use one more adjustment layer.

renamed the adjustment layers in the Layers panel so that they make a little bit more sense. This layer is called Desaturate Color Cast.)

Now let's say I want to make that area a little brighter as well. I could create a new Curves adjustment layer and drag the center point of the curve up (**Figure 41.3**). The problem here is that the adjustment is going to make the entire layer brighter—there is a white mask over everything. I don't have the control to isolate it to that one area where I desaturated the color...yet.

To be completely honest, the work that I've done in the lower-left corner of the image isn't that extensive, but you could find yourself in a position where you don't want to have to keep redoing the work. So the question is, how can you quickly duplicate the mask and apply it to a new adjustment layer?

If I were to select the mask by Command-clicking on it, and then tried to paste it, that wouldn't work because Photoshop would assume that I wanted those brushstrokes in a new layer (**Figure 41.4**).

The best way to copy a mask from one layer onto another is to hold down the Option key (PC: Alt) and click-and-drag the mask from the first layer onto the second. You'll know you did it right when you see a double arrow appear (**Figure 41.5**). I'll use this method to copy the mask from the Desaturate Color Cast adjustment layer onto the new Curves adjustment layer (**Figure 41.6**). This allows me to brighten the area where I removed the blue color cast from the hubcap, without brightening the rest of the image.

Figure 41.2 The Desaturate Color Cast adjustment layer mask.

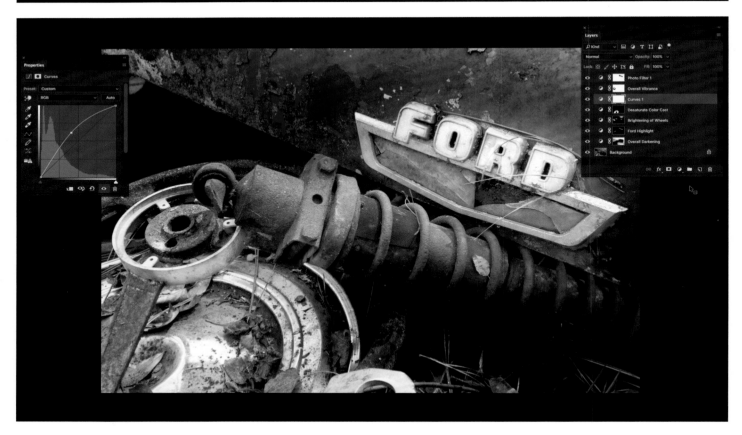

Figure 41.3 Adding a new Curves adjustment layer brightens the whole image.

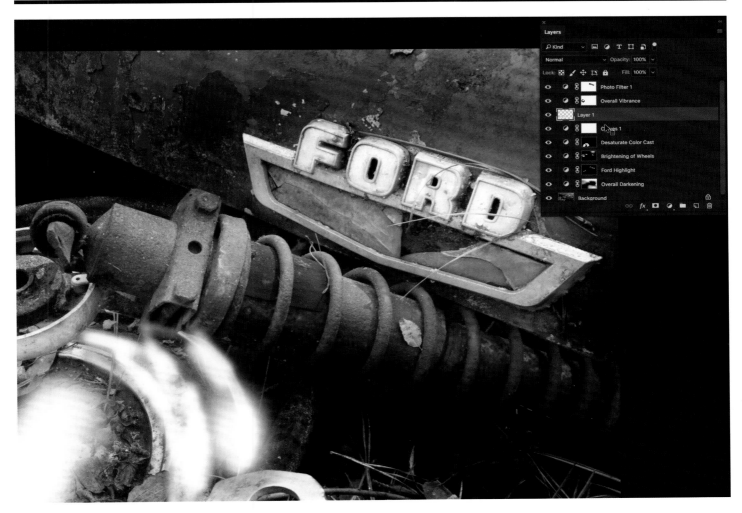

Figure 41.4 If you try to paste from a selection, Photoshop will put the selection on new layer.

Figure 41.5 Copying a layer mask from one layer onto another.

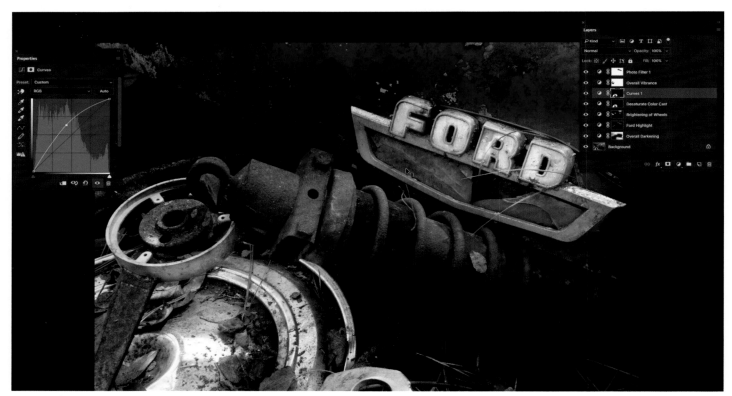

Figure 41.6 I've copied the mask from the Desaturate Color Cast adjustment layer onto the new Curves layer to brighten only the area in the hubcap.

Figures 41.7-41.8 When I drag the Desaturate Color Cast adjustment layer mask onto the new Curves layer, Photoshop asks me if I want to replace the layer mask.

This is a great way to speed up your workflow because you don't have to spend a bunch of time going back in and painting the same masks over and over.

It is important to note that to do this successfully, you must hold down the Option key (PC: Alt) while you drag the mask. Let's say I grab the mask in the Desaturate Color Cast adjustment layer and drag it onto the new Curves layer (**Figure 41.7**), but I do not hold down the Option key while doing so. I'll get a warning dialog that asks, Replace Layer Mask? (**Figure 41.8**).

This would not be a good idea because it would remove the mask from the Desaturate Color Cast layer and place it on the new Curves layer. This would be helpful in terms of adding the mask to the Curves layer, but it would mean that the desaturation would be applied to the entire image because that layer would no longer have a mask attached to it (i.e., the blue would be desaturated in the entire image; **Figure 41.9**). Not good.

Since I do not want to do this, I'll select No from the Replace Layer Mask dialog. If I had selected Yes, I could reverse the change by going to *Edit > Undo Add Layer Mask* (remember that Photoshop saves all of these steps—up to 50 of them).

Figure 41.9 This is not a good place to be. I've removed the mask from where I need it on the Desaturate Color Cast adjustment layer.

7

RETOUCHING AND CONTENT-AWARE TECHNIQUES

CHAPTER 7

In many of your Photoshop projects, there will be imperfections that you may want to consider fixing, from blemishes in a person's skin to inconsistent background elements. Photoshop has some great techniques that you can use to fill all of these unwanted spaces or take care of some blemishes that detract from your picture.

In this chapter you'll learn how to remove blemishes with the Spot Healing tools and Patch tools, and more importantly, when you would want to use one tool versus another. We'll also explore the concept of Liquify, which is one of the most controversial yet beneficial tools in the Photoshop arsenal. Lastly, I'll give you a few retouching techniques that will help you achieve a better effect with a softer hand when you're performing any of these manipulations.

42. USING CONTENT-AWARE FILL AND SCALE

A GREAT FEATURE of Photoshop CC is its ability to fill a specific area in a picture based on other information in that picture. Filling in an area in an image used to require a lot of work with the Clone tool. You would sample bits and pieces of another area to try and get it to match. The task has become much easier due to Photoshop's Content-Aware technology. Put very simplistically, when you make a selection where you want to fill in your image, Content-Aware scans the picture to find the most appropriate area from which to draw information to fill your selection. It then fills the area you selected with that information, giving you a pretty seamless look.

I use this a lot when I run out of background, like I did in **Figure 42.1**. I shot this image on a white backdrop and, while I like the picture, I can see some of the wall behind the backdrop. This may seem like it would be very easy to fix—select the area and fill it with white. But when I use my eyedropper (keyboard shortcut I) to sample the backdrop, I can see that it is not exactly white, and the color is not the same throughout (**Figure 42.2**). To make this area more consistent with rest of the image, I'd be better off using Content-Aware Fill.

Figure 42.1 Some of the wall behind the backdrop is still visible, so I need to get rid of that.

For this image, I'm going to use a Polygonal Lasso tool to make a selection around the area that is not covered by the backdrop (**Figure 42.3**). *Tip:* If you're using a Polygonal Lasso tool, you can click beyond the edges of the document and your selection will automatically snap to the very edge of the picture. That way you don't have to guess where the edge of a picture is.

Once I've made my selection, I'll go *Edit > Fill*. In the Fill dialog box, the Contents dropdown menu allows you to choose what you want to use to fill your selection—a specific color, foreground color, background color, white, black, 50% gray, or Content-Aware technology. I'm going to select the Content-Aware option (**Figure 42.4**). This can also be accessed with the keyboard shortcut Shift+Delete (PC: Shift+Backspace).

In **Figure 42.5** you can see that the Content-Aware technology does a really good job of filling in the area I selected based on the surrounding area, giving me the extra white background I need.

That same type of Content-Aware technology can also be used to scale pictures up and down. Let's walk through an example of another issue I commonly run into and how I solve it. A DSLR camera is usually set for a 3:2 aspect ratio, which gives me a picture like the one shown in **Figure 42.6**. But if I want to put this picture in an 8×10-inch frame, which is a common size, I need to transform it to make it fit.

Figure 42.2 The backdrop is not solid white, so I can't just fill the area next to it with white.

Figure 42.3 I used the Polygonal Lasso tool to select the area to fill.

Figure 42.4 Selecting Content-Aware from the Fill dialog box.

Figure 42.5 The filled area now matches the rest of the white background.

Figure 42.6
A picture of Central Park that I shot with my Nikon, which is set to a 3:2 aspect ratio.

I'll start by creating a new 8×10-inch document in Photoshop, and set the resolution to 240 PPI (**Figure 42.7**). Now I can move the Central Park picture onto the new blank document (**Figure 42.8**). To move an image to another document, select the Move tool and click-and-hold on the picture that you want to move. While holding down the mouse button, drag the picture onto the tab for the new document to switch to that document. Maintain pressure on the mouse button while you move your cursor down to the document, and then release.

When I move my Central Park image onto the new document, I can't see all of it, so I need to zoom out before I start transforming it (**Figure 42.9**).

Once I get the picture to size, it's clear that it doesn't fill the aspect ratio of the frame I've selected. I can zoom in, but if I zoom in I'm going to lose the buildings on the left and right sides of the image. When I perform a Free Transform to keep the image at the same ratio but fit it into the document, I end up with a whole bunch of white space at the top and bottom (**Figure 42.10**).

I'll commit this transformation by hitting the Enter key, and then go to *Edit > Content-Aware Scale*. This will bring back the same transformation handles, but there is a very big difference here. As I drag the top edge of the image up, Photoshop samples the area around that portion of the picture and duplicates it to scale the picture up.

I'll drag the top handle up to the top of the frame and the bottom handle down to the bottom of the frame, and now my picture has been scaled up with samplings from the sky and the trees (**Figure 42.11**). This maintains the perspective that I want.

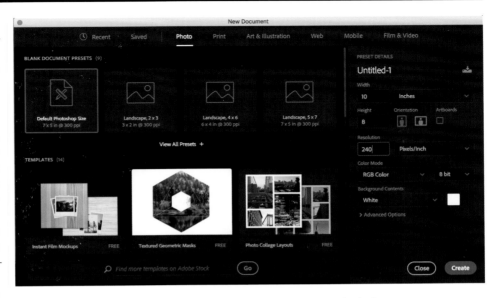

Figure 42.7 Setting up a document for a standard 8×10-inch frame.

Figure 42.8 Moving a picture from one document to another.

Figure 42.9 The picture is too big, so I need to zoom out to see all of it.

Figure 42.10 My picture doesn't fit the aspect ratio of the document.

Figure 42.11 I used Content-Aware Scale to resize this image so that it will fit an 8×10-inch frame.

I can also use Content-Aware Scale to make the bike photograph from the beginning of this lesson work better for me. I'll use a Rectangular Marquee tool to make a thin, rectangular selection to the right of the man's foot (**Figure 42.12**). Then I'll select *Edit > Content-Aware Scale* and drag the transformation handle on the right side over to the right edge of the frame, and Photoshop will automatically fill in that area (**Figure 42.13**). I'll make another rectangular selection across the top of the image and use Content-Aware Scale to fill the top area evenly as well (**Figure 42.14**).

Figure 42.12 Making a selection for Content-Aware Scale.

Figure 42.13 Using Content-Aware Scale to fill in the background.

Figure 42.14 Using Content-Aware Scale to fill in the top of the image.

IN ANY PHOTOSHOP project you're going to have to correct some little trouble spots or blemishes. Rather than immortalizing someone's problem spots in this book, I'm thinking the best thing to do is to use the person who I know has the most problem spots: me (**Figure 43.1**).

First, we'll look at the Spot Healing Brush tool, which you can access with the keyboard shortcut J, or by clicking on the toolbar icon that looks like a Band-Aid with a little half circle on top (**Figure 43.2**). As you can tell by its name, this is a brush-based tool, so all of the different brush commands we've talked about will apply here. All you have to do is make a nice, soft brush and click on the problem spot, and the spot will disappear.

I'm going to start with the center of my nose (**Figure 43.3**). This is where I have a mark that I lovingly call, "that spot my mother told me to leave alone when I had chickenpox." So I have a permanent crater on the tip of my nose. I'll make my brush as soft as possible and zap that one spot to make it disappear.

Figure 43.1 What better subject for talking about erasing flaws than myself?

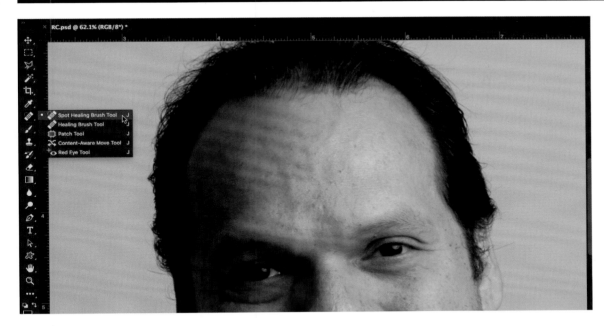

Figure 43.2 Accessing the Spot Healing Brush.

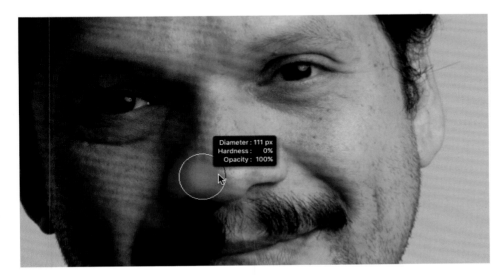

Figure 43.3 Removing a mark on the tip of my nose with the Spot Healing Brush.

Moving over to the right side of the picture, you'll find fuel for my daughter's favorite pastime—pulling these hairs out of my ear (**Figure 43.4**). (Actually, I didn't even *know* that I had hairs coming out of my ears until a couple of months ago!) Thankfully, I have a much less painful way to handle this—with the Spot Healing Brush.

I'll select a smaller brush and drag it across the hair, making the hair disappear (**Figure 43.5**). While I'm at it, I'll also use this brush to take care of that one blemish I have just under my eyebrow (**Figure 43.6**).

Seems easy enough, right? It's tempting to use this brush in a much bigger capacity to get rid of the sleep marks I have directly under my eyes, but I do not recommend doing something like this. One thing I've come to realize is that when you use the Spot Healing Brush at a larger size, the resulting marks tend to be a little softer. You'll see a little bit of a blur in the area where you used it, and it won't look very good (**Figures 43.7** and **43.8**).

For this type of correction, I would much rather use the Patch tool that sits inside the Spot Healing Brush tool group. The icon for this tool looks like a square with stitch marks around the edges. You can access it by clicking and holding on the Spot Healing Brush until the tool group menu pops up, or by pressing Shift+J to cycle through the tool group.

The Patch tool allows you to draw a selection around an area, and then drag it over to another area from which you want to pull information to replace the area in your original selection. In this instance, I'm going to draw a selection around the crease under my eye, and then drag it directly underneath that area where the good skin is (**Figures 43.9** and **43.10**). Photoshop will use the texture from the new area to fill in those bags quite nicely (**Figure 43.11**). I'll do the same thing to my other eye.

Figures 43.4–43.6 Getting rid of small spots with the Spot Healing Brush.

Figures 43.7-43.8 Using the Spot Healing Brush incorrectly leaves you with a very plastic look.

Figures 43.9-43.10 Using the Patch tool to get rid of the bags under my eye.

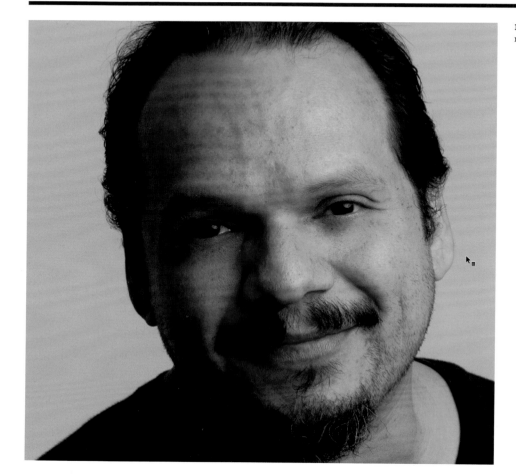

Figure 43.11 Don't I look so much more refreshed? Not really.

Now that I've used the Patch tool to eliminate the bags under my eyes, you can see that there is a much more textured look to this repair than when I tried using the Spot Healing Brush. This picture is by no means perfect, but this gives you a good idea of how you can use these two tools to correct blemishes on a face. In Lesson 46, I'll give you a tip on how you can pull back on some of this to create a more realistic (less botched plastic surgery) look.

Let's move this into a more practical scenario, like the example in **Figure 43.12**. Here I can use Content-Aware Fill to clean up the border areas around the picture where the white backdrop is missing (**Figure 43.13**), and I can use the Patch tools to get rid of all of the bicycle marks on the floor.

Figures 43.12-43.13 Extending the white backdrop at the top with Content-Aware Scale.

While Content-Aware Fill does a really good job of sampling areas to use to fill selections, sometimes it will sample a portion of the image that you do not want to copy into the selection, creating a really weird artifact (**Figures 43.14** and **43.15**). That's totally fine. If the rest of the selection looks like it's okay, just go ahead and make a selection around the artifact (**Figure 43.16**), and use Content-Aware Fill again to get rid of the problem area.

Now that I've taken care of the background, I want to use the Patch tool to get rid of those tire marks. I'll draw a selection around the tire marks, and then drag the selection to the left (**Figures 43.17** and **43.18**). Photoshop will replace the area with the tire marks with the clean area. The paper on the floor has a little bit of a bump in it, so by moving my selection to the left where there is still a bump in the paper, I can get a good match for the fill.

Now I have a much more solid foundation for a picture that I can finish up later (**Figure 43.19**).

Figures 43.14–43.15 Sometimes Content-Aware Fill creates weird artifacts, but this is easy to fix.

Figure 43.16 I can fix this problem by making a selection around the artifact and using Content-Aware Fill once more.

Figures 43.17-43.18 Removing the tire marks from the floor.

Figure 43.19 The background is filled in and the tire marks are gone.

IF YOU FIND that Content-Aware Fill is sampling too much of an area that you do not want sampled, you can hide that area before performing a fill.

Let's use the image from the previous lesson as an example. First, I'm going to use the Lasso tool to make a selection around the element that I would like to hide from Content-Aware Fill (**Figure 44.1**). I can click on the Add layer mask icon in the Layers panel to hide that information (**Figure 44.2**).

Once that's hidden, I'll go back with a Lasso tool and select the area I want to fill. In this case, I'm going to use a Polygonal Lasso tool because I can get really close to the edges of the area that I want to fill, and I can go outside the document bounds to make sure my selection goes all the way to the edges of the image (**Figure 44.3**).

Figure 44.1 Making a selection around the area I want to hide from Content-Aware Fill.

Figure 44.2 Adding a layer mask to hide the selection.

Figure 44.3 Using the Polygonal Lasso tool to select the area I want to fill.

After I've completed my selection, I'll switch back over to the actual image by selecting the image thumbnail in the Layers panel. It's important to make sure that the mask thumbnail is not selected. If you do any fill with the layer mask selected, Photoshop will do the fill on the mask.

Now I'll go to *Edit > Fill* and select Content-Aware from the Contents drop-down menu (**Figure 44.4**). Because I have the man on the bike hidden, Photoshop will not sample that area, so I will be left with a much cleaner result (**Figure 44.5**).

Finally, I'll drag the mask into the trash (**Figure 44.6**), and my subject will be visible again (**Figure 44.7**).

Figure 44.4 Make sure the image thumbnail is selected (not the mask thumbnail) before you perform the Content-Aware Fill.

Figure 44.5 The results of the Content-Aware Fill are much cleaner this time.

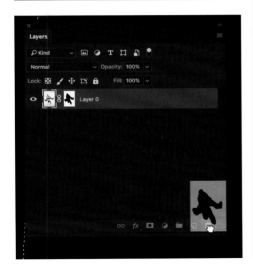

Figure 44.6 Deleting the mask.

Figure 44.7 The finished product.

45. USING THE LIQUIFY TOOLS

THERE ARE NO Photoshop tools that cause more controversy than the Liquify tools. These are the tools that are used in a lot of magazine articles to transform pictures entirely. So I'm going to give you an overview of how these tools work, and let you decide on how you want to work with them.

Open the Liquify filter by going to *Filter > Liquify*. You will be presented with a series of tools on the left side of the window and some panel options on the right. The toolbar

menu here works the same way as the toolbar in the general Photoshop interface (**Figure 45.1**). Hover over any of the tools and you'll see the associated keyboard shortcut.

It's important to note that a lot of these tools are brush-based, so when you look at the panels on the right side of the Liquify window, you'll notice settings like Pressure, Sensitivity, Size, Hardness, much like you would see for any other brush-based tool.

So let's take it from the top. The first tool

in the toolbar is the Forward Warp tool. With this tool, once you specify the size of a brush, you can manipulate different components of the picture or push them around, almost as if the picture were made out of clay. In **Figure 45.2**, I'm pushing my eye to a really unnatural place.

The tool directly under the Forward Warp tool is a Reconstruct tool, which you can think of as a history brush (**Figure 45.3**). It basically paints back in what you originally

Figure 45.1 The Liquify toolbar.

Figure 45.2 My eye should never look like this. But it does, thanks to the Forward Warp tool.

Figure 45.3 I used the Reconstruct tool to paint my eye back in.

had in your document. So instead of having to undo all of your steps, you can just use the Reconstruct tool to paint back in a small section of the original image.

A little further down is the Rotate tool, which looks like a little swirl (**Figure 45.4**). You click on a spot to rotate it clockwise, and each click increases the rotation. If you hold down the Option key (PC: Alt), it will create a counterclockwise rotation.

Figures 45.5 and **45.6** show the results of the Pucker and Bloat tools. Pucker, as the name implies, makes whatever you paint smaller, and Bloat makes things larger. It's important to note, however, that if you have the Pucker tool selected and you hold down the Option key, it will make things bigger. And if you're using the Bloat tool and you hold down the Option key, it will make things smaller. So if you don't want to switch back and forth between the two, you can always hold down the Option key to toggle them.

Figure 45.4 The results of using the Rotate tool on my eye.

Figure 45.5 The Pucker tool.

Figure 45.6 The Bloat tool.

Invariably, when you're working with the Liquify filter, you'll inadvertently move some things that you didn't intend to. Freeze Mask and Thaw Mask are two tools that you can use to make sure things stay put (**Figures 45.7** and **45.8**). With the Freeze Mask tool, you can paint over any areas that you don't want to move, and those areas will not move no matter what tool you use. A red overlay will mark any areas that have been painted with the Freeze Mask tool. If you happen to paint over too much area, you can use the Thaw Mask tool to remove some of the red overlay.

In **Figure 45.9**, I've made a really large Forward Warp tool, which I want to use to bring in my jawline. However, I don't want it to affect the rest of my face, so I used the Freeze Mask tool to paint a red overlay across the center of my face.

I don't like using the Liquify tools for anything more than some basic reconstruction. These tools are often used to reconstruct or move around fabrics. I am not the best dresser in the world, so I almost always wear a black T-shirt and something else. If I want to clean this up, however, I'll use the Forward Warp tool to kind of bring in the shirt and smooth it out over by my arm (**Figure 45.10**). The moment I started smoothing out the arm, I invariably moved the canvas a little bit. I could always use the Forward Warp tool in a smaller size to push back some of that canvas and cover the transparent area.

Figures 45.7–45.8 Freeze Mask tool and Thaw Mask tool.

Figure 45.9 I froze the center of my face so it wouldn't be affected by the Forward Warp tool.

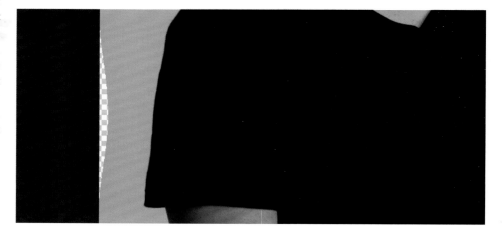

Figure 45.10 Smoothing out fabric with the Forward Warp tool.

My friend Mia gave me permission to use a picture of her to illustrate another common use of the Liquify tools—to adjust a subject's hair (**Figure 45.11**). In this portrait, I wanted to smooth out Mia's hair a bit, so I used the Forward Warp tool to push in the hair from the right side, scrunching it in a little bit. I also got rid of a little extra fabric on her sleeves (**Figure 45.12**).

Prior to the latest release of Photoshop CC 2017, the tools we've gone over so far were the main tools that everybody used for any kind of Liquify work. But in the newest version of Photoshop, Adobe has added the Face tool, which I think is pretty incredible. You can access the Face tool with the keyboard shortcut A, or by clicking in the little head-and-shoulders icon at the bottom of the toolbar (**Figure 45.13**).

When you select the Face tool, Photoshop will take a look at the picture and detect what it believes to be a face. You'll see two thin, white lines on either side of the face (**Figure 45.14**). Once the face is selected, expand the Face-Aware Liquify panel on the right side of the window, and it will shock you to see how many things you can adjust here.

Photoshop has taken a lot of the guesswork out of manipulating faces by giving us the ability to change anything we want with a series of sliders. You can even make a sad person slightly happier with the Smile slider (**Figures 45.15** and **45.16**).

Figure 45.11 I used the Forward Warp tool to adjust Mia's hair.

Figure 45.12 More fabric adjustments with Liquify.

Figure 45.13
The Face tool
in the Liquify
filter.

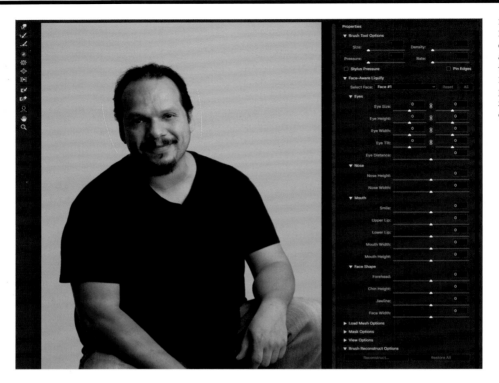

Figure 45.14
Photoshop has
detected my face,
and I can now use
the settings in the
Face-Aware Liquify
panel to make an
incredible number
of adjustments.

Figures 45.15–45.16 Adding a little bit of a smile with Face-Aware Liquify.

I've had the good fortune to teach Photoshop to thousands of students around the world, and I always approach the Liquify tools with a little bit of trepidation. Every single time that I present them, I put up a picture of my daughter, Sabine, who is now eight years old (**Figure 45.17**). She is my constant reminder that we need to be responsible with these tools.

When we look at images in magazines and other media, a lot of what we see promotes a very unrealistic view of what women should look like. The use of these tools contributes to this problem and creates an environment in which little girls like Sabine have to decipher whether something they see is real or not. Body image problems among children—especially girls—are very real. I remind Sabine often that she is amazing and special, and that these tools are out there, sometimes turning things into make believe.

This serves as a reminder to myself. Would I make any adjustments to an image that would offend her or alter how she sees things? In addition to being the reason my heart beats, she is my ethical compass. Hopefully, as you tackle your own projects, you'll have an ethical compass that you can rely on as well.

Figure 45.17 My daughter, Sabine.

46. HELPFUL TIPS FOR RETOUCHING

BEFORE WE LEAVE the world of Liquify, I want to give you a couple of tips that I think are absolutely important as you start moving and pushing pixels around.

When I'm pushing pixels around, I almost never use a solid brush and I don't use the center of a brush. In **Figure 46.1**, notice that I'm using the very edge of my brush to push my cheek inward. I would probably use a smaller brush than this, but not too much smaller.

This brings me to my next point. In the Liquify tool, brush sizes used to be limited to about 1,400 pixels, which meant that you would work with Liquify in small segments. Now, the brush size for Liquify tools goes all the way up to about 14,000 pixels, so you can make really large changes and move things around quite a bit. Often, if I want to tighten up some of the body and facial features in a picture just a tiny bit (sometimes a camera lens makes facial features appear wider), I'll select the Forward Warp tool and make it really big, and then drag in just slightly on the image (**Figure 46.2**).

Figure 46.1 Using the edge of a brush to push my cheek inward.

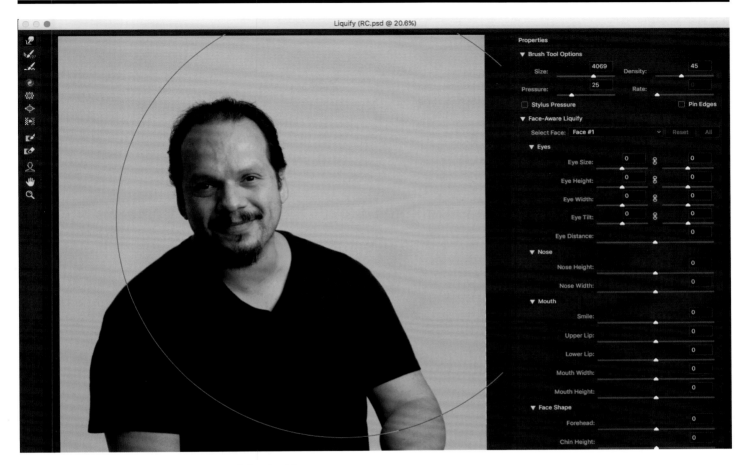

Figure 46.2 Tightening up an image with Liquify.

My next tip should come as no surprise. At the very bottom of the panels on the right side of the Liquify window, there is a preview checkbox (**Figure 46.3**). This should be toggled off and on repeatedly as you're working on a project so that you can clearly see the amount of pushing and pulling you're doing. It can be easy to do a lot of Liquify work, only to be shocked at the results when you hit Okay. Check your work often.

The last tip I want to give you doesn't deal with Liquify, but is more about working with the Spot Healing Brush and Patch tools.

In Lesson 43, I did some work on my face and my nose and the bags under my eyes—all elements that are really just a product of no sleep and poor choices that I made as a younger man. However, there is no lying to myself that I'm not over 40 at this point, so if I were to look at a picture of me that had none of these features, it would be a little shocking.

Furthermore, I always keep one thing in mind whenever I'm doing any kind of retouching: one man's mole is another man's beauty mark. You have no idea how someone

is going to react when you remove a portion of an image.

I'm not really looking to have an image retouched so that it looks like I'm 20; it's not going to look like me. (But if you could add seven to ten hours of extra sleep to my face, that would be great.) So I recommend this: Duplicate the layer you're going to be working with, and then do the retouching on that layer (**Figure 46.4**). Once everything is nice and smooth, hide the layer with a mask.

Now you can use a soft, white, low-flow brush (Tame Way!) to softly bring back in

Figure 46.3 Toggle the Preview off and on to keep an eye on how much work you're doing with the Liquify tools.

Figure 46.4 Duplicating a layer before doing any retouching.

some of that retouched layer and blend it with the layer underneath it. We don't want all of the wrinkles to go away, we just want them to be softer. Blending the retouch in with the original image can help here. Should the client come back and say, "Listen, I want it all to go away," you're obviously going to do what the client wants. But, in my opinion, the goal is make sure that the marks of age are still there, but are ever so subtle (**Figure 46.5**). That is a good retouch.

Figure 46.5 Softening up the retouch.

8

BEYOND THE BASICS

CHAPTER 8

If you've gotten this far, then you have a good command of the anatomy of Photoshop—the processes and procedures that enable you to perform some basic Photoshop tasks. This chapter is designed to give you one thing: a series of tried-and-true techniques that I use to work on most of my pictures. In it, you'll learn techniques for creating panoramic and HDR images, and I've even thrown in a lesson on how to use a little-known feature called Puppet Warp to help you manipulate large panoramic images.

This chapter serves as an introduction to a toolset of techniques that you can keep in your belt to tackle any of the problems that you may run into as you start working with photographs. The beauty of all of this is that these techniques are very easy to understand, and you will come to rely on them over and over again as you start making better pictures.

47. CREATING A PANORAMIC IMAGE IN PHOTOSHOP

THE ADOBE CAMERA RAW plug-in makes it easy to create a panoramic image from a series of photographs. In Photoshop, go to *File > Open*, and navigate to the location in which the images you want to use are stored. Shift-click all of the images and select Open to open all of the files in Camera Raw. The images will appear in the Filmstrip on the left side of the Camera Raw window (**Figure 47.1**). From here, you can make any type of tonal adjustments to the images. (*Note:* When you Shift-click to open a series of JPEG images, they will open in separate tabs in Photoshop. To open them in Camera Raw, you must configure your preferences first. Go to *Photoshop CC > Preferences > Camera Raw*, and under JPEG and TIFF Handling, select Automatically open all supported JPEGs from the drop-down menu. Now when you Shift-click on the JPEG files, they will open in Camera Raw.)

Once you're happy with the tonal adjustments you've made, click on the options menu icon (four horizontal lines) to the right of the word Filmstrip and choose Select All. Click the options menu icon again and select Merge to Panorama (**Figure 47.2**). You will see a progress bar as Camera Raw prepares a preview of the panorama (**Figure 47.3**).

When the preview is complete, it will open in the Panorama Merge Preview window where you can select how you want the final image to look (**Figure 47.4**). It's important to note here that the processing of this preview is really fast, thanks to the fact that Photoshop leverages the graphics processing unit (GPU) of your computer and uses the embedded thumbnails for each of the individual RAW files. This allows you to quickly determine whether or not the panoramic image is one that you want to work with.

In the Panorama Merge Preview window there are three different projection types available: Spherical, Cylindrical, and Perspective. Each of these creates a different look, and which one you use is entirely up to you. Click on each to see which one you like best.

When you create a panoramic image, you'll notice that there's a lot of white space that is a result of the merging of the files. You can deal with this white space in a couple of different ways. First, you can select the Auto Crop checkbox, which will immediately crop the image to minimize the white space (**Figures 47.5** and **47.6**). You can also drag the Boundary Warp slider to the right to warp the edges of the picture toward the edges of the frame. This creates a little bit of distortion, but it eliminates the need to excessively crop the image.

When you're happy with how your panorama looks, click Merge, and you'll be presented with a dialog box where you can name the file and choose a location in which to save it (**Figure 47.7**). "Pano" is automatically added to the end of your filename.

Figure 47.1 Opening the individual images in Camera Raw.

Figure 47.2 Merging the images to create a single panoramic image.

Figure 47.3 A progress indicator will be displayed while Camera Raw works on merging the images into a panorama.

Figure 47.4 A preview of your panorama will open in the Panorama Merge Preview window. This shows the Spherical projection option.

Figure 47.5 This shows the Perspective projection option. When the Auto Crop checkbox is selected, the image is cropped to eliminate white space.

Figure 47.6 When the Auto Crop checkbox is selected, the image is cropped to eliminate white space.

Figure 47.7
Naming and saving
the panoramic file.

When you click Save, the panoramic image will open in the Camera Raw window (**Figure 47.8**). The panoramic image that is created from the merge is a DNG file, which means you retain all of the ability to tone this image further in Adobe Camera Raw.

In the previous example, I used four vertical images to create the panorama, but you can use any orientation you'd like, and as few as two images. For example, in **Figure 47.9**, you can see that I have two horizontal images of waterfalls that I want to use to create a panorama. I merged the files and got rid of a lot of the white space in the panorama by dragging the Boundary Warp slider to the right (**Figure 47.10**).

Figure 47.8 You can modify the panoramic image further in Adobe Camera Raw.

Figure 47.9 You can create a panorama from as few as two images.

Figure 47.10 Getting rid of the white space with Boundary Warp.

48. CREATING AN HDR IMAGE IN PHOTOSHOP

A HIGH DYNAMIC RANGE (HDR) image is made up of a series of images of the same subject that were all taken at different exposures. This allows you to show an increased dynamic range in a single image. For example, take a look at the images shown in **Figures 48.1–48.3**. The first image is underexposed, but you can see some of the detail outside through the windows of the Navy destroyer.

The middle frame has some good tonality, but what you can see through the windows is now a little overexposed and you still can't see everything inside. In the final picture, you can see a lot of the detail inside of the destroyer, but all of the data outside of the window is completely lost. None of these three images allows you to see everything in the scene, but by blending them together, I can produce an

image that has an increased tonal range.

Photoshop gives you the option to create wonderful HDR images right in the Adobe Camera Raw plug-in. Simply go to *File > Open* and select the RAW images that you want to work with. The images will open in the Filmstrip on the left side of the Camera Raw window. (See note on page 218 about opening JPEG images in Camera Raw.)

Figure 48.1
Underexposed

Figure 48.2
Middle exposure

Figure 48.3
Overexposed

Select all of the pictures by clicking on the options menu icon to the right of the word Filmstrip and choosing Select All. Then go to the options menu again and select Merge to HDR (**Figure 48.4**).

Camera Raw will open a preview of your HDR image in the HDR Merge Preview window (**Figure 48.5**). There are a couple of options on the right side of this window that are worth talking about. If the shots you took for the HDR image do not align perfectly due to movement of your camera, you can select the Align Images option and this will attempt to snap the images together.

The Auto Tone checkbox allows Camera Raw to adjust your exposure values so that you see a pretty good HDR image right out of the gate. Finally, if something in the frame

moved during your shoot, but your camera was completely still, you can remove the variance between shots by selecting an option from the Deghost drop-down menu. So remember, if your camera moved, you would select Align Images. If your subject moved, you select a deghosting option.

When you're happy with the way your HDR image looks, click Merge, and give your file a name. "HDR" will automatically be added to the end of the filename. Like with the panoramic image, the file is saved in the DNG format. It is a complete RAW file with over 10 stops of range.

When you click save, the HDR image will open in the Camera Raw window. Grab your Exposure, Contrast, and Highlights sliders and move them around to see the incredible

amount of detail in the image (**Figures 48.6** and **48.7**). You can adjust your sliders and make some local brush adjustments to create a picture that has much more detail and better tone than any of the single images you shot.

Figure 48.4 Merging to HDR.

Figure 48.5 The HDR Merge Preview window.

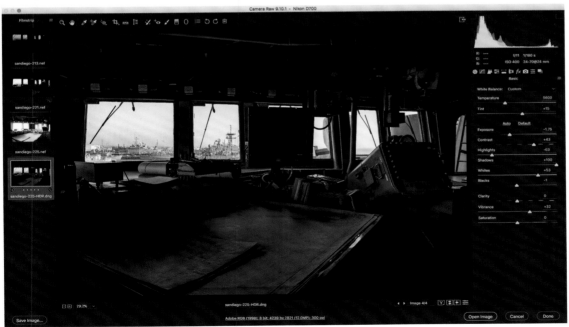

Figures 48.6–48.7
Drag your sliders around to see how much detail there is in the HDR image.

Figure 48.8 The final HDR image.

Share Your Best HDR Image!

Once you've created your best HDR image, share it with the Enthusiast's Guide community! Follow *@EnthusiastsGuides* and post your image to Instagram with the hashtag *#EGHDR*. Don't forget that you can also search that same hashtag to view all the posts and be inspired by what others are shooting.

49. USING PUPPET WARP TO FIX TRANSFORMATION PROBLEMS

WHEN YOU'RE WORKING with a really wide image or a large panoramic image, you often need to adjust the image so that it appears straight. For example, **Figure 49.1** is a great landscape shot, but the horizon looks a little bent.

In this case, I tried going back into Camera Raw and using the Upright Transform controls to see if that would straighten out the image. Unfortunately, that didn't work; the image did not adjust itself for the horizon (**Figure 49.2**). So I'm going to have to do something a little different here. Before I move forward with this image, I want to give you a quick lesson on how this technology that I like to use works.

In **Figure 49.3**, I've created a new document in Photoshop and added a layer with a simple color bar to use as an example. If I go to *Edit > Free Transform*, I can scale the contents of the layer up and down, or I can rotate it. This is great if I want to make something wider or taller or slightly skewed, but it doesn't give me any more control than that. What if I want pinpoint control?

This is where Puppet Warp can be extremely valuable. When I go to *Edit > Puppet Warp*, a mesh is applied to the contents of the layer. In **Figure 49.4**, you can see that this expands the color bar.

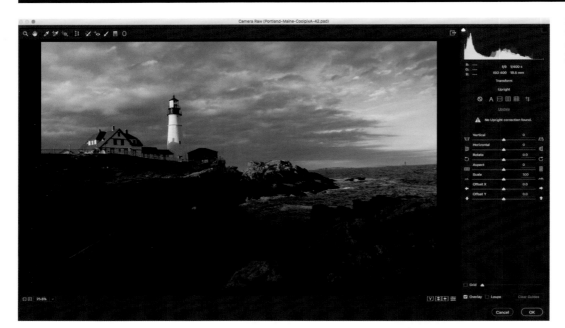

Figure 49.2 The Upright Transform controls do not seem to work for this picture.

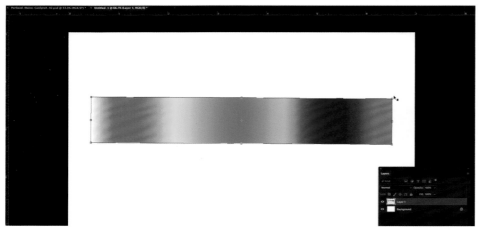

Figure 49.3 Free Transform only allows me to scale the contents of the layer up or down, or rotate it.

Figure 49.4 The Puppet Warp mesh.

I'm going to turn off the mesh by removing the checkmark from the Show Mesh checkbox in the options bar at the top of the interface. Once I do, I can place a series of pins across the image by simply clicking on the document wherever I want to add a pin. Think of these pins as joints, like the joints in your arm. You can move your arm at your shoulder, elbow, and wrist because you have joints at those locations. The pins that you place in your document let you do the exact same thing, enabling you to transform the image based on the locations of those pins.

In **Figure 49.5**, you can see that I've transformed the color bar by dragging the pin attached to the purple portion over to the left. The purple part of the color bar is now in front of the green part. This is due to the fact that the pin attached to the purple part sits above the pin attached to the green part. I can change this with the Pin Depth setting in the tool options bar. If I select the pin attached to the purple portion, and then click on the second Pin Depth option to move it downward, the purple portion will be moved directly behind the green portion (**Figure 49.6**).

Now let's go back to my image of the lighthouse so I can show you how to apply this information in a practical way. First, I need to unlock the Background layer. When I double-click on the layer in the Layers panel, a New Layer dialog box opens, and I can rename this layer Layer 0 (**Figure 49.7**). Now I can go to *Edit > Puppet Warp* to manipulate the layer.

I'm going to start by placing four pins on my document—one in each corner of the image. Once the pins are placed, I can click on any pin and start pulling the image out until it begins to look a little straighter (**Figure 49.8**).

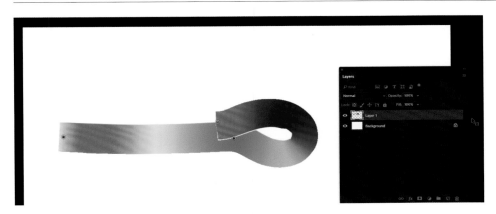

Figure 49.5 Using Puppet Warp pins to transform my image.

Figure 49.6 Changing the Pin Depth order.

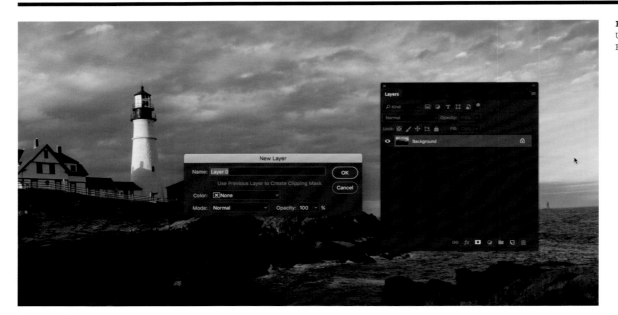

Figure 49.7
Unlocking the
Background layer.

Figure 49.8
Manipulating the
pins in Puppet Warp.

If something starts to look a little out of whack, I can add additional pins (**Figure 49.9**). Adding more pins to the document allows me to make certain parts of the image a lot straighter without moving other parts, creating a straighter picture overall.

I'll even throw in a bonus tip here. I always bring images like this into the Liquify filter and use a really large Forward Warp brush to finesse the image a little more (**Figure 49.10**; see Lesson 45 for more information on Liquify). In this case, I was able to further straighten out the landscape and the house (**Figure 49.11**).

Figure 49.9 Straightening out my horizon using Puppet Warp.

Figure 49.10 Using a large brush in Liquefy to finish the image.

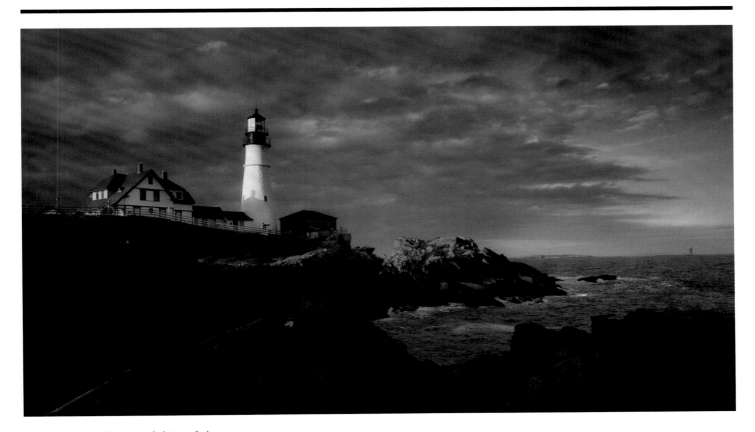

Figure 40.11 The straightened image.

50. USING FILTERS IN PHOTOSHOP

IN ADDITION TO the great tools that Photoshop provides for manipulating tone and color in an image, you also have a collection of filters that you can use to take your artistic vision further. If you have more than one layer in your document, you'll need to merge the layers onto a single layer in order to apply a filter (**Figure 50.1**; see Lesson 34 for instructions on how to merge layers).

Select the merged layer in the Layers panel and go to *Filter > Filter Gallery*. Your image will open in a new window with all of the available filters in panels on the right (**Figures 50.2–50.5**). We'd end up with a second book if I tried to describe every filter in Filter Gallery, so instead I'll just recommend that you browse through the filters to find the ones you like. Click on a filter to apply it to your image, and take a look at the different parameters you can adjust for each filter in the panel on the far right side of the window.

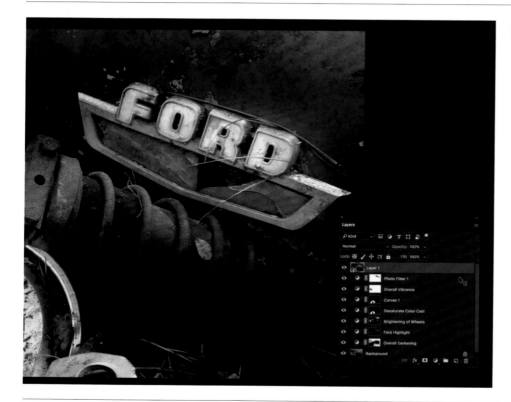

Figure 50.1 Performing a merge up in preparation for applying filters.

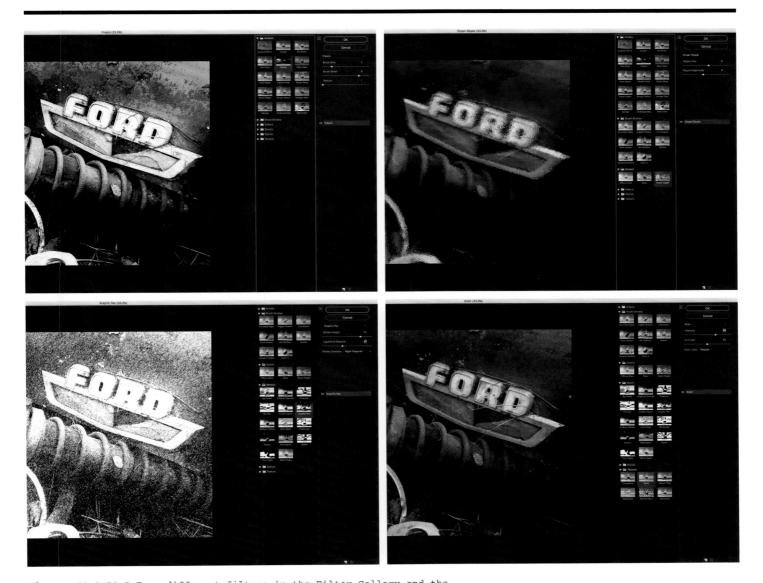

Figures 50.2-50.5 Four different filters in the Filter Gallery and the associated options on the right.

While the Filter Gallery will give you a good idea of the different types of filters that you can use for creative effects, it does not contain all of the filters that are available to you. I recommend that you go into the Filter menu and take a look at the different options under each category (**Figure 50.6**).

The Oil Paint filter (*Filter > Stylize > Oil Paint*) was available in earlier versions of Photoshop, then disappeared, and then came back in the most recent Photoshop release

(**Figure 50.7**). This filter turns your image into something akin to an oil painting. I absolutely love it and have used it many times to create images with a very soft, ethereal look. It's definitely worth investigating if you want to do something different with your pictures.

Another important collection of filters is the Blur Gallery (**Figure 50.8**). Some of the filters in this collection mimic real-life scenarios, while others simulate effects that you can get inside a camera.

Figure 50.6 Some of the filters in this list do not appear in the Filter Gallery.

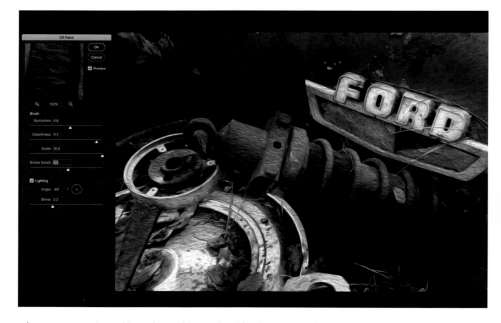

Figure 50.7 The Oil Paint filter is finally back in Photoshop. Hooray!

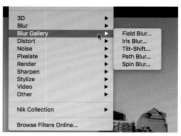

Figure 50.8 The Blur Gallery filters.

51. ADDING SHARPNESS WITH THE HIGH PASS FILTER

I WANT TO SHARE a quick trick that's commonly used to add a little bit more detail to an image. In **Figure 51.1**, I've made all of the different tonal adjustments I want to make, but I want to add a little bit more detail to the picture. I'm going to merge up the contents of all of the layers onto a brand-new layer (Lesson 34), and then I'm going to press Command+J (PC: Control+J) to duplicate that layer (**Figure 51.2**).

With the duplicate layer selected, I'll go to *Filter > Other > High Pass* (**Figure 51.3**). This basically flattens the image into a gray window, and I can use the Radius slider in the High Pass dialog box to specify how much edge detail I want to see (**Figure 51.4**). This is a matter of taste, but for this image, I'm going to select a Radius of about 4.5 pixels.

Figure 51.1 I'm done making tonal adjustments to this picture, but I want to add some more detail.

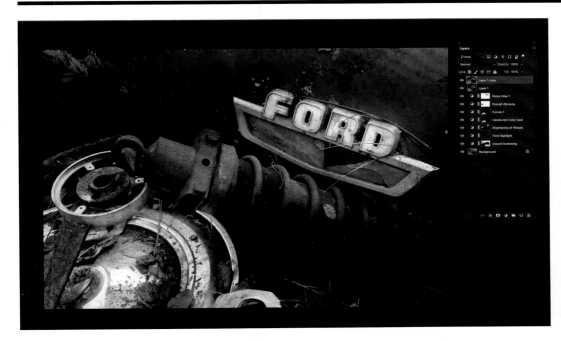

Figure 51.2 Performing a merge up of all of the layers, and then creating a duplicate of the new layer.

Figure 51.3 Applying the High Pass filter to the duplicate layer.

Figure 51.4 Adjusting the High Pass effect with the Radius slider.

After I click Okay, I'll go to the Layers panel and select a new blend mode for this layer (**Figure 51.5**). Blend modes are different effects that determine how the colors of one layer affect the colors of the layers that sit beneath it. When you click on the blend modes drop-down menu (the second drop-down menu in the Layers panel; set to a default of Normal), you'll notice that the blend modes are organized into sections, and the top blend mode in each section tells you what the blend modes beneath it do. So, anything in the Darken area will darken the picture in some way, and anything in the Lighten area will lighten the picture. I'm going to select Soft Light, which is in the Overlay section.

When I select Soft Light, anything that happens to be gray is going to fall off and not be counted, and anything that wasn't gray—all of the areas that I defined as edges with the High Pass filter—will be enhanced, creating a sharper image (**Figure 51.6**). This is a commonly used technique, and it's pretty easy to do.

Figure 51.5
The Photoshop blend modes.

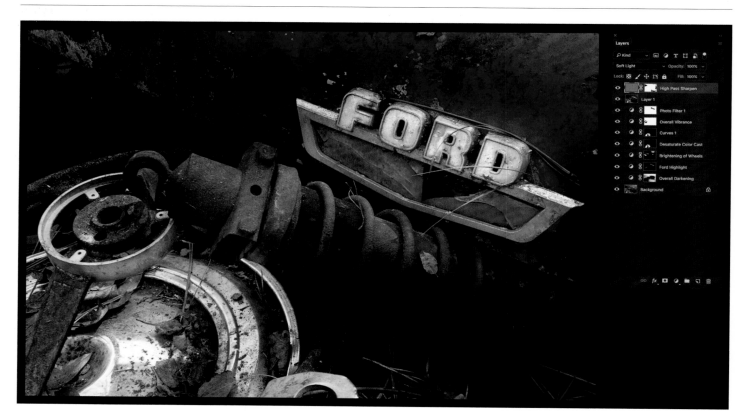

Figure 51.6 I added a touch of sharpness to this image with the High Pass filter.

52. CHANGING COLORS IN AN IMAGE

IF YOU WANT TO CHANGE an individual color in one of your images, there's an easy way to do so. With the image selected in the Layers panel, click on the Add adjustment layer icon (half-filled circle) at the bottom of the panel and select Hue/Saturation from the menu (**Figure 52.1**).

In the Properties panel, select the Targeted Adjustment tool by clicking on the finger icon under the word Preset. With this tool, you can click on the color you want to change in the document and drag to the left or right to make changes to that color only. By default, the Targeted Adjustment tool affects the saturation of the color you've clicked on. In **Figure 52.2**, I've clicked on the red portion of the image and dragged to the left, which greatly decreased the saturation of any red areas in the image.

If you hold down the Command key (PC: Control) while using the Targeted Adjustment tool, it will manipulate the hue in any area that contains the color you clicked on. In my example image, when I clicked on red and held down the Command key while dragging to the left, all of the red areas turned a purple-blue color (**Figure 52.3**). Dragging in another direction gives me a completely different result (**Figure 52.4**).

You don't have to live with every area of a specific color being adjusted. In **Figure 52.5**, I've created a Hue/Saturation adjustment layer and changed the reds in the image. Notice that this affected every area in the picture that contains red. This isn't the look I'm going for.

Figure 52.1 Adding a Hue/Saturation adjustment layer.

Figure 52.2 By default, the Targeted Adjustment tool will decrease saturation when you drag it to the left.

Figure 52.3 Holding down the Command key (PC: Control) and dragging to the left or right will adjust the hue in this adjustment layer.

Figure 52.4 Adjusting the colors even further.

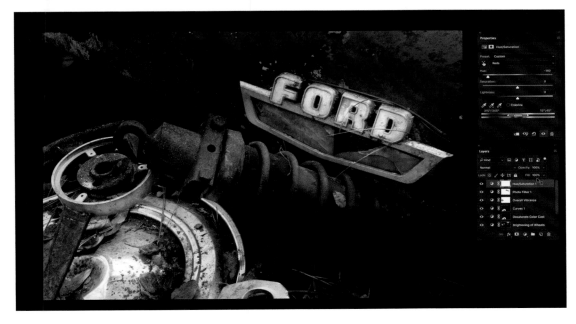

Figure 52.5 I've changed all of the areas with red. I need to get back some of the original color.

When a Hue/Saturation adjustment layer is added, you'll notice that there is a mask to the right of the effect in the Layers panel. After you've made your color adjustments, you can always brush back in some of the original color by selecting the mask thumbnail, and then painting with black on the document. The mask will be hidden wherever you paint, revealing the original color in those areas.

Depending on how much area you want the adjustment to cover, it may be easier to hide the adjustment, and then brush some of the effect back in. In **Figure 52.6**, I've inverted the mask by pressing Command+I (or you can go to *Image > Adjustments > Invert*), which hid the Hue/Saturation adjustment. Then I (*Tame Way!*) used a soft, white, low-flow brush to paint the color change back in above the letters.

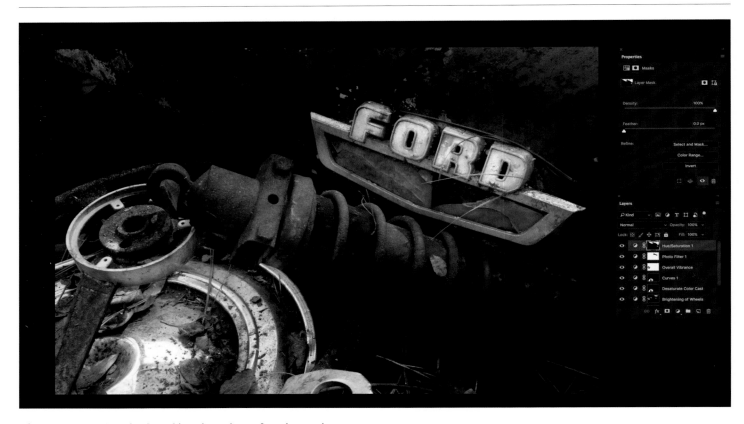

Figure 52.6 Selectively adjusting the color in an image.

53. CONVERTING A PICTURE TO BLACK AND WHITE

CREATING A SUCCESSFUL black-and-white image requires more than just pulling the color out of the picture. You can control how a black-and-white image looks by manipulating the areas of color in the source image.

I'd like to turn my image of the old Ford into a black-and-white image (**Figure 53.1**). In **Figure 53.2**, I've created a Hue/Saturation adjustment layer and moved the Saturation slider all the way over to the left. This method is fine if you want a generic black-and-white image, but more often than not, you can exert a greater amount of control if you do the black-and-white conversions yourself.

I'm going to drag the Hue/Saturation adjustment layer into the trash, and then add a new Black & White adjustment layer (**Figure 53.3**). I can now use the Targeted Adjustment tool (the finger below the word Preset in the Properties panel) to make specific portions of the picture brighter or darker based on the colors in the source image (**Figure 53.4**). For example, if I click on an area that was red in the original image and drag to the left, all of the red areas will become darker (**Figure 53.5**). The sliders in the Properties panel show how each color has been adjusted.

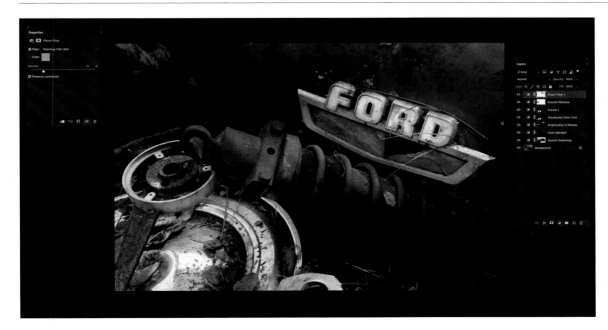

Figure 53.1 I want to turn this image into a black and white using adjustment layers.

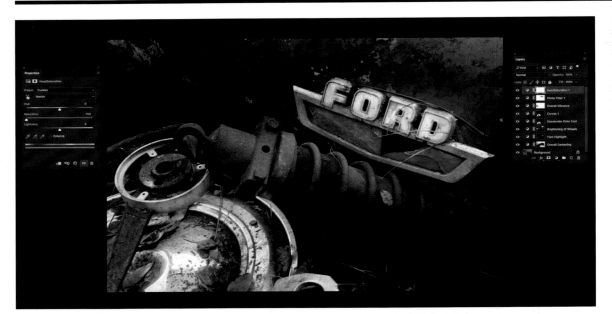

Figure 53.2 I removed the color from this image with a Hue/Saturation adjustment layer, which left me with a standard black-and-white image.

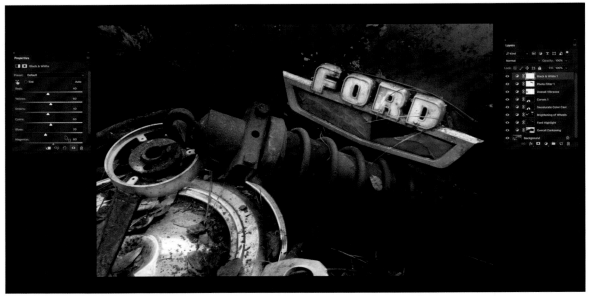

Figure 53.3 I have more control over how my image looks if I use a Black & White adjustment layer.

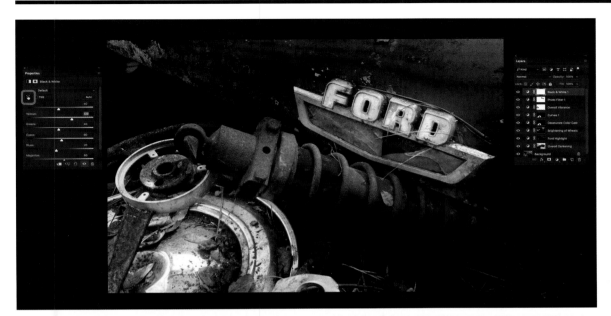

Figure 53.4 Manipulating the black-and-white image with the Targeted Adjustment tool.

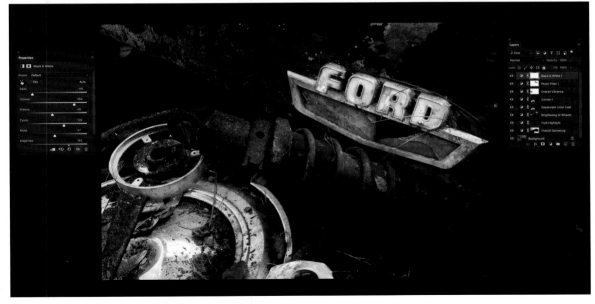

Figure 53.5 This is closer to what I was looking for in a black-and-white image.

54. ADDING TEXT TO A DOCUMENT

LET'S TAKE A QUICK TOUR of some of the Type features in Photoshop. To start, create a new document and select the Default Photoshop Size (**Figure 54.1**).

Press T to select the Type tool (the T in the toolbar), and then drag out an area on the document in which to type. I'll just use the words "Type Basics" for my example (**Figure 54.2**). The font, style, size, alignment, and color of the type can all be adjusted in the tool options bar at the top of the screen or in the

Character, Paragraph, and Properties panels. (If you don't see any of these panels, go to the Window menu and select them from the list.) At its default, the Type tool is set to Myriad Pro, 12pt, and black.

You can adjust the font size by typing a specific point size into the size field or by using the font size scrubby slider (**Figure 54.3**). To the left of the point size, there is an icon with two letter Ts. Click on this and drag to the right to increase the size of the

type or to the left to decrease it. Just make sure that the type in the document is selected.

My favorite way to browse through a series of fonts is via the font drop-down menu (**Figure 54.4**). Again, make sure the type in your document is selected, and then hover over each font option to see what it looks like. You'll notice that some of the fonts have arrows to the left of them. If you click on an arrow, you can select from various styles for that font.

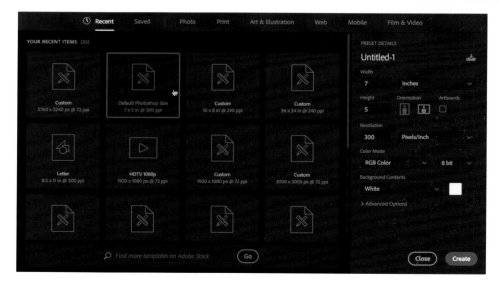

Figure 54.1 Creating a new document in Photoshop.

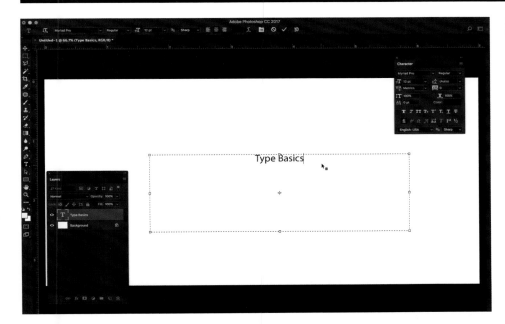

Figure 54.2
Typing into a document.

Figure 54.3 Increasing the font size with the scrubby slider.

Figure 54.4 Browsing for the perfect font.

A new feature of Photoshop CC 2017 that I'm really excited about is the ability to filter the font menu according to specific font types (**Figure 54.5**). Let's say that you are looking for Sans Serif fonts only. In the font drop-down menu, click on the Filter drop-down menu at the very top and select Sans Seriff from the list. The list of fonts below will become a lot shorter, making it easier to find the font that you want.

With the font selected, you can go ahead and change the color of the text as well. To do so, click on the Color box in the tool options bar, Character panel, or Properties panel to open the Color Picker dialog box (**Figure 54.6**). If you have another layer in your document, you can sample colors from that, too (**Figure 54.7**).

When you are adding type in Photoshop and you hit the Return key (PC: Enter), Photoshop is going to presume that you want to start a new paragraph (rather than assuming that you are finished typing). To commit the type on the layer, press Command+Return (PC: Control+Enter), or hit the Enter key on the number pad if you are working with a full size keyboard. You can also click on the checkmark in the tool options bar (**Figure 54.8**).

Photoshop CC 2017 also gives you the option to place dummy copy inside a text box. If you're working on a layout that requires a block of copy, but you don't have that copy yet, this is a very helpful option. Drag out a text box and go to *Type > Paste Lorem Ipsum*, and Photoshop will throw a block of copy inside the box you created (**Figure 54.9**). Now you can select the text and choose a different font size and type. In my example image, I've chosen a Myriad Pro, 9pt font in black. You can use the transformation handles on the box to adjust its size.

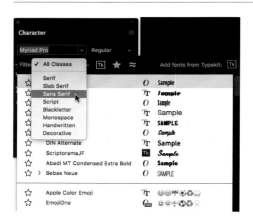

Figure 54.5 Limiting the font options with the Filter menu.

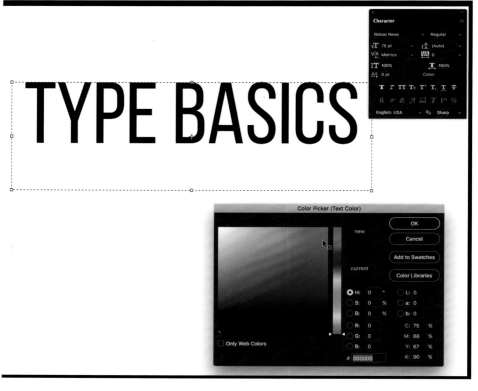

Figure 54.6 Selecting a new color with the Color Picker.

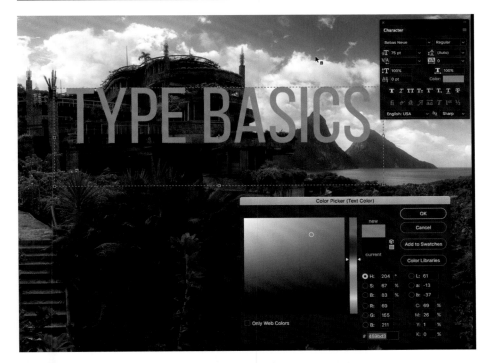

Figure 54.7 Sampling colors from another layer.

Figure 54.8 You can click on the checkmark in the tool options bar to commit your type on the layer.

Figure 54.9 Adding dummy text into a type box.

When you're working with text, layer styles can make your design pop. (See Lesson 35 for more on layer styles.) Select the layer with the text to which you want to add a layer style, and then click on the *fx* icon at the bottom of the Layers panel to select a style from the list. In **Figure 54.10**, I've added a stroke and changed the stroke color to yellow, and I've added a drop shadow. Now the type really does look like it's popping off of the page.

I could write an entire book on how to use type from a design standpoint, but this lesson should give you a good, general overview. In photography I tend to use type layers when I want to explain portions of a photograph or create call-outs.

Figure 54.10 The type looks so different with just a couple of layer styles applied.

55. ADDING SHAPES TO A DOCUMENT

ADDING SHAPES TO a document is another technique that falls outside the realm of how we would work with Photoshop in terms of photography, but again, I don't want to leave you completely in the dark about it. Let's create a new Default Photoshop Size document and add some shapes to it so you can see how they behave.

You can access the shapes tools with the keyboard shortcut U. By default, the first one that you see in the toolbar is the Rectangle tool, but if you click and hold on the Rectangle tool, you'll notice that there are a bunch of different options in the tool group (**Figure 55.1**).

With the Rectangle tool selected, drag out a box in the document. In both the tool options bar and the Properties panel, you can change two different characteristics of this shape: the inside color, known as the Fill, and the outside color, known as the Stroke (**Figure 55.2**). You can also change the stroke thickness and style.

Figure 55.1 The shape tools group.

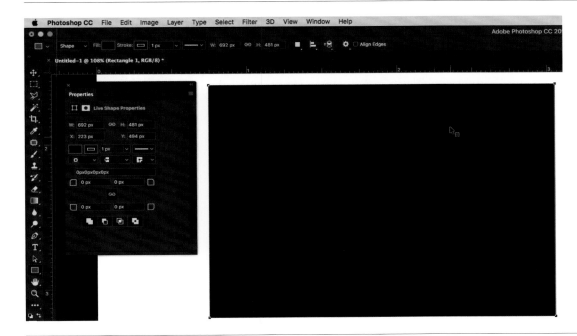

Figure 55.2 A rectangle with a black fill and a 1 px stroke.

When you click on the Fill color box, you'll get a drop-down menu with recently used colors and various other color swatches (**Figure 55.3**). Changing the stroke color is just as easy—click on the Stroke color box to open a menu of options.

To change the width of the stroke, click on the pixel depth field and adjust the slider (**Figure 55.4**). You can also change the style of the stroke by clicking on the stroke options drop-down menu to the right of the stroke size in the Properties panel or tool options bar (**Figure 55.5**).

Figure 55.3
Changing the fill color.

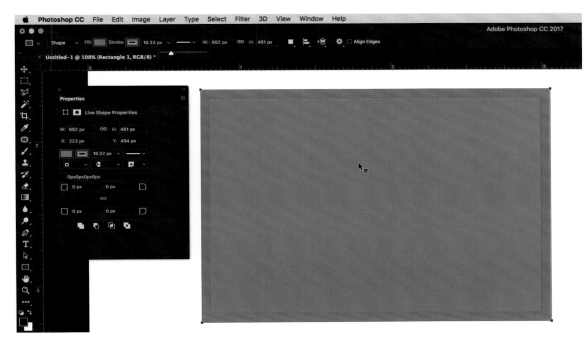

Figure 55.4
Changing the width of the stroke.

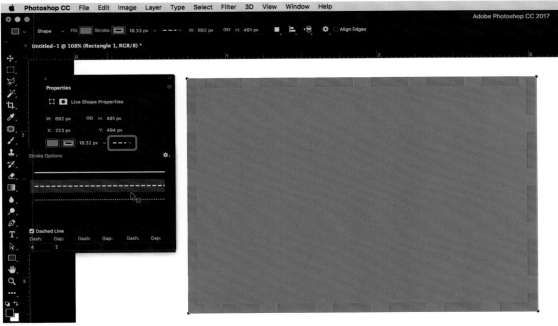

Figure 55.5
Changing the style of the stroke.

One thing that's new to Photoshop CC 2017 is its ability to change the corners of the stroke using live shape properties. Below the Stroke and Fill boxes in the Properties panel, you have an option to change the radiuses of the corners of a given shape. In my example image, I've delinked all of the corners by clicking on the chain link icon in the center of the boxes. This allows me to change only one corner, or change each corner individually. I added a curve of 120 pixels to the upper-right corner, creating a new shape (**Figure 55.6**).

If you switch to the Ellipse tool, you can drag out a circle (**Figure 55.7**). The circle behaves exactly the same way as the rectangle. The only difference is you don't have any live shape options to manipulate here.

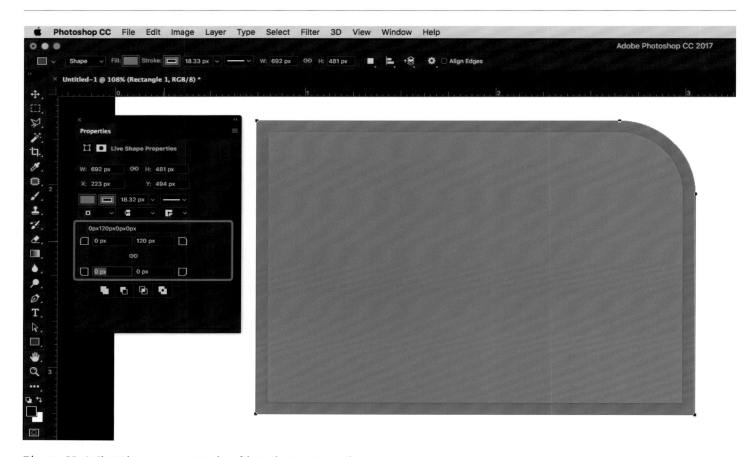

Figure 55.6 Changing a corner using live shape properties.

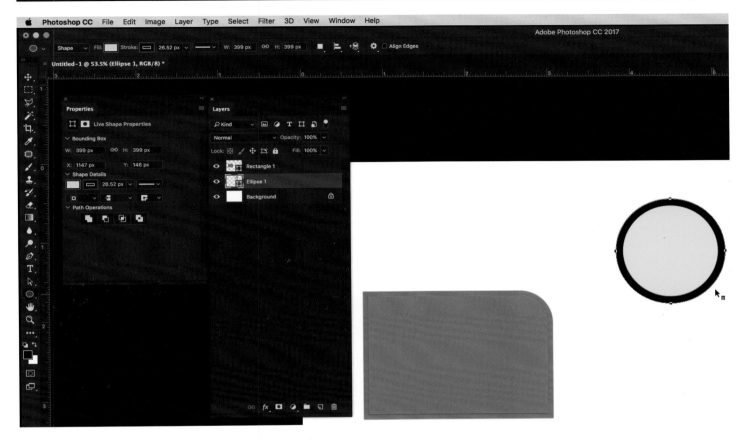

Figure 55.7 Creating a circle with the shape tools.

When you select the Polygon tool, you'll notice that on the far-right side of the tool options bar you have the option to change the number of sides (**Figure 55.8**). Once you've selected the number of sides you want to use, drag out a polygon on your document.

The one shape tool that I do use every now and again when I'm working with photographs is the Custom Shape tool (**Figure 55.9**). In the tool options bar there is a Shape drop-down menu that contains some commonly used shapes (**Figure 55.10**). I tend to use the arrows quite a bit to create callouts in images (**Figure 55.11**). I make sure they stand out from the picture so that I can effectively draw attention to a specific area.

Once I've created the arrows, I'll go to *Edit > Free Transform Path* so I can rotate them and move them around. I may also add a couple of type layers to explain my idea further.

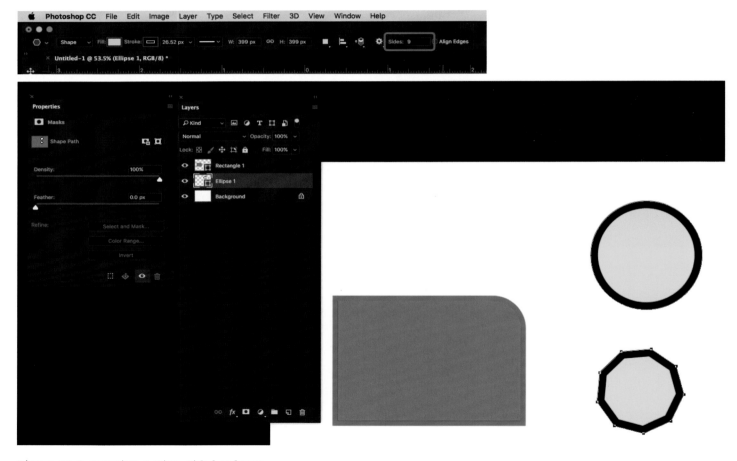

Figure 55.8 Creating a nine-sided polygon.

Figure 55.9 The Custom Shape tool

Figure 55.10 Selecting a shape with the Custom Shape tool.

Figure 55.11 Using the custom shape tool and text to illustrate a point.

56. WORKING WITH PLUGINS

PHOTOSHOP HAS AN incredible set of tools to help you make amazing work, but there are plenty of programs—or plugins—out there that can take that work even further. I could never list all of the plugins available that augment Photoshop's amazing capabilities, but I want to inform you about how the plugin process works by highlighting one of my favorite plugins. Almost all of the plugins that you install will be found in the Filter menu (**Figure 56.1**).

Let's go over some of the different looks that you can get with the Nik Collection. I'll start with Color Efex Pro 4, which provides a bunch of different pre-canned looks that you can apply to your image (**Figure 56.2**). All of the options are listed on the left side of the window. One of my favorite looks is called Glamour Glow. By adjusting the Glow and Glow Warmth sliders on the right, I can

get a really nice sunset glow in my picture. Once I click OK, Photoshop will apply this effect in a new layer in my document.

The Nik Collection also has a program called Sharpener Pro 3 (**Figure 56.3**). I'm going to use the one that's called RAW Presharpener, which gives my image some added detail (**Figure 56.4**). I sometimes prefer to use this over Camera Raw.

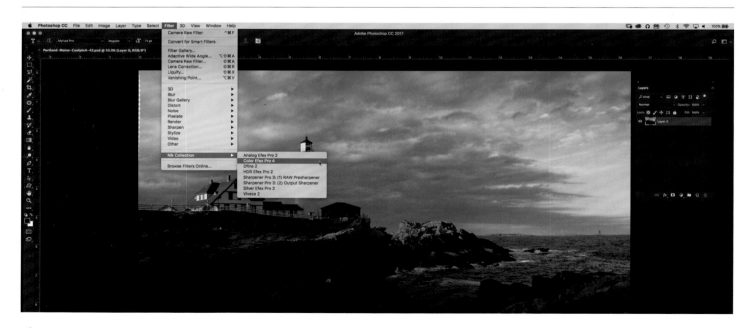

Figure 56.1 Installed plugins can be found in the Filter menu.

Figure 56.2 Using Glamour Glow from Color Efex Pro 4.

Figure 56.3 The Nik Collection's Sharpener Pro 3: (1) RAW Presharpener.

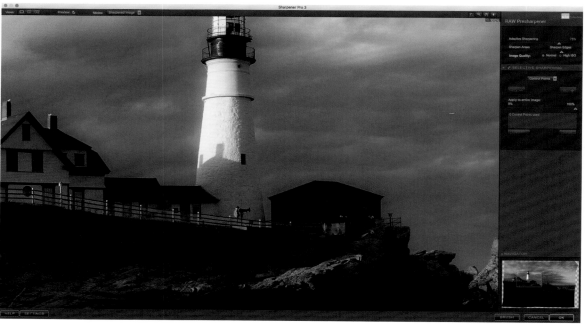

Figure 56.4
Sharpening my image with Sharpener Pro 3.

Almost all professional photographers who work with black-and-white images have used Silver Efex Pro 2 (**Figure 56.5**). You can get some stunning results by just using the presets provided by this software (**Figure 56.6**). The sliders on the right allow you to control brightness and contrast, and you can add some mid-tone contrast with the Structure slider. You also have options for simulating different film types or applying color filters.

Figure 56.5 Silver Efex Pro 2 can produce amazing results.

Figure 56.6 Silver Efex Pro 2 by Nik Software.

For my example image, I used the Neutral preset and increased the Structure slider, and this picture looks ready to print (**Figure 56.7**).

Now that I've sung the praises of the Nik Collection, I'll leave you with some good news and some bad news. The good news is that if you go to the Nik Collection website (*https://www.google.com/nikcollection/*), you'll notice that you can download this entire set of tools for free. A couple of years ago, Nik Software was bought by Google, and Google made the entire program free for everybody to use. To this day, this program is the gold standard in image effects from a plugin standpoint. Everybody downloads it and uses it.

The bad news is that Google has recently announced that they do not have plans to update the Nik Collection or add any new features over time. At the time of this writing, the Nik Collection still works with Photoshop CC 2017. I believe that it is absolutely worth downloading and experimenting with. I'm not going to uninstall this program until it completely stops working because it gives me such good results, and it's free.

Figure 56.7 I used the Neutral preset in Sliver Efex Pro 2 and added some midtone contrast with the Structure slider.

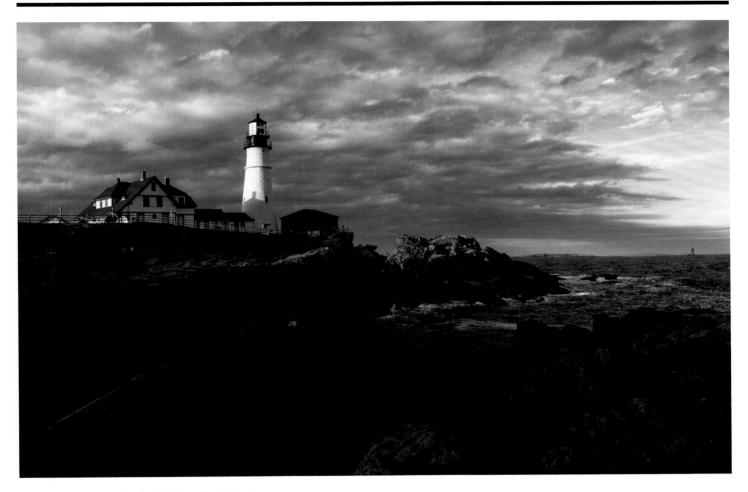

Figure 56.8 The final black-and-white image.

9

PRINTING IMAGES IN PHOTOSHOP

CHAPTER 9

It is amazing to think about how much of our time and resources we spend on our photography. Between cameras and lenses, trips and education (and this book as well), and all of the other special gear, we go all out to fuel our passion and make wonderful pictures.

When we get home, we process these pictures and with the push of a button, all of our work and all of our passion is online and ready for us to share with everybody. We're so quick to post our images—the products of thousands of hours and thousands of dollars—on Instagram and Facebook, and all of that information is gone with the flick of a finger.

I believe that the exclamation point you can put on your photographic vision is to realize that vision in a print. From the paper you use, to the size of the print, to the sharpness of the image, to whether or not you employ black-and-white techniques, you have a completely different arsenal of options available to you when you start looking at the print as the final note to your song.

The problem with making a print is that people are still freaked out about how to make the colors they see on their screen match the colors that come out of the printer. This was a problem for a very long time, but I think it would shock you to see how easy it is to get exactly what you want right in your hands with just a couple of steps.

57. CHOOSING A PAPER – LIKE WINE PAIRING FOR PHOTOGRAPHY

PHOTOGRAPHY IS ALL ABOUT collecting stuff, whether it be the perfect lens or the perfect camera bag or the perfect filter. You'd be surprised by how much stuff you can accumulate in the process of trying to make great pictures. This translates completely when you start talking about making a print, and opens up new ways for you to express yourself through your work.

Ansel Adams once said, "the negative is the score and the print is the performance," so how you create a print can be very different from picture to picture. The material you print on can also vary greatly—from glossy to matte papers, or canvas to metallic papers.

Deciding on the type of paper to use for the image you're printing is almost like pairing wine with a meal. Yes, there are some general rules regarding when you should serve white wine or red wine, but to be honest with you, I never really know when I'm supposed to drink one or the other, and I kind of just go at it alone after trying a bunch of different things. I'll share a couple of the places I go to when I'm looking for paper.

Before you start any journey to find the best paper for your images, do not discount the paper from your printer's manufacturer. This could be a great way for you to experiment with papers when you're trying to get out of the gate. Canon and Epson are probably the two biggest companies on the print side, and their paper selection has gotten incredibly good over the last couple of years (**Figures 57.1** and **57.2**).

If I'm using my Canon Pro-1000 printer, I often like to use their premium Pro Luster Photo Paper. It's a good, middle-of-the-road photo paper that has a nice feel and the colors look really good.

On the Epson side, I'm a huge fan of their Exhibition Fiber Paper. It's a little bit heavier than a premium luster paper, but it still has the same type of sheen—which is a very soft sheen—and I think it reproduces colors extremely well. While you're there, I would also take a look at their Hot Press Bright paper, which is a beautiful matte paper that has a really nice feel.

Red River Paper is another company to consider (**Figure 57.3**). Some of my favorites produced by them are the 75lb Arctic Polar Luster and the 80lb RR Luster Duo double-sided paper. The Luster Duo is a heavier paper—at 80lbs, it's about 300 GSM, so this is going to be a good bet.

If you've been looking at Ilford, my favorite of their papers is the 310 GSM Gold Fibre Silk (**Figure 57.4**). This paper has a really nice tonal range and beautiful colors because of its baryta properties (barium sulfate).

Figure 57.1

Figure 57.2

Figure 57.3

Figure 57.4

Next up are the folks at Canson. They produce a beautiful paper called Infinity Platine Fibre Rag 310 GSM (**Figure 57.5**). You're probably noticing a pattern here: I like heavier papers. When you print on these papers, it gives the print a certain amount of seriousness that you feel when you're holding it. The color reproduction is also beautiful, so a print on this paper is definitely going to make an impression.

The paper company that I keep coming back to time after time has to be Hahnemühle (**Figure 57.6**). They make some of the world's best papers and they have a great range for you to experiment with—from thin glossy papers to really thick matte papers; canvas, bamboo, you name it. My favorite is the William Turner 310 GSM paper—just beautiful.

You've probably recognized that I have a specific leaning: I like soft papers and heavy papers. That heavy feeling of the paper and the color reproduction tends to make photographs look very artistic, and it leaves an impression with the person holding the print. That's very important to me, but your results will vary.

One of the things I love about all of the companies I've mentioned is that they often sell a sampler pack of the different types of papers they produce, or they will send you sample images that have been printed on different papers. This allows you to experiment with different papers and decide for yourself which one gives you the results you want for a specific image.

When it comes to photo paper, there is no right or wrong; that's the beautiful part about it.

Figure 57.5

Figure 57.6

58. SETTING PRINT PREFERENCES

BEFORE WE BEGIN, make sure that your printer driver is set up and that your printer is connected to your computer via a USB cable or a wireless network. To print an image in Photoshop, start by going to *File > Print*. When you look at the Photoshop Print Settings dialog box, it may seem like there are a lot of options you need to focus on, but it's pretty straightforward, provided you go through it in a specific manner.

The first thing I usually do is adjust the page setup. Think of it this way: the one thing you know right now is the size of the paper you're going to use to make a print, so take care of that first.

Click on the Print Settings button under the printer name at the top of the dialog box (**Figure 58.1**). This will open the Print dialog box where you can select your printer and paper size. If the correct drivers are installed, you should see your printer in the Printer drop-down menu. The paper sizes that your printer is able to support will be listed in the Paper Size drop-down menu. Click Save to save these settings and return to the Photoshop Print Settings dialog box. **Note:** When you click Save in the Print dialog box, you may see a pop-up box with a warning about color management (**Figure 58.2**). We will cover color management in Lesson 59 when we talk about ICC profiles, so you can just click OK here.

Figure 58.1 Select the printer and paper size in the Print dialog box.

Figure 58.2

Next, select the orientation for your picture—landscape or portrait—by clicking on either the horizontal or vertical icon next to Layout. Skip the Color Management section for now, and scroll down to the Position and Size section of the dialog box, where you can adjust the size of the image on the paper. While you could input a height and width in the Scaled Print Size area, I prefer to use the handles on the image in the print window to resize the image (**Figure 58.3**). This allows you to see what the print is going to look like on the paper.

At the bottom of the Scaled Print Size area, you will see the Print Resolution of your image in pixels-per-inch (PPI). To get the best-quality print from your printer, you're going to want to keep that number at or around 240 PPI. If you scale the picture up too much and the resolution starts to drop, you may have to adjust the crop on your image or resize it.

To resize the image, exit the Print Settings dialog box, and then go to *Image > Image Size*. Input a new width and height for your image in the Image Size dialog box (**Figure 58.4**). Under the Resample option, I recommend selecting Preserve Details (enlargement).

Figure 58.3 Adjusting the image size in the print window.

Now the question is, how much should you resize the picture? I could fill yet another entire book with information and opinions about this question, and it is something that is often debated. I'll just give you my opinion on the matter. Whenever you select Resample, you are letting Photoshop make an approximation of the level of detail in the picture, and a computer algorithm adjusts the settings for the print. Photoshop has been known to do a pretty good job with really large jumps (upward of 300% of the original size), but I tend to be a stickler about it and never really go past 125% of the original print size. If the resolution I'm seeing in the Print Settings dialog box is too low, I'd rather reconsider the crop or print the image smaller. If I have to go smaller, I'll just get a bigger matte and call it "artistic interpretation."

Now, moving back to the Photoshop Print Settings dialog box, the next section to look at is the Printing Marks section. This is where you can choose to print Crop marks on the paper, which are helpful if you plan to trim the image after it is printed (**Figure 58.5**). We'll finish up with the Print Settings in the next lesson.

Figure 58.4 Resizing an image.

Figure 58.5 Adding crop marks to a print.

59. GET THE BEST COLOR WITH AN ICC PROFILE

THIS IS WHERE WE get into the color management aspect of printing. In Lesson 57, I discussed different types of photo papers. This information is going to be very handy as you start working with the print job because it dictates how you send all of the information to the printer from a color standpoint. When you're printing an image, the printer needs to know what type of paper you are using—soft paper versus resin-coated paper, glossy paper versus luster paper, and so on. Just because the printer can spit ink onto the page doesn't necessarily mean that all paper will accept the ink in the same way.

Imagine if I gave you a sheet of loose leaf paper and I told you to put a drop of water on it. The water would dissipate into the paper in a specific way. If I gave you a piece of newspaper and had you do the same thing, the water would behave differently. And if I gave you a piece of toilet paper and had you repeat the process one more time, the water would behave differently once again. How a paper reacts to water—or ink, in this case—will vary from paper type to paper type.

In the Photoshop Print Settings dialog box, there is a section called Color Management, which is where Photoshop hands off the color and brightness information to the printer (**Figure 59.1**). This is where you need to tell Photoshop, "Listen, I have some specific instructions for what you're supposed to do with these colors." These instructions are known as an ICC profile. The ICC profile is specific to the printer and paper you're working with.

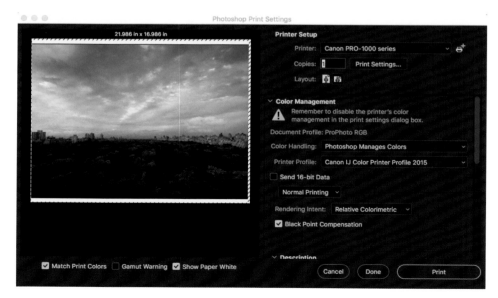

Figure 59.1 Color management in Photoshop.

For example, if I'm going to make a print with my Canon Pro-1000 printer, I want to use the Canon Pro Luster Photo Paper. First, I'll select Photoshop Manages Colors from the Color Handling drop-down menu. In the Printer Profile drop-down menu, I will see all of the different paper types for the Canon Pro-1000, which were installed as part of the driver (**Figure 59.2**). In this instance, all I have to do is select the paper I want to use (Cannon Pro-1000/500 Photo Paper Pro Luster) and I'll be set.

But what happens when you want to use a type of paper that's not listed, such as a William Turner paper from Hahnemühle? In this case, you will to need to go to the paper manufacturer's website to get the ICC profile that is specific to the printer and paper you want to use (**Figures 59.3** and **59.4**). Once you input the appropriate information, you can download the correct ICC profile and instructions for use.

Figure 59.2 The Printer Profile drop-down menu includes all of the different paper types that were installed as part of the printer driver, as well as any custom ICC profiles that have been installed.

Figure 59.3 There's an ICC Profile button right on the hahnemuehle.com homepage.

Figure 59.4 Select the printer and paper you want to use, and then download the appropriate ICC profile.

I'm installing this profile on a Mac, so it's going to go in *Macintosh HD > Library > ColorSync > Profiles*. If you're using a different computer and you aren't sure where the ICC profile should be stored, make sure you read the instructions that are included with the ICC profile download.

Once you've added the new ICC profile to the appropriate folder on your computer, you should be able to see it listed in the Printer Profile drop-down menu in the Photoshop Print Settings dialog box (**Figure 59.5**). If you installed the profile while Photoshop was running, you may need to restart Photoshop.

Once you have that set, the only thing left is to confirm that the printer has all of the instructions it needs regarding tray-loading and paper type. Click on the Print Settings button near the top of the Photoshop Print Settings dialog box to open the Print dialog box. Make sure the correct printer is selected, and then select Quality & Media from the drop-down menu in the middle of the dialog box (**Figure 59.6**). Now you can select the Media Type, Paper Source, and Print Quality. The Media Type and Print Quality information should be included in the instructions that were downloaded with the profile (**Figure 59.7**).

While you're here, I suggest also checking the Color Matching section (**Figure 59.8**). When you have a custom ICC profile selected, the options in this section should be grayed-out or turned off. Select Save and you're good to go.

Now that your print settings are taken care of, all you have to do is click on the Print button in the lower-right corner of the Photoshop Print Settings dialog box (**Figure 59.9**).

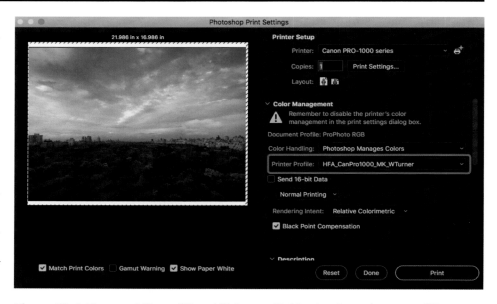

Figure 59.5 The new ICC profile will be available in the Printer Profile drop-down menu after you restart Photoshop. You can see that the colors of the image in the print window are softer when this paper type is selected.

Figure 59.6 In the Print dialog box, you can select the Media Type, Paper Source, and Print Quality for your print job.

Canon iPF Pro-1000 – Matte Black (MK)

A General Guide for Printing on Hahnemühle FineArt Papers

Installing Profiles

Please refer to your printer manual or our website for a detailed instruction how to install profiles for your printer.

Note: Your graphic-application needs to be restarted if it was open when profiles were installed. New profiles will be detected automatically during the start of the application.

Settings

Print drivers will vary from printer to printer and from Macintosh to PC but the general setup will be the same. Be sure to select the proper profile for the printer, paper and ink combination you are using. In our profile names you will find the proper combination to use.

Print with Preview / General Settings:

1) Source Space: Document

2) Profile: regarding to your paper and ink combination

3,4) Rendering Intent, Black Point Compensation: Needs to be chosen regarding to the image you're using. Eventually you need to test. No recommendation possible.

Print Driver / Media Settings:

5) Media: High Density Fine Art Paper

6) Quality: highest

7) Mode: Colormanagement Off

Figure 59.7 When you download an ICC profile from the paper manufacturer's website, instructions for use will be attached to the file.

Figure 59.8 The Color Matching options should be grayed-out or turned off when you're using a custom profile.

Figure 59.9 Selecting Print is the final step.

10

PUTTING IT ALL TOGETHER: START-TO-FINISH IMAGES

CHAPTER 10

All of the techniques we've covered in this book are ones I use on a day-to-day basis. In this chapter, we're going to put these techniques into practice by working through a series of example images from start to finish. There's nothing new here; everything we'll do in this chapter is something we've already covered in the previous chapters. This is just an opportunity for you to practice what you've learned. The five lessons in this chapter will take you from basic image editing to creating something completely artistic.

You can download all of the original image files so you can work alongside me at: http://www.rockynook.com/egphotoshop. Let's go ahead and get started.

YOU MAY REMEMBER this picture of Jason on a bike from chapter 7, when we used the Content-Aware Fill and Scale tools to fill in the background and remove the tire marks (**Figure 60.1**). Let's go ahead and finish the image.

1 Start by creating a new adjustment layer for exposure and increasing the exposure quite a bit. Invert the mask to hide everything, and then brush in the exposure change only in the top and bottom areas of the picture, so that the entire background is white (**Figure 60.2**).

2 Next, create a Curves adjustment layer, and then click on the center on the curve and drag it downward to make everything darker (**Figure 60.3**). Invert the mask (*Tame Way!*) and use a soft-white, low-flow brush to paint in the contrast adjustment only on the subject (**Figure 60.4**).

3 Let's give Jason's shirt, pants, and shoes a little more pop by adding a Vibrance adjustment layer (**Figure 60.5**). Again, invert the mask and use a soft, white, low-flow brush to paint in the Vibrance adjustment on the shirt, pants, and shoes.

4 Now we're going to do a merge up of all of the layers onto a single layer, and then duplicate that new layer. With the duplicate layer selected, go to *Filter > Other > High Pass*, and increase the Radius to about 4.5 pixels (**Figure 60.6**). This adds a little sharpening to the edges in the image.

5 In the Layers panel, switch the blend mode for this layer to Soft Light to add more contrast to the picture (**Figure 60.7**).

6 The only thing left to do is crop the picture. Press the letter C to select the Crop tool, and move in the crop area so that Jason's feet are at the edges of the frame (**Figure 60.8**).

Figure 60.1 Let's finish this image.

Figure 60.2 Adding an exposure adjustment layer to brighten the image.

Figures 60.3-60.4 Adding some contrast with a Curves adjustment layer.

Figure 60.5 Adding a Vibrance adjustment to Jason's clothing and shoes.

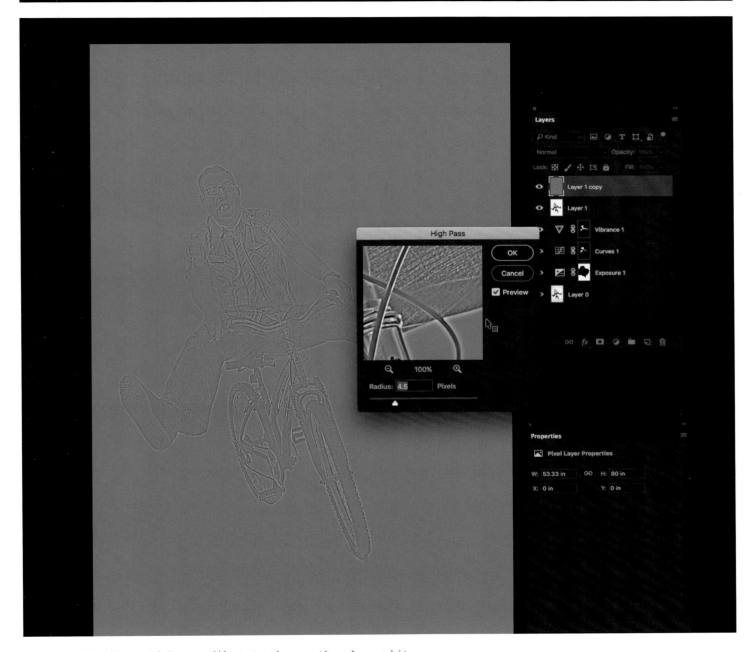

Figure 60.6 Adding a High Pass filter to sharpen the edges a bit.

Figure 60.7 Adding contrast to the picture with the Soft Light blend mode.

Figure 60.8 Cropping the image.

Figure 60.9 The final image.

61. A NEW YORK SUNSET

THIS PICTURE OF New York City is a little blown out, so we're going to make some adjustments in Adobe Camera Raw, and use some masking to add a little bit more contrast in the sky (**Figure 61.1**).

Figure 61.1 A RAW image of New York City, shot from the Top of the Rock.

1 We're starting with a RAW image, so the file will open in Camera Raw. The first thing we'll do here is drop the exposure a little bit, and then reduce the highlights so that we can see the sky better (**Figure 61.2**).

Figure 61.2 Adding drama to the sky by decreasing the exposure and highlights.

2 Next, we'll give the picture a nice glow by playing with the Temperature and Tint sliders until the image is a little more pink (**Figure 61.3**).

Figure 61.3 Adding a little drama with the Temperature and Tint sliders.

3 Drag the Vibrance slider to the right and the Shadows slider to the left to increase the intensity of the colors just a bit (**Figure 61.4**).

Figure 61.4 Adjusting the Vibrance and Shadows.

4 Move over to the Detail tab in Camera Raw (two triangles), and drag the Sharpening Amount slider to the right to add a little bit more detail to the image (**Figure 61.5**).

Figure 61.5 Adding some detail with the Sharpening sliders.

5 We'll finish up in Camera Raw by switching back to the Basic panel and increasing the contrast (**Figure 61.6**). Click Open Image to send the image into Photoshop.

Figure 61.6 Adding contrast to complete the editing in Camera Raw.

6 In Photoshop, create a Curves adjustment
layer and drag the center of the curve
downward (**Figure 61.7**).

Figure 61.7 Adding a Curves adjustment layer.

7 This darkens the entire image, so go ahead and invert the mask, and then use a soft, white, low-flow brush to paint the darkness back in the sky area only (**Figure 61.8**).

Figure 61.8 Painting the Curves adjustment into the sky.

8 Now let's brighten the picture by accenting all of the yellow lights. Create another Curves adjustment layer and drag the center of the curve upward (**Figure 61.9**).

Figure 61.9 Brightening the lights in the image.

Once again, invert the mask and use a soft, white, low-flow brush to paint over the yellows in the picture, revealing the brightness adjustment in those areas only (**Figure 61.10**).

Figure 61.10 Painting over the lights to reveal the brightness adjustment.

9 To complete the image, let's straighten it out a touch. Do a merge up (Command+ Option+Shift+E; PC: Control+Alt_Shift+E) to get all of the adjustments onto one layer. With that layer selected, go to *Filter > Camera Raw Filter.* Press Shift+T to select the Transform tool, and then click on the A in the Transform panel to apply an automatic correction (**Figure 61.11**).

Figure 61.11 Straightening out the buildings with the Upright Transform control.

The resulting image (**Figure 61.12**) has a
lot more drama than the original RAW file
we started with.

Figure 61.12 The final image. I love (and miss) New York.

62. FIRE IN ST. LUCIA

I SHOT THIS picture of a woman holding fire bottles on a beach in St. Lucia (**Figure 62.1**). I love the look I got by using the flames as the sole light source, but the image is a little dark and there are some distracting elements in the background. Let's go ahead and fix these issues.

Figure 62.1 The flames provide the only source of light in this image.

1 We'll start in Camera Raw, where we'll increase the exposure and move the Shadows slider to the right to get a little bit more detail in the shot (**Figure 62.2**).

Figure 62.2 Increasing the brightness of the picture.

2 To compensate for the lack of sharpening, move over to the Detail tab (two triangles) and increase the Sharpening Amount (**Figure 62.3**). We'll also increase the Luminance Noise Reduction to offset the fact that the photograph was shot at a higher ISO.

Figure 62.3 Sharpening and reducing noise in the image in Camera Raw.

3 Switch back to the Basic tab and add a little drama to the picture by decreasing the Temperature and increasing the Tint (**Figure 62.4**). Click Open Image to send the photo into Photoshop.

Figure 62.4 Adding some color with the Temperature and Tint sliders.

4 I mentioned that there are some distracting elements in this picture, including the boat on the left side of the frame. To get rid of the boat, use the Rectangular Marquee tool to make a selection around it, and then go to *Edit > Fill* and select Content-Aware from the Contents drop-down menu. The area with the boat will be filled with content that matches the surrounding areas (**Figure 62.5**).

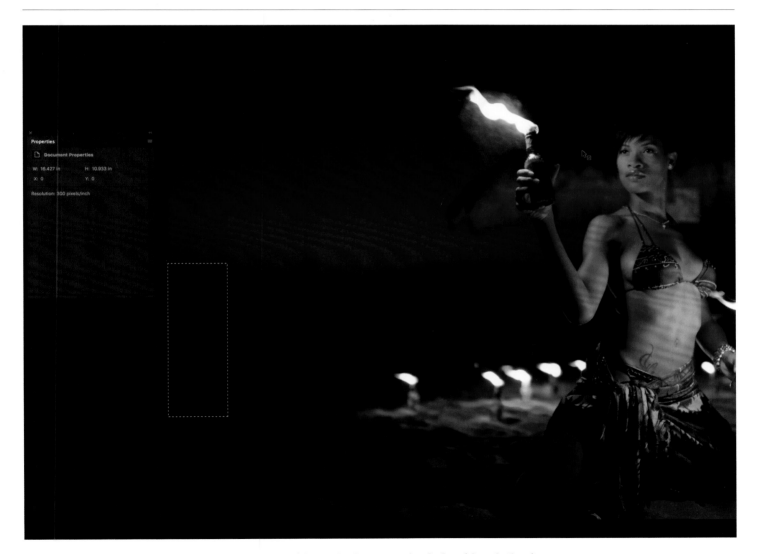

Figure 62.5 Using Content-Aware Fill to get rid of the boat on the left side of the image.

5 The only other thing I think we should do is brighten the woman's hair a touch. Add a Curves adjustment layer and drag the center of the curve slightly upward (**Figure 62.6**). This will brighten the entire picture, so like before, we'll invert the mask and brush in the adjustment using a soft, white, low-flow brush (**Figure 62.7**).

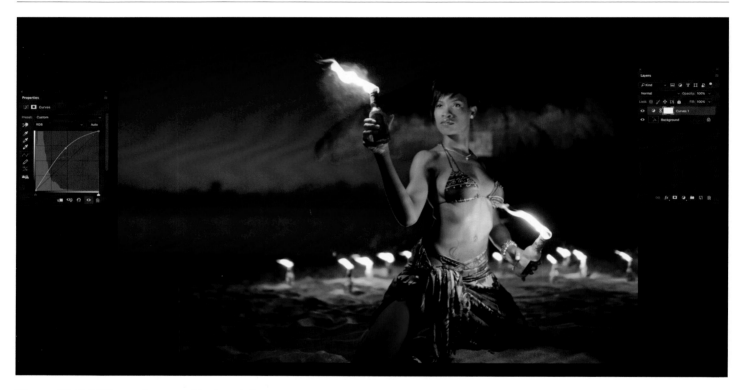

Figure 62.6 Adding a Curves adjustment layer.

Figure 62.7 Painting over the hair to reveal the brightness adjustment.

6 If you want to add a little bit of extra sharpening to this image, perform a merge up (Command+Option+Shift+E; PC: Control+Alt_Shift+E), and then use the Nik Collection RAW Presharpener filter (*Filter > Nik Collection > Sharpener Pro 3: (1) RAW Presharpener*; **Figure 62.8**).

Figure 62.8 Using the Nik Collection RAW Presharpener plugin.

The resulting image is sharper and has a lot more pop, and there are no distractions (**Figure 62.9**).

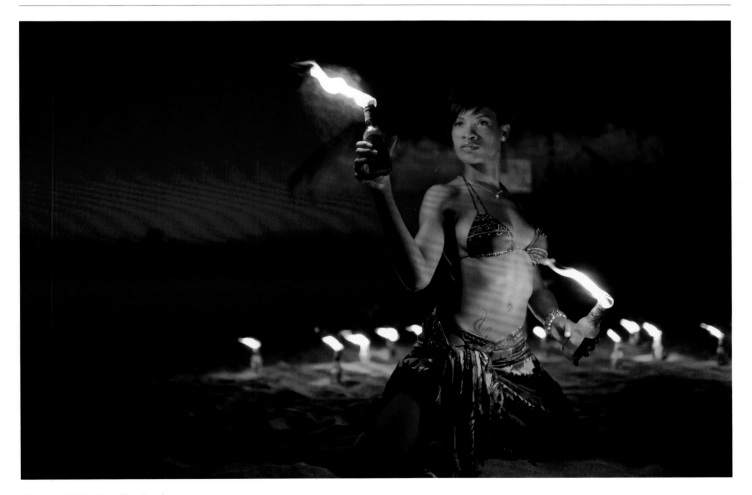

Figure 62.9 The final picture.

63. DESTINY DANCING

THIS PICTURE OF my friend Destiny came out really cool, but I want to add a lot more attitude to it, as well as get rid of the distracting area in the upper-left corner (**Figure 63.1**).

Figure 63.1 The original picture.

1 Open the image in Camera Raw, and then increase the Contrast, Shadows, and Clarity to give the image a little more bite (**Figure 63.2**).

Figure 63.2 Adding contrast with the Contrast, Shadows, and Clarity sliders in Camera Raw.

2 Back in Photoshop, let's use the Polygonal Lasso tool to create a selection around the upper-left corner of the picture so we can get rid of that distracting element. Remember that you can click outside of the document bounds to make sure the very edge of the picture is selected (**Figure 63.3**). Now go to *Edit > Fill* and select Content-Aware from the Contents drop-down menu to fill in that area.

3 Next, we'll add a Curves adjustment layer and drag the center of the curve down to create a target picture (**Figure 63.4**). Invert the Curves adjustment layer, and then use a soft, white, low-flow brush to paint in the darkness on the ground and in the graffiti behind Destiny, so that it really showcases him (**Figure 63.5**).

Figure 63.3 Preparing the selection for Content-Aware Fill.

Figures 63.4-63.5 Darkening the background and floor to highlight Destiny.

4 Perform a merge up (Command+Option+ Shift+E; PC: Control+Alt_Shift+E), and then duplicate the merged layer. With the duplicate layer selected, go to *Filter > Other > High Pass* to apply a High Pass sharpening filter. Set the High Pass Radius to about 4.5 pixels (**Figure 63.6**).

Figure 63.6 Using the High Pass sharpening filter.

I'd love to say that there are more steps here,
but this image is complete (**Figure 63.7**).

Figure 63.7 The final image.

64. AMSTERDAM, NETHERLANDS

I WANTED TO CLOSE out this book by doing something a little artistic—to leave you with a source of inspiration, if you will. I took this picture in Amsterdam and it felt a little flat when I brought it home, but that didn't stop me from trying to do something whimsical and creative with it (**Figure 64.1**).

Figure 64.1 A picture I took in Amsterdam—the original file.

1 In Camera Raw, we can bring back a lot of the detail by increasing the Shadows and Whites and decreasing the Highlights and Blacks. We'll round out the picture by adding some Vibrance and Contrast. To warm it up a little bit further, we'll also increase the Temperature (**Figure 64.2**).

Figure 64.2 Making some adjustments in Camera Raw.

2 Move over to the Detail tab (two triangles) and increase the Sharpening and Noise Reduction (**Figure 64.3**).

Figure 64.3 Increasing the Sharpening and Noise Reduction in Camera Raw.

3 Click Open Image to bring the image into Photoshop. Let's start by getting rid of the sensor spots in the sky. With the Patch tool selected, circle all of the spots and drag them immediately to the left (**Figure 64.4**). This will ensure that there isn't any blur inside of those spots.

Figure 64.4 Removing spots with the Patch tool.

4 Next, we'll add a little more saturation in the sky by creating a Hue/Saturation adjustment layer (**Figure 64.5**). Select the Targeted Adjustment tool (the finger icon directly under the word Preset in the Properties panel) and click-and-drag on the sky. As usual, this will increase the saturation in the entire picture, so we'll need to invert the mask and brush in that color change only in the sky (**Figure 64.6**).

Figure 64.5 Adding a Hue/Saturation adjustment layer.

Figure 64.6 Painting over the sky to reveal the color adjustment.

5 Now we're going to darken the sky and foreground by adding a Curves adjustment layer (**Figure 64.7**). Grab the center of the curve and drag it downward to darken the sky. Once again, we'll invert the mask and brush in the darkening effect at the top an bottom of the image (**Figure 64.8**).

Figure 64.7 Adding a Curves adjustment layer.

Figure 64.8 Darkening the sky and foreground.

6 Let's bring back in a little bit of warmth by just adding a Photo Filter adjustment layer (**Figure 64.9**).

Figure 64.9 Adding some warmth with a Photo Filter adjustment layer.

7 Now let's create some art. Perform a merge up (Command+Option+Shift+E; PC: Control+Alt_Shift+E), and then go to *Filter > Stylize > Oil Paint*. I like to experiment with different settings for Stylization, Cleanliness, Scale, and Bristle Detail until I find a combination that makes the image look like it was painted (**Figure 64.10**). You can spend a ton of time playing around with this if you want. I used the following settings for this image: Stylization, 4.9; Cleanliness, 8.5; Scale, 0.9; Bristle Detail, 0.7.

Figure 64.10 Getting my art on with the Oil Paint Filter.

8 To give the image a little bit of an ethereal effect, we'll use the Nik Collection Color Efex Pro 4 plugin (*Filter > Nik Collection > Color Efex Pro 4*). I love the Glamor Glow effect. We can increase the Glow and Saturation quite a bit, and add a little bit of Glow Warmth (**Figure 64.11**). This gives the image a very Kinkade-type feel.

Figure 64.11 Adding a little Glamor Glow.

The final picture has a beautiful, surreal look (**Figure 64.12**)—very different from the original shot.

The techniques we've spent our time building upon in this book are ones that are commonly used for a variety of different projects. Photoshop has a ton of different features, and we have only scratched the surface to get to this point, but the techniques we've covered are vital for the day-to-day processing of images in Photoshop.

I hope this book has helped you become familiar with the anatomy of Photoshop, and that you now have a solid core of techniques you can use to get the very best out of your pictures. I would love to see all of the amazing work that you create. If you want to see more of my work, please visit me at aboutrc.com. I also teach online courses at FirstShotSchool.com.

Figure 64.12 The final picture.

INDEX